SOL LEWITT

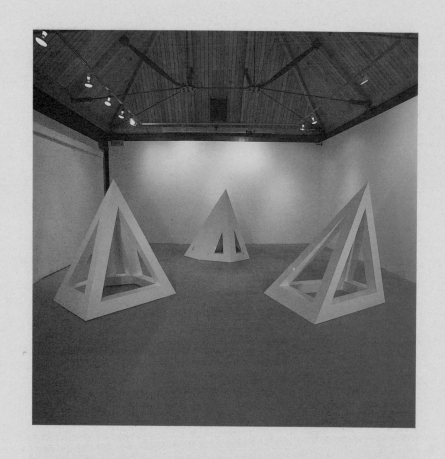

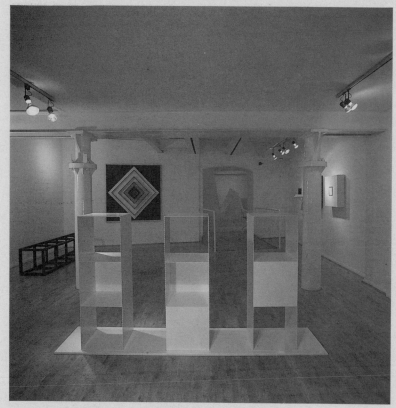

SOL LEWITT – STRUCTURES 1962–1993

THE MUSEUM OF MODERN ART, OXFORD

*Published to accompany the exhibition SOL LEWITT –
STRUCTURES 1962–1993, Museum of Modern Art Oxford,
24 January – 28 March 1993, and subsequent tour. Exhibition organised
by the Museum of Modern Art, Oxford. Curated by Chrissie Iles.*

*Exhibition sponsored by Nina Ricci, Paris
Nina Ricci is an award winner under the Business Sponsorship Incentive
Scheme for its support of the Museum of Modern Art. The BSIS is a
Government scheme administered by the Association of Business
Sponsorship of the Arts.*

Supported by the Henry Moore Sculpture Trust

*Published by the Museum of Modern Art, Oxford
Designed by Sol LeWitt
Edited by Sol LeWitt
Type set in Monophoto Bembo by August Filmsetting, St Helens
Texts copyright © 1993, Sol LeWitt, the authors and the Museum of
Modern Art, Oxford. All rights reserved.
German translation by Peter Fischer, additional work by Cornellia Benson
ISBN 0 905836 78 2
Printed in England by Balding & Mansell, Wisbech
Distributed in Great Britain and Europe by Art Data*

*Cover: ONE OF FIVE MODULAR STRUCTURES
(SEQUENTIAL PERMUTATIONS ON THE NUMBER FIVE),
1972, Scottish National Gallery of Modern Art, Edinburgh*

*Frontispiece and final page: installation of the exhibition SOL LEWITT
– STRUCTURES 1962 – 1993 at the Museum of Modern Art, Oxford,
January 1993.*

*The Museum of Modern Art
30 Pembroke Street, Oxford OX1 1BP*

*The Museum of Modern Art is a Registered Charity (No. 313035) and
receives financial assistance from the Arts Council of Great Britain,
Oxford City Council, Oxfordshire County Council, Visiting Arts and
Southern Arts. Recipient of an Arts Council Incentive Funding Award.*

MUSEUM OF MODERN ART, OXFORD
24 January–28 March 1993

VILLA STUCK, MUNICH
29 April–18 July 1993

HENRY MOORE INSTITUTE, LEEDS
12 August–17 October 1993

FRUITMARKET GALLERY, EDINBURGH
13 November 1993–9 January 1994

NEUES MUSEUM WESERBURG, BREMEN
February – April 1994

A MESSAGE FROM THE SPONSOR

Nina Ricci has always been proud to be part of the artistic and creative world. From the very outset, when it launched its House of Haute Couture in 1932, the policy of Nina Ricci has been to look to art for the sources of its creative inspiration.

As a result we have, over a period of more than half a century, enjoyed highly privileged relationships with the artists who have collaborated with our ventures, first into fashion, then perfume, and now into beauty products.

By working together with painters, sculptors and photographers, and participating with them in the heady process of creation, whilst totally respecting their artistic integrity, we have been able to stay attuned to the sensibilities of each generation and at the same time remain true to the essential spirit of Nina Ricci.

Our collaboration with Sol LeWitt over Ricci Club arose naturally out of this process. This men's fragrance, born from a union of opposites, embodies the contradictory nature of our times, in which coexist a regard for traditional values and a passionate interest in the contemporary world.

It is important to be reminded that there can be no aesthetics without ethics; no modernity without reference to the past; nothing new created that is not rooted in our culture.

In renewing the art of mural frescoes, Sol LeWitt has revived a form of artistic expression which had fallen into oblivion since its great flowering during the Renaissance. This radically contemporary artist, with his modular and ruthlessly logical construction, has opened a whole new field for exploring what foreshadows and should become the classicism of tomorrow.

For all of these reasons I am particularly honoured to be able today to associate the name of Nina Ricci with an exhibition devoted to a man who has profoundly influenced and shaped the aesthetic movements of our time, and for whom I have the greatest personal admiration.

Gilles Fuchs
President of Nina Ricci

ACKNOWLEDGEMENTS

Many people helped in giving their time to the realisation of this exhibition and the accompanying book. We would especially like to extend our thanks to Sol LeWitt for his support, advice and guidance throughout the whole project, and to Susanna Singer for her untiring support and efficient help during all stages of its realisation. We are particularly grateful to the lenders who have so generously made their works available for the exhibition: Jeffrey Deitch: Sondra and Charles Gilman Jr.; The Lisson Gallery, London; The Scottish National Gallery of Modern Art, Edinburgh; the National Gallery of Art, Washington; the Wadsworth Atheneum in Hartford Connecticut, and to those lenders who prefer to remain anonymous. We are also grateful to David Batchelor and Rosalind Krauss for their catalogue texts, both of which provide a long-overdue analysis of the historical and aesthetic context for Sol LeWitt's structures. Our particular thanks go to Nicholas Logsdail at the Lisson Gallery, London, for his help and advice during research for the exhibition. We would also like to thank Janet Passehl of the LeWitt Collection, and Kim Davenport of the Wadsworth Atheneum, as well as Carol LeWitt for her kind hospitality. Also Maryrose Carroll, Sophie Clarke, David Connearn, Sharon Essor, Elyse Goldberg, Michael Hayes, Annetta Massie, Kazuko Miyamoto, Yoshitsugu Nakama, Nebato, Joyce Nereaux, Tina Oldknow, Doris Quarella, Lehni; Susan Reynolds, Fausto Scaramucci, Mark Schippers, Berma; Natasha Sigmund, Nena Singleton, Françoise Sunier, Treitel Gratz, Jo Watanabe, Watanabe Studio; John Weber and Donald Young. We have been pleased to collaborate with the Villa Stuck, Munich, the Henry Moore Institute, Leeds, the Fruitmarket Gallery, Edinburgh and the Neues Museum, Weserburg, Bremen, in presenting this first retrospective exhibition of Sol LeWitt's structures in Britain and Germany.

We would not have been able to mount this exhibition without the valued support of Nina Ricci. We would like to thank Gilles Fuchs, President of Nina Ricci, for his generosity, and Jeremy Faull, Caroline Crabbe and Jane Dobson for making the sponsorship such a success.

David Elliott
Director

Chrissie Iles
Exhibitions Organiser

PHOTOGRAPHIC CREDITS

Allyn Baum 7, 13, 19, 20, 22, 23, 33
David Bellingham 85, 105
Quentin Bertoux 139
Leonard Bezzola 58
Robert Bonis 8, 12
Eduardo Calderon 85, 86
Dennis Cowley 146
Ivan Dalla Tana 78
Georges Engels A B Photocenter 93, 94
John Ferrari 100
Dorothee Fischer 95
J.C. Frisse 66
Norman Goldman 17
Antonio Guerra 106, 108, 109, 112, 117
Akira Hagihara 6, 24, 34
Studio Hartland 52
Jan Jedlicka 123
Bernd Kehrer 129
Gretchen Lambert 15, 27, 29, 30, 31, 32,
Nanda Lanfranco 130
Marcel Lannoy 14
Salvatorie Licitra 128
Robert E. Mates and Paul Katz 62
Attilio Maranzano 99
Cary Markerink 102
Chris Moore 125
André Morain 37, 49
John Riddy 103, 104
Installation photographs of the exhibition
 at the Museum of Modern Art, Oxford
Walter Russell 53, 55, 61
John Schiff 21, 35, 44, 45, 48
Fred Scruton 3, 74, 79, 127, 141
Nitsan Shorer 131
Michael Tropea 80
Skip Weisenburger 2, 11, 125, 126
Westfälisches Landesmuseum für
Kunst und Kulturgeschichte, Münster 138
Kevin Fitzsimons 145
Basil Williams 134
Gareth Winters 81, 82, 83, 84

CONTENTS

INTRODUCTION
Chrissie Illes

This exhibtion and accompanying catalogue bring together a selection of Sol LeWitt's structures from 1962 to the present, and they provide a rare opportunity of surveying an area of his work which has been strangely neglected in Britain (the last exhibition of his three-dimensional work in a British public gallery also took place at the Museum of Modern Art Oxford, in 1977). Sol LeWitt has chosen 153 illustrations for the catalogue, including many previously unpublished photographs, which place the works shown here in a wider historical context.

LeWitt's structures established his central position within the Minimal and Conceptual art movements which emerged in New York during the 1960s. By the 1970s they had become one element within a larger, non-hierarchical grouping of media which included wall drawings, drawings, prints and artists' books. His earliest structures embraced the two directions art took during the 1960s – art as concept and art as action/process – to establish a system which underlies his work to this day. From their appearance in 1962, when the structures became the primary medium for his ideas, to the open and closed pieces of the seventies, and the more recent complex forms, maquettes and outdoor pieces, each new development has emerged from the seemingly infinite possibilities contained within the perameters of his 'permutational system'. The tension arising from the relationship between the idea and its physical realisation, so central to the early thinking of LeWitt and others, remains at the heart of his work, sustained by the strength of his enduring conceptual model.

The new sculpture made by the inter-related groups of Minimal and Conceptual artists of which LeWitt was at the forefront marked an almost unprecedented break with the past, transforming the definitions and boundaries of aesthetic experience. In their rejection of the gestural, anti-intellectual art of the Abstract Expressionists, action ground to a halt. An inert, monumental, cerebral, non-referential, non-relational sculpture took its place. 'To get inside the systems of this work ... is ... to enter a world without a centre, a world of substitutions and transpositions, nowhere legitimated by the revelations of a transcendental subject. This is the strength of this work, its seriousness and its claim to modernity'.[1]

According to the artists themselves, the immediate precedents for this aesthetic revolution were largely literary. Work by such writers as Robbe-Grillet, Beckett, Wittgenstein, Fuller and Borges was consumed, its attractiveness enhanced by its distance from the art historical and art critical worlds. It has been suggested by Benjamin Buchloh that the proliferation of the square and cube the art of the sixties was due to it being the visual form that corresponded most accurately to Robbe-Grillet's linguistic tautology ('If art is going to be anything, then it has got to be everything'). According to this argument the square (and its three-dimensional equivalent, the cube) is the ultimate form of self-reflexiveness, 'incessantly pointing to itself as spatial perimeter, plane, surface and support'[2]. The square seemed to imply the existence of a relief or object, and it transferred easily from two to three dimensions in the transition from painting to sculpture which so many artists, including LeWitt, made.

A primary influence on LeWitt's earliest two-dimensional work was Jasper Johns, whose central concern had also been with issues of perception. Johns (who had himself been influenced by Duchamp) had dealt with these issues in often monochromatic series of works which bridged the gap between painting and sculpture by using repetition (a legacy from the Readymade), paradox, chance, serial images, language (stencilled random words), the grid and the compartment – all features of LeWitt's early work.

In his first hybrid wall structures, LeWitt ruptured the picture surface, first cutting a strip round a square at the centre of the canvas to expose the wall behind, then by lifting out and projecting the squares to create three-dimensional protrusions into

space. Once space had been ruptured in this way, the square protrusions began to evolve into the format of a cube, which he adopted as the primary unit for his structures, using an arbitrary mathematic ratio of measurement. The idiosyncratic, irrational mathematical models which LeWitt and many others created (doubtless influenced by the New Mathematics which had just emerged, employing new diagrammatic methods: sets, the matrix, geometry and topology) contained their own internal logic. LeWitt's interest in mathematical models was also stimulated by Ruth Vollmer, an older German artist living in New York, whose sculptures, constructed using pure mathematical principles (which, like music, were free from external associations), he greatly admired.

From the mid sixties onwards, LeWitt's structures were made up of repeated series of individual equal units contained within an overall grid. His adoption of serial procedures was shared by numerous other artists: Ed Ruscha, Dan Flavin, Mel Bochner, Robert Smithson and Eva Hesse. By giving individual units equal status, LeWitt answered the question to which he had already provided a more opaque answer in his earlier works, particularly in those which had combined language with spatial experiment: to which of two elements within the piece (language or surface) should the viewer attach the greater importance? According to Buchloh he was not asking us to prioritise one over the other, but to embrace both equally, with all the contradictions that this implied.[3]

LeWitt had first worked with serial procedures in 1963 in his telescopic *Wall Structure*. Two years later, dis-satisfied with the surface of the large, slab-like minimalist pieces he had been making in wood, which did not give him the industrial look he wanted, he stripped the 'skin' of the piece away to reveal the skeleton beneath. This step re-defined his relationship to space. Unlike other Minimalists, who Lucy Lippard described as occupying, denying, dispersing and conquering space, LeWitt *incorporated* it.[4]. Interior space became the focus of his work, in permutations of open and closed geometrical serial forms – always in white, to obliterate the possibility of expressiveness.

For Robert Smithson, the inertia and stasis of the new monumental, serial sculptures of the sixties, whose progressions led to no conclusion, celebrated a kind of entropy which suspended time within a grid of infinity, in a motionless, perpetual present. Perception had become 'a deprivation of [both] action and reaction. This made him think of LeWitt's 'desolate but exquisite surface structures . . . As action decreases, the clarity of such surfaces increases'. This feeling of entropy also suggested to him the 1930s, a period of anti-organic anti-realism, when mirrors were commonly used to create prisms of infinity in interior design. Repetition and seriality also appeared in architectural forms all over New York, in formats borrowed from ancient civilisations – ziggurats, pyramids, obelisks, spirals; all 'prime monuments'[5]. In 1966 Le Witt wrote an article on the ziggurat formations in New York architecture, in which his analysis of the creation of these by the Zoning Code of 1916 (which insisted that architects allow sufficient air and sunlight into the street) seemed to echo directly his own aesthetic system.

'The zoning code preconceived the design of the ziggurats, just as an idea might give any work of art its outer boundaries and remove arbitrary and capricious decisions . . . The ziggurat buildings conform to the code, yet no two are alike . . . The zoning code established a design that has much intrinsic value. The ziggurat buildings are heavy-looking, stable, inert and earthbound . . . There is also a logic in the continually smaller set-backs, which allow for intricate geometric patterns. By having to conform to this rather rigid code, aestheticism was avoided, but the code was flexible enough to allow great originality of design'.[6]

Ziggurat forms have been present in LeWitt's work from the beginning, in his first serial piece, then in his open lattice structures and in many of his more recent, increasingly monumental maquettes and outdoor pieces. Pyramids and obelisks, which are both implied in the very early work, re-appeared in the early 1980s as clearly distin-

guishable forms. Smithson said that our fascination with pyramids lies in their unseen cores. He described the 1930s as 'an infinite pyramid, with a mirrored interior and a granite exterior'.[7] This description touches on LeWitt's fundamental concern with the relationship between the hidden core and the exterior surface, manifested as a dialectic between open and closed space. The elongated cubic form of *Standing Open Structure, Black* (1964) could be read as a visualisation of the central core of the cube. As the cube opened up its core disappeared from view, and the elongated forms became invisible, like the missing sections of the *Incomplete Open Cubes*. LeWitt's proposal to place a piece of Cellini jewellery in a block of cement suggests a core invisible but only physically present inside a closed object. It also shows 'an almost alchemic fascination with inert properties'.[8] The basis of alchemy is the notion of primary matter (or, to draw parallels with LeWitt's method, thought), which exists first as potential, and then acquires form only when actualised through the alchemical process (or, the work of art).

In this contradiction between the potential and the actual, it is the mind which instinctively attains the whole, as Lucy Lippard observed. Just as our eye completes the missing sides of the *Incomplete Open Cubes*, one is prepared and obliged, to believe that the closed parts of the *ABCD* series contain the same underlying framework as the open parts, and we take on trust the contents of LeWitt's '*Buried Cube*' (1968), which remain unseen and unknown except to the artist and the two witnesses to its burial in an unknown location.

The ten black and white photographs concealed inside the inert horizontal black box of *Muybridge II* (1964) also suggest a secret, hidden presence. The images remain invisible until the viewer activates a flashing light inside the box and looks through ten tiny consecutive apertures. *Muybridge II* was made in response to the work of the nineteenth century English photographer Eadweard Muybridge, who stimulated the involuntary visual impulse by which our eye completes an incomplete sequence. His series of photographs captured different stages of animals and humans in motion – frozen and mapped out as a collection of individual units or frames, grouped inside a grid. This placing of separated stages of action within an overall graphic device suggested an original single, unified movement, and influenced LeWitt's own serial method.

The ten images of a naked, motionless, seated woman show the camera moving progressively closer to the figure until her navel fills our field of vision, documenting stillness and action simultaneously. A kind of Minimalist zootrope, this sequence of images turns Muybridge's model on its head. It is not the figure, or subject, which moves, but the camera and viewer. Movement is also present in the rhythm of the sequence ('Regular spacing might . . . become a metric time element, a kind of regular beat or pulse')[9]. LeWitt again brings paradox and contradiction into play by placing opposites side by side in equal measure and by refusing to prioritise one over the other. The grid of the box at once separates and unifies the individual images, providing a physical framework within which the viewer can move backwards and forwards. This visual dismantling reverses the unified illusionism of Muybridge's original zootrope. Similar experiments were being made by structuralist film-makers, who reversed projection, slowing movement to a standstill and thereby revealing the physical structure of the film frame. Lucy Lippard described the work LeWitt was making as 'depicting time and motion without anything actually moving'.[10] LeWitt later mapped stillness onto movement in real time in *Dance*, a collaboration with the choreographer Lucinda Childs and composer Philip Glass. A black and white film which froze the action of the dancers in split-frame images was projected at angles in front of the action taking place on stage, in a giant grid.

Just as the conceptual model LeWitt established in the sixties has been retained, the quality of motionlessness which pervaded all his early work has been carried through to his more recent structures. The forms of his maquettes and outdoor pieces continue to echo the inert monumentality of the Modernist architecture of New York as well as

forms derived from ancient cultures. Traces of other architectural forms have also appeared: the stark, elegant stalactites of certain Complex Forms soar upwards like the spires of Gothic cathedrals. The vertical (or hidden core) has re-asserted itself in space, at the same moment that the cube has become almost obscured by a geometric chiselling away of its original form. The sculptural inferences of this correspond to the increasing painterliness of his recent coloured gouache drawings. It is now the cube itself that has become hidden, as LeWitt turns yet another idea inside out.

LeWitt's concern with the invisible, the absent, perhaps finds its most eloquent expression in the final image in this catalogue. *Monument to the Missing Jews* (1987, installed in the Platz der Republik, Hamburg) draws the eye into the infinite space of a large black horizontal block, evoking a feeling of the overwhelming absence and loss of a core, or heart. This is a place of memory; 'a nothing, a void, something of the universe before birth or after destruction'.[11]

NOTES

1. Rosalind Krauss, *The Originality of the Avant-Garde and other Modernist Myths*, MIT Press, Cambridge Massachusetts, 1985.

2. Benjamin H. D. Buchloh, 'Conceptual Art 1962 – 1969' in *October*, Cambridge Massachusetts, No.5, Winter 1990. See pp.113–115 in particular for an analysis of LeWitt's early structures using language.

3. Ibid.

4. Lucy R. Lippard, 'Rejective Art', *Art International* Vol.10, October 1966.

5. Nancy Holt (ed.) *The Writings of Robert Smithson*, New York University Press, New York, 1979.

6. Sol LeWitt, 'Ziggurats', *Arts Magazine* (New York), November 1966, reprinted in Alicia Legg (ed.), *Sol LeWitt*, Museum of Modern Art, New York, 1978.

7. Holt, *op. cit.*

8. ibid.

9. Sol LeWitt, quoted in Lucy R. Lippard and John Chandler, 'The Dematerialisation of Art', *Art International*, February 1968.

10. Lippard and Chandler, *op. cit.*

11. Christine Buci-Glucksmann, 'Images of Absence', *Bracha Lichtenberg Ettinger: Matrix Borderlines*, Les Cahiers du Regard, Herblay, 1993.

WITHIN AND BETWEEN
David Batchelor

Take Sol LeWitt's *Floor Structure, Black* of 1965 [cat.7]. A seventy two inch long construction sub-divided into five twenty inch cubes, it is made from square-section machined timber, painted in a uniform black lacquer. The artist commented that he had been dissatisfied with the finish of some enclosed forms he had exhibited previously, so: 'I decided to remove the skin altogether and reveal the structure. Then it became necessary to plan the skeleton so that the parts had some consistency. Equal, square modules were used to build the structures. In order to emphasise the linear and skeletal nature, they were painted black'.[1] Such a straightforward explanation seems appropriate to this clear and unfussy work. Decisions concerning the structure are presented as responses to practical problems experienced in previous work. LeWitt's aim was to make the surface look 'hard and industrial', an effect which had been 'negated by the grain of the wood'.[2] The solution which was found in the modular cube structure became the basis for an extensive and varied body of work over the next decade and beyond. By the end of 1965 the structures were painted white (which 'mitigated the expressiveness of the earlier black pieces'), and LeWitt fixed the ratio between the material of the structure and the space it described at 8.5:1. By 1967–68 LeWitt was making work in aluminium and steel as well as wood.[3] Many of these structures are free-standing, floor-based works; others are located against walls or in corners; some are hung on walls, either as flat reliefs or projecting into the gallery space. These wall-based works hark back to LeWitt's earliest relief structures from 1962–64 [cat.1,2,3,4]. In particular they refer to a relation which is embodied in LeWitt's work from the early sixties to the present: the relation between painting and sculpture, between two- and three-dimensional projection, between image and object. But in investigating the possibilities of open modular structures, LeWitt did not simply abandon the use of closed forms. Rather, 'open' and 'closed' is treated by LeWitt as another relation, one which he explored in his first systematic serial works of 1966 and 1967 [cat.8,9] as well as in more recent structures [cat.19, 20].

Much of this essay looks at these and other relations as they are constituted in LeWitt's work. But there is also another kind of relation to be considered, one which might help to provide an approximate context within which to view the emergence and development of LeWitt's structures, processes and terms of reference. All works of art exist, by definition, in relation to other works of art, past and present. And much of the critical significance which is attached to certain works of art is given in their being allocated a significant place in a historical narrative. Consider the following passage:

'The new construction-sculpture points back, almost insistently, to its origins in Cubist painting: by its linearism and linear intricacies, by its openness and transparency and weightlessness, by its preoccupation with surface as skin alone... Space is there to be shaped, divided, enclosed, but not to be filled. The new sculpture tends to abandon stone, bronze and clay for industrial materials like iron, steel, alloys, glass, plastics, celluloid, etc.,

1. *Pablo Picasso, Construction: Guitar, Autumn, 1912. Musée Picasso, Paris.* © *Photo R.M.N.*

14

which are worked with the blacksmith's, the welder's and even the carpenter's tools. Uniformity of material and colour is no longer required, and applied colour is sanctioned. The distinction between carving and modelling becomes irrelevant: a work or its parts can be cast, wrought, cut or simply put together; it is not so much sculptured as constructed, built, assembled, arranged. From all this the medium has acquired a new flexibility in which I now see sculpture's chance to attain an even wider range of expression than painting.'[4]

Here is as clear an appraisal of the origins and means of LeWitt's three-dimensional work as you could hope for. Rooted in the stoical tradition of Cubism, his modular work finds its critical profile in the negation of established sculptural convention – carving and modelling – in favour of 'construction'. The only problem is that the text was written with nothing like LeWitt's work in mind. Not only was it published several years before LeWitt made any structures, by a critic who has never subsequently indicated any particular interest in his output, but work such as LeWitt's came to be regarded mainly as a diversion from the historical paths mapped out in this essay. The writer was Clement Greenberg; the date 1958.[5]

LeWitt has written about his own work and working methods from time to time, but has not discussed such questions of history. However, since 1962 LeWitt has titled his three-dimensional work 'structures' rather than 'sculptures'. The implication here is that in some important respect these works are to be distinguished from the types of objects we associate with the category 'sculpture'. His contemporary Donald Judd made a similar point in 1965 when he opened his essay 'Specific Objects' with the sentence 'Half or more of the best new work of the last few years has been neither painting nor sculpture but "three-dimensional work"'.[6] So, on the one hand Greenberg maps out a tradition of 'construction-sculpture' which appears to but doesn't allow for the inclusion of LeWitt's and Judd's work; on the other hand, LeWitt and Judd make 'three-dimensional work' which suggests in its materials and means of fabrication a link with earlier types of constructed sculpture, a link which they refuted. If this seems confusing, it should at least be clear that the distinction between sculpture and structure meant something far more specific than a change of basic techniques or materials. Greenberg recognised that carving and modelling had been pretty much displaced from the sculptural mainstream by the 1930s. He could point to a line of 'constructed' work – from Brancusi and Picasso through Tatlin and Gonzalez to David Smith – in support of a claim that this represented the most advanced and demanding sculpture of the twentieth century [figs.1–3]. It is hard to imagine Judd or others finding much to disagree with in this. Clearly, then, the differences between 'sculpture' and 'structure' lay somewhere within the broadly accepted category of 'construction', and not between it and some other category, such as carving.

It is generally accepted that during the early to mid 1960s, LeWitt, Judd and others (Frank Stella and Carl Andre for example) were seeking to distance themselves from certain prevalent forms of painterly composition and sculptural construction. Or, more to the point, from the kinds of experience these types of composition and construction were understood to embody. LeWitt was after a 'hard and industrial' look, something which was incompa-

2. Vladimir Tatlin, Counter-Relief, 1913/14, reconstruction by Martyn Chalk. 1979. Courtesy Annely Juda Fine Art

3. David Smith, Hudson River Landscape, 1951. Collection of Whitney Museum of American Art, New York.

15

tible with a certain kind of worked surface and 'expressiveness'. But this did not reduce simply to a matter of using metal instead of wood. It was in the compositions of 'equal, square modules' as well as in certain finishes that this look was first achieved. In an often referred-to interview conducted in 1964, Judd and Stella both stressed the importance of getting away from what they termed 'relational' compositions of European abstract art. 'The basis of their whole idea is balance' said Stella, 'You do something in one corner and you balance it with something in the other corner'.[7] For Judd, 'The big problem is to maintain the sense of the whole thing' over and above relations-between-parts. The point is not that their work did without relations-between-parts but that they changed the form of those relations, and altered the emphasis between the parts and the whole [figs.4–5]. Characteristically these relations became highly regulated or modular, stripped of sudden movements and dramatic shifts in shape, scale or colour. Elements in the work and divisions between them were made increasingly equalised and regular.

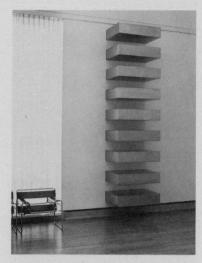

4. Donald Judd, Untitled, 1966. Staatsgalerie, Stuttgart

For Judd, relational art was tied up with a discredited tradition in European philosophy. There was some vagueness surrounding this idea, but he clearly found within such art an implied division between its visible surface and some metaphysical substance. Or at least, he found the critical language which tended to surround such work guilty of employing this kind of speculative metaphysics. Judd sought to cancel the possibility of such rhetorical reflection in his singular, whole, thing-in-itself sculpture. And insofar as he does not use one material (say, stone) to refer to another (say, flesh), he maintains he has also cancelled any possibility of representation in his work. Stella too stressed his aversion to the old 'humanistic' assertion that 'there is always something there besides the paint on the canvas'. His own work was 'based on the fact that only what can be seen there is there... What you see is what you see.' Painting and sculpture had meant a tradition of illusion and representation; as their work stood for the elimination of representation it was 'neither painting nor sculpture', but 'an object'.[8]

Each of the main terms in the opposition – 'sculpture' and 'structure' or 'three-dimensional work' – has its own loose cluster of defining terms hovering around it. 'Sculpture' is characterised (by Judd and Stella) as relational, pictorial, humanist, crafted and expressive, whereas 'three dimensional work' is singular, literal, anti-humanist, industrial and inexpressive. Clearly some of these terms are more descriptive than others – some refer to literal properties of the objects (how and what they are made from), while others deal with metaphorical properties (their effects, what they look like). In certain cases it is not so easy to distinguish literal from metaphorical characteristics. Judd's three-dimensional works, for example, both look 'industrial' and are made in a factory, although there is no necessary relation between the facts and the effects of the work – industrial production can simulate a crafted appearance, and hand-made work can be made to look anonymous and mass-produced. And some of the characteristics ascribed to 'sculpture' and 'structure' are not so much intrinsic (literal or metaphorical) properties of the works as properties of the process of opposition. Whether something looks 'balanced' rather depends on what the alternatives are. If a work by Anthony Caro [fig.6] is taken to exemplify the term, then it will not seem applicable to a LeWitt cube structure. But if the LeWitt were placed next to a 'scatter' piece by Andre or Serra then 'balanced' might seem a more appropriate description of LeWitt's work.

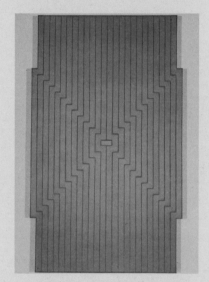

5. Frank Stella, Six Mile Bottom, 1960, Tate Gallery, London

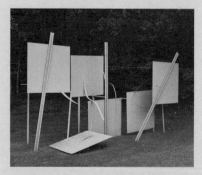

6. Anthony Caro, Pompadour, 1963, Rijksmuseum Kroller-Müller, Otterlo

16

Many of the terms used to describe the effects of works of art are relative in this sense, dependent upon a framework of possible alternatives.

Whether or not gestural painterliness and 'balanced' compositions are inherently humanistic is not really the point. That they were perceived as such at the time is what matters. A shared sense of unease with the prevailing conventions of art making was enough. But Judd and Stella, in signalling their departure from the terms of European art and expressionist abstraction, were also establishing a relationship with it. And necessarily so, for it is in this relationship that their own forms and techniques acquired significance as art. If freehand drawing and 'balanced' compositions were taken to correspond to a kind of humanism, then ruled lines and modular compositions would signify, at least, not-that-relationship. These sorts of lines and shapes (and materials, finishes, colours, etc) marked out a negative area, they constituted a move against what had become an increasingly academic convention. Certainly during the late fifties and early sixties there appears to have been a consensus among a generation of young artists that certain forms of art and criticism had become formulaic and mannered. They could no longer act as a positive resource in tackling their own experience of modernity, or their own experience of other art – such as Pollock's.[9] But the negation of established ways of going on is not just negative. It also points in different directions, produces fresh likenesses, invites us to make different kinds of comparisons and asks us to see aspects of the world in different terms.

Judd's language of the 1960s is one of an absolute break with prior art. (Stella was a lot more circumspect about the differences between their own work and the rest of modern art.) Greenberg's sketch of sculpture's recent history, by contrast, is entirely dependent on a sense of continuity. But in one area there was agreement: the work which went under the label 'Minimalism' (a misleading term used by everyone except the artists whose work it is meant to describe) was not a part of the tradition of 'constructed' work mapped out by Greenberg. That tradition was continued in Anthony Caro's and others' balanced constructions, not in the modular structures of LeWitt, Judd or Andre [fig.7]. For Greenberg that was the point of the tradition; for Judd that was the problem with it. During the 1960s it seems this latter work could only be conceived of in terms of a break from tradition, from whichever side it was viewed. But what was then represented as a break might now be seen as an order of continuity which the prevailing language was blind to.

For example, I think it is possible to see, even and perhaps especially in the most uncompromising modular structures of the mid-sixties such as LeWitt's or works by Andre, not so much the defeat as the development of aspects of pre-war European art. For Cézanne, Mondrian, Matisse and others, the principle of *equivalence* acquired a central place in their work – both technical and moral. Equivalence as an ideal relation meant in practice the attempt to abolish hierarchy from painting. But hierarchy – the placing of one thing morally above or below another – seems almost a precondition of painting. Even its most basic terms, 'figure/ground', are ordered hierarchically. For Mondrian, only a painting in which all the elements exist in a relationship of equivalence and equilibrium is one free from the interests, prejudices and mere habits of everyday existence. The abolition of figure/ground became a precondition of transcendence, of going beyond the wilful and moralised relationships of life [fig.8].

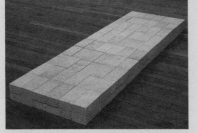

7. Carl Andre, Equivalent VIII, 1966, Tate Gallery, London

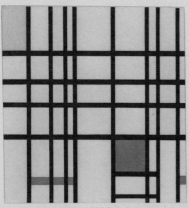

8. Piet Mondrian, Composition with Red, Yellow and Blue, circa 1937–42, Tate Gallery, London

17

LeWitt's and others' modular works of the mid-sixties take the principle of equivalence and de-centredness a stage further and into three dimensions. The differences are important. Here equivalence is an exact and preconceived relation in the work, not a relation achieved in the process of the work's execution. It is a literal relation between identical elements, not a fine tuning of non-identical elements. But while this type of work lacks the dramas of 'push-and-pull', a lack which rendered it artless in many contemporary eyes, this does not constitute a simple negation of earlier art. Rather, the scepticism concerning 'balance' served more to rephrase the issue of equivalence than abolish it. Andre, knowingly, titled his sequence of notorious fire brick works of 1966 *Equivalent I–VIII*.

'Tradition' and 'newness' in art are not opposites but, for want of a phrase, dialectical relations. The new in art is often the rephrasing of traditional forms and concepts in unaccustomed ways. Newness continues tradition in non-traditional ways. When new work emerges, the extent to which it departs from the standard is its most striking feature. Over time, as newness turns to familiarity, more traditional aspects of the work may become increasingly apparent. This, I would argue, has happened with LeWitt's work. Whilst at first it appeared to stand apart from artistic tradition, now its connection with tradition is more visible. It looks as much a part of a tradition of light, open, linear, constructed sculpture, as apart from the tradition sketched out by Greenberg forty five years ago. Some remarks by LeWitt also convey this ambivalence. Whilst his term 'structure' carries with it the implication of a break from artistic tradition, he also stated in a discussion that 'I would like to produce something I would not be ashamed to show Giotto'.[10] Andre too has been keen to stress the connections between his work and a kind of deep, almost primitive, cultural tradition.[11] Even Warhol, another artist from the same period who sought a kind of 'hard, industrial' look, now comes across as less a threat to than a skilful exponent of established painting genres – portraiture and still-life in particular.

It is perhaps the preconceived-ness of LeWitt's, Andre's, Judd's, Stella's and others' compositions of the mid-sixties which represented the greatest threat to convention. When Mondrian, during 1918–19, executed a few paintings based upon an absolutely regular division of the canvas surface [fig.9], he also worked hard on breaking up the rigid format of the grid. Not only were colours irregularly placed, but lines were widened, darkened, lightened, softened and dissolved in different parts of the composition. For Mondrian, an art of pure repose was always a one-off intuitive achievement, something discovered anew in each work (assuming the work was successful). It was not something that could be conceived in advance and executed according to a set of instructions. Thus the regular grid became irreconcilable with the demands of a pure art, as had the limitations of naturalistic painting before. Repetition might have succeeded in abolishing hierarchy, but it also threatened to kill painting in the process. For Mondrian the task was to steer abstract art on a course between the Scylla and Charybdis of hierarchy and pattern. Once the symmetrical structure was dropped in favour of a more malleable irregular division of the canvas, he never returned to the regular grid. But what was for Mondrian dead ground became for many artists of the 1960s the most fertile area of inquiry. The implications of the preconceived grid were no longer to be avoided but investigated.

9. Piet Mondrian, *Checkerboard, Light Colours*, 1919, Haags Gemeentemuseum

There was a further problem attached to the grid for Mondrian. Whilst it helped to abolish the vestiges of illusionistic deep space, it simultaneously ushered in another kind of illusion – that of lateral extension, as the unbroken grid could appear to continue beyond the framing edge of the canvas. In applying the grid to the real space of sculpture, LeWitt and Andre sidestepped many – but not all – of the problems of infinite extension. It is hard to imagine any example of a sculpture which implies continuation beyond its actual limits. Even the Venus de Milo ends, so to speak, where she ends. We do not imaginatively complete the figure as we do in the case of a cropped photograph or painting – or at least, not in the same way. At the same time, the grid is by definition endlessly extendable; it has no natural limit in either two or three dimensions. Any actual limit is never given in the grid but imposed upon it. Perhaps in recognition of this, both LeWitt and Andre have made considerable quantities of grid-based structures in many different formats and sizes. Furthermore, both have at times imposed in advance certain physical or conceptual restrictions and gone on to explore the possibilities within those set limits. LeWitt's five-module and nine-module structures, for example, are all variations contained within the limits of a pre-ordained, if imaginary, cube [cat.9,10,11.] Even so, works such as these clearly do not exhaust all the conceivable variations given within the set limits. Rather, each structure represents one possible development, but one no more or less necessary than any other one. It is perhaps for this reason that these works, for all their rigidity of conception and structure, appear so provisional and un-fixed.

It is in the serial structures and serial drawings – works in which all the possible permutations of a pregiven set of structures, lines or colours are elaborated – that the grid's tendency toward infinity is held in check (but not overcome) through being overlaid with a self-contained, finite, system. In *Serial Project No.1 ABCD* (1966–68), LeWitt exploits both the relation between two- and three-dimensional representation and the relation between open and closed forms, in a conceptually precise but perceptually complicated group of permutations. But again the system is something imposed upon the grid – literally in this case – to establish its limits; the limits are not a property of the grid itself. It is only when LeWitt begins to break down the grid, in his dissections of the modular unit which comprise *All Variations of Incomplete Open Cubes* [cat.11], that he finds its inherent limits.

But it was the issue of the grid's preconceived-ness which stuck like a bone in the throat of artistic integrity. It begged questions of cherished assumptions. Above all, the logic of preconceived-ness appeared to short-circuit the passage in art between idea and realisation, the passage which is trodden in the space of the artists' studio. The kind of 'balanced' work which Stella recoiled from, and the kind of worked surface which LeWitt sought to negate, were indelibly marked by traces of the artist's struggle to negotiate this passage. In effect pre-conceivedness introduced a form of self-imposed alienation into the work of the studio. This work would no longer reflect a hard-won triumph over alienated labour, it would embody that alienation. Whereas 'fragmented' compositions might have signified the possibility of unified human expression, the 'wholeness' of the minimalist object would be achieved by the division of labour into discrete parts. The work of art would involve a different type of work. The artist became split into a designer who drew up plans and a labourer who mechanically followed the brief. As the work of *art* had achieved

19

a kind of de-centredness in its form, now the *work* of art was itself de-centred. At least this highly attenuated mode of production appeared further to jeopardise the centred humanist self implied in 'relational' art. Modular designs cannot be significantly revised in the course of realisation and the bulk of the aesthetic decisions – size, shape, composition and materials – must be made in advance of construction. Given the preferred finishes of 'minimalist' structures – consistent, plain, unembellished, unexpressive – the most appropriate materials are often those used in modern industrial production: sheet steel, aluminium, machined timber. And once a formal division of labour was established in principle, it was a short and practical move for many artists to have the structures fabricated in specialist workshops by skilled workers. In this work, studio activity does not so much begin with a sketch as conclude with a diagram. The studio becomes one stage in the production process of art instead of a self-contained cottage industry.

Since the mid-sixties Judd has had his metal sculptures fabricated in engineering works. All LeWitt's three dimensional work and wall-drawings are or may be executed by assistants according to his precise instructions. But whereas for Judd this seems to answer a practical problem in a practical way, LeWitt has made the relationship between idea and execution a subject in his work. It is an important difference, and one which became increasingly visible in LeWitt's work of the later sixties. It is also a difference which might be used to distinguish 'minimal' from an emergent 'conceptual' art. The three-dimensional work of the mid-sixties sought to cancel or suppress representation in favour of objectness – at least in Judd's and Stella's characterisation of things. Conceptual art could be said to have reversed the terms of the problem by cancelling (or threatening to cancel) the object by way of an inquiry into the conditions of representation.

Clearly Conceptual Art meant many things to many people, but much of it is marked by a kind of critical self-consciousness concerning the relations between different modes of representation – visual and verbal in particular. Art & Language took their name from that relation; Joseph Kosuth, Lawrence Weiner, On Kawara, LeWitt and others made work out of the space between depiction and description. In some Conceptual art the relationship was dealt with in terms of a narrative between 'idea' and realisation, with the former being privileged over the latter. LeWitt said just this – 'In Conceptual art the idea or concept is the most important aspect of the work' – in his *Paragraphs on Conceptual Art* of 1967.[12] The realisation of an object or image, the reasoning goes, is an optional extension of the original idea.

The radical downplaying of the visual or objective character of art surely had an important critical value at a time when an increasingly ossified emotivist criticism prevailed. But the privileging of 'idea' over 'execution' was not intended to imply that the idea itself was necessarily profound. On the contrary, in LeWitt's work the ideas were usually 'ludicrously simple'.[13] The aim for LeWitt was not to inject art with deeply significant ideas, but to find out whether it could still be interesting to look at or think about if it was derived from a 'ludicrously simple' starting point and executed in a largely mechanical fashion. That is, could art stand up without its familiar crutches of profound subjects and hard won results, and if so what would it be like? Similarly the serial extension of works, the playing out of every conceivable permutation of a given group of shapes or forms, has more to do with the spirit of building a

house of cards than with elevating art to a form of quasi-scientific inquiry. There is a kind of discrete anarchy in these early works of Conceptual art. A manic smile lurks behind LeWitt's precise shapes, simple rules and orderly progressions. There is pleasure in the mental overload which often results from the careful elaboration of simple instructions. Here 'orderly' is not synonymous with 'rational'. There is no deep platonic order underlying LeWitt's lines, grids and serial progressions, only a 'ludicrously simple' idea and some arbitrary decisions. 'Irrational thoughts should be followed absolutely and logically', LeWitt stated in his *Sentences on Conceptual Art* of 1969.[14] In these ways LeWitt's work of the late sixties has something in common with Buren's binary division of the picture space into vertical 6.7 cm stripes and his unwavering commitment to this essentially arbitrary decision. Likewise, the decision concerning the ratios and colour of the modular structures was described by LeWitt as 'an arbitrary decision, but once it had been decided upon, it was always used'.[15]

The main components of LeWitt's two-dimensional works from around 1968 are lines and words. Each of his earlier wall drawings is accompanied by a precise verbal description of its elements and means of execution. The stated relation between idea and execution in conceptual art has sometimes been interpreted as the privileging of words over images, texts over pictures. This is not the case with LeWitt's words. They are not explanations of the drawings but instructions or descriptions which run parallel to them. The words, like the lines, are an expression of the idea which, LeWitt has said, 'remains unstated'.[17] In several books produced by LeWitt during the early seventies, words and lines are used to describe and display one another. In a work from 1970, a drawing displays exactly what a text states – Six Thousand Two Hundred and Fifty Five Lines – but it would take a lot to recover the information from the drawing alone. Though the text says it in one line, it does not say it all – there are many aspects of the drawing (length of the lines, their placing, colour, straightness, etc) which it does not reveal. The same text could produce any number of different drawings, just as the same drawing could produce any number of equally true but different descriptions. In this case, the setting of the drawing on the page suggests the image preceded the words. But in other works – for example, *Ten Thousand Lines, 5" Long, Within a 7" Square*, of 1971 – the reverse is clearly the case [fig.10].

The Location of Lines is a small square format book made in 1974. In this and in a number of related books, drawings and prints from around the same time, LeWitt places a line adjacent to a precise textual description of its placing. The first two pages of the book show a simple horizontal line and its description: 'A line from the mid-point of the left to the mid-point of the right side'. There is a kind of symmetry between the two – they are about the same shape and size, and seem to take about the same time to take in. The conventions of reading suggest the text, on the left page, narratively precedes the image on the right page. But as the book progresses, an extreme asymmetry appears between text and image. The last page contains a short diagonal line, [fig.11] but its description on the preceding page runs to a hundred and fifty words, thus:

'A line between the two points where two sets of lines would cross if the first line of the first set were drawn from a point halfway between the centre of the page and the upper left corner to a point halfway between the mid-point

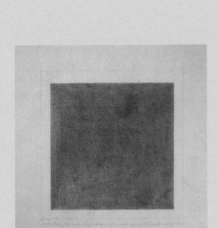

10. *Sol LeWitt, Ten Thousand Lines 5" Long within a 7" Square, 1971, [reproduced in Sol LeWitt Drawings, cat.146]*

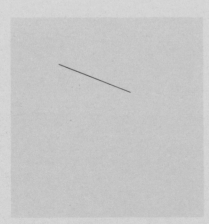

11. *Sol LeWitt, The Location of Lines, 1974, courtesy Lisson Gallery, London*

of the bottom side and a point halfway between the centre of the page and the lower left corner; the second line of the first set from a point halfway between the mid-point of the top side and the upper left corner to a point halfway between the centre of the page and the lower left corner; the first line of the second set from the mid-point of the top side to a point halfway between the mid-point of the right side and a point halfway between the centre of the page and the lower right corner; the second line of the second set from the upper right corner to the centre of the page.'

The asymmetry here is quantitative but also qualitative. For all its precision, the description sounds crazed. It is almost impossible to follow, unlike the line itself, which looks absurdly simple by comparison. The accuracy of the description is also a kind of insanity. Or a kind of poetry. Most of all, the text gives away little sense of what the image would look like. What can be shown in an instant is almost impossible to say in a paragraph. And what is indicated in these works is not that pictures can be subsumed into words, but that they occupy distinct realms. A single line or a short sentence can produce a kind of aporia when put into another symbolic mode. In these works, the line between word and image and between cause and effect is tangled. No hierarchy between word and image can be assumed or sustained. The causal space between word and image is rendered as unstable as the optical space of a Mondrian canvas – except in this case the absence of hierarchy does not guarantee equivalence. Furthermore, the 'idea' is shown to have no existence outside an expression, but every expression reveals only a particular instance of the 'idea', never a pure essence prior to its contingent forms.

In 1974 LeWitt brought structures and photographs into his dialogue between lines and letters. *All Variations of Incomplete Open Cubes* [cat.11] consists of the descriptive title and a sequence of 122 isometric projections, 122 structures and 122 photographs all of which depict the entire development of three- to eleven-part incomplete cubes. The work has something in common with certain works by Joseph Kosuth, whose *One and Three Frames*, for example, pits a photographic representation and a dictionary abstract against an example of an actual picture frame [fig.12]. But there are also significant differences, the most obvious of which shows itself in the scale and extension of LeWitt's work. The referent in LeWitt's is also purely abstract (a geometric form as opposed to a concrete object) and always absent – the cube is only ever there by implication, to be completed in the viewer's mind. In addition, Kosuth's work has its origins in the readymade – two of the three forms are 'found' (in a shop and a dictionary) – whereas LeWitt's finds its own form in the process of its execution. LeWitt's work narrates its own development in several discrete but interlocking voices. Once again, and this is perhaps the most striking difference, LeWitt's work, in all its order and precision, seems on the verge of chaos. In all, *All Variations of Incomplete Open Cubes* comprises 366 separate elements, nine labels and a book combining the diagrams and labels. By comparison, the three-part Kosuth has the quality of a textbook demonstration.

The relations between text, diagram, structure and photograph in the *Incomplete Open Cubes* are less ambiguous than the relations between word and image in the drawings mentioned above. In a strict serial progression of this kind, the three-dimensional work presupposes the existence of some kind of map, and the photographs obviously document a pre-existing set of structures. But if the concept 'incomplete open cubes' precedes the execution, and the aim

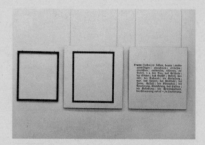

12. *Joseph Kosuth, One and Three Frames, 1965, Ludwig Museum, Cologne*

is to produce a work in which the finished form is given (but not necessarily known) to the artist in advance, this scarcely displaces all decisions concerning the visible form of the finished work. Many considerations – such as the width, colour and surface of the bars, the overall dimensions and placing of the cubes, and so on – are simply not given in the concept. They are specific to the realm of execution. And as with LeWitt's many serial drawings of the period, works in which the kinds of decisions associated with 'relational' art were eliminated by the imposition of a strict set of rules governing execution, the results rarely, if ever, negate the autonomy of the visual. On the contrary, they nearly always do far more to demonstrate the irreducibility of the image, to show how it can never be boiled down to a set of words without a significant remainder, how the text can never fully describe the image. At the same time, of course, though the image may conform strictly to the stipulations of the text, it is never simply an illustration: as often as not it is barely possible to unravel the originating concept from the executed version. What you see *is* what you see: it is other than what can be said or written (readers of exhibition catalogues take note.)

Conception and perception has become an immensely fertile relation in LeWitt's two- and three-dimensional work, a relation which is sustained in more recent structures. The complex forms and pyramids are mostly irregular and multi-faceted, seemingly impossible to represent in clear conceptual schemas. However, each is in fact originated by LeWitt in surprisingly simple diagrammatic form [fig.13]. In these maps the diagonal lines across the grid represent the ground-plan of the form, and the small cross indicates its apex, the point where the faces meet. The only additional information needed to fabricate the structure concerns the height of the apex from the base. In these works the gap between conceptual and physical form is extreme, far greater than in the case of *All Variations of Incomplete Open Cubes*. The diagram precisely determines the shape of the work's visible faces, but gives very few clues as to exactly what it will look like. The result is something both highly determined by and quite independent of its plan.

This paradoxical relation between the conceptual and physical forms – this determined autonomy, so to speak – is a feature common to many of LeWitt's structures. The complex modular cube structures executed since 1966 are often based on simple sequential progressions. They are conceptually uncluttered. But the viewer's passage around the actual structures is continually punctuated by a series of fleeting perceptual effects. Shadows are cast by one bar upon another, softening and scrambling the works' strict geometry. Square and hexagonal channels appear at points to cut shafts into the structure, then break up and re-emerge at other points. The concept may be the maker of the final form, but not its master.

The point here is not that LeWitt relinquishes control of his work after the planning stage. Through experiment and experience one learns the approximate types of effect likely to be produced in one or other type of structure. The executed form of one series is bound to have some bearing on the conceptual shape of the next group of works. Effects turn into causes. To some extent this accounts for the sense of narrative and formal consistency which runs through LeWitt's thirty years of structures and drawings. The division of labour in LeWitt's work operates by degrees and contains a kind of flexibility. The aim in the end is not to demonstrate the workings of a system but to make art which he 'would not be ashamed to show Giotto'. There is also another level

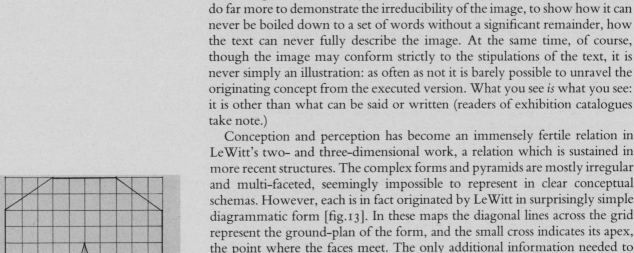

13. *Sol LeWitt, diagram for Complex Form, 1986*

of consistency in LeWitt's art of the last three decades. It is in the spirit of the work, a spirit which I can only describe as one of quiet but joyous inquiry. This inquiry is directed to and finds form in a number of abstract relations – relations of idea and execution, conception and perception, plan and structure, word and image, image and object, structure and sculpture, rationality and irrationality, order and disorder, tradition and newness. It is not so much that the work is about these relations as these relations are embodied in the work. And as relations they are all marked by kinds of reflexivity, which is what gives his work a mood of lightness, openness and substance. The knots of prejudice and habit which hold these relations in fixed position are worked loose. The pleasure of the work is the pleasure of experience confounding expectation, as it must. A world in which experience is not allowed to go beyond expectation is tyranny.

NOTES

1. Sol LeWitt, commentary on his work in *Sol LeWitt*, Museum of Modern Art, New York, 1978, p.57.

2. Sol LeWitt, *ibid*, p.53.

3. Sol LeWitt, *ibid*, p.59.

4. Clement Greenberg, 'The New Sculpture', in *Art & Culture*, Thames & Hudson, 1973, p.142. (The end of the essay quotes two dates: 1948 and 1958. The passage quoted here is from the revised version).

5. See for example Greenberg's 'Recentness of Sculpture', reprinted in Battcock (ed). *Minimal Art: a critical anthology*, Dutton, New York, 1968, pp.180–186. The essay was originally published for the exhibition catalogue *American Sculpture of the Sixties*, Los Angeles County Museum of Art, 1967.

6. Donald Judd, 'Specific Objects', *Arts Yearbook 8*, 1965. Reprinted in *Donald Judd: Complete Writings 1959–1975*, Nova Scotia, 1975, pp.181–190.

7. 'Questions to Stella and Judd', an interview with Bruce Glaser broadcast on WBAI–FM, New York, February, 1964; published in *Art News*, September 1966. Reprinted in Battcock, *ibid*, pp.148–164.

8. 'Questions to Stella and Judd', *ibid*, pp.157–158.

9. For a fuller discussion of the complexities of this period see Charles Harrison, *Essays on Art & Language*, Blackwell, Oxford and Cambridge Mass., chapters 1 & 2.

10. LeWitt, 'Excerpts from a Correspondence, 1981–83', in *Sol LeWitt: Wall Drawings 1968–1984. Stedelijk Museum, Amsterdam.*

11. See '3000 Years: Carl Andre interviewed by David Batchelor', *Artscribe* no.78, Summer 1989, pp.62–63.

12. Sol LeWitt, 'Paragraphs on Conceptual Art', *Artforum*, vol.5 no.7, June 1967, pp.79–83.

13. Sol LeWitt, 'Paragraphs on Conceptual Art', *ibid*.

14. Sol LeWitt, 'Sentences on Conceptual Art', *Art-Language*, vol.1 no.1, May 1969, pp.11–13. For an intriguing account of the relations of rationality and irrationality in LeWitt's serial work see Rosalind Krauss, 'LeWitt in Progress', 1977, in *The Avant Garde and other Modernist Myths*, pp.244–258.

15. Sol LeWitt, in *Sol LeWitt*, *op. cit*, p.59.

16. Sol LeWitt, 'Paragraphs on Conceptual Art', *op. cit*.

THE LEWITT MATRIX
Rosalind Krauss

I. In 1980 Sol LeWitt published his *Autobiography*. The work consists, for over more than a hundred pages, of photographs that present every square inch, every nook and cranny, every detail of the loft in New York where LeWitt then worked and lived. Or rather, this inventory is given as a sequence of nine-part grids, with nine perfectly square images made available per page, each image held in place by thick regulating bands of white, locked within a continuous and relentlessly unfolding geometrical frame. As the account of this life-space proceeds – over the details of the pressed tin ceiling, onto each hanging pot or pan, into the closet with its sheaths of garments, onto the floor-bound assemblies of pairs of shoes, amidst the houseplants with their fans of fronds, in front of each chair and table, past all the shelves with their books aligned in picketed rows, or the tapes framed as crystalline strata – these objects are gradually overtaken by the matrix that holds them in place, the grid that fixes and flattens them, the method that skewers them like so many specimens on the pins of so many categorical spaces; a life is transformed into a taxonomic system.

In this sense *Autobiography* is at the far end of a trajectory that began in the early '70s when LeWitt published the schematics for various of his serial expansions: the *Incomplete Open Cubes* (1974), for example, or, the over nine hundred possible permutations of the *Five Cubes on Twenty-Five Squares with either Corners or Sides Touching* (1977). In these cases the vehicle of the presentation – the gridded page – seemed merely a discrete formal echo of the geometrical operations on display. Just as LeWitt's *PhotoGrids* (1977), in their capture of the lattice as readymade – the city's repressed returning continually in the form of grating, mesh, grille, scaffold, curtain wall, etc. – seemed to marry the photographs' subject with the system of their presentation, foreground and background mirroring one another, frame and framed in mutual recognition.

With *Autobiography* something new had happened, something that had been signalled the year before when a photographic inventory of the visual detritus on the walls of a ten-block radius of Manhattan's Lower East Side became LeWitt's project for *Artforum*. Nothing in this chaos – the bubble-lettering of the graffiti that reads *SHERLOCK* or the one announcing *KISS*; the signs for Lisa's Social Club or the United League Speaking Tour; the wall-high spider or the crazily precise image of the top hat and cane; the torn posters, the enigmatic logo – can be said to rhyme visually with the grid. And so 'system' – the grid that sponsors the images – separates itself out as one end of a bi-polarity of which the object presented is the other term. And in this structure which opposes system and object, system is equated with subject, with the subject, with subjectivity, with self. From *Incomplete Open Cubes* to *Autobiography*. From system as object to system as self.

II. Joseph Kosuth is anxious to tell us about Conceptual Art. Even the term is his, he modestly informs us, forgetting about the much earlier, opening salvo of LeWitt's manifesto-like '*Paragraphs on Conceptual Art*.'[1] Kosuth has corralled the import of this notion as well, explaining that it involves art transformed into philosophical investigation, art focused on an interrogation of how semiotic systems come to mean, beginning with language as such,

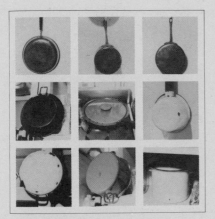

Sol LeWitt, *Autobiography*, 1980

before going on to the cultural production of meaning.

But then practically none of his apologists has ever doubted that LeWitt was a philosopher: Kant ('If anyone could perceive the structural beauty of ... Kant's treatises and then go on to recreate them as exclusively visual metaphors, it is surely LeWitt');[2] Descartes ('Running "them over in a continuous and uninterrupted act of thought," reflecting "upon their relations to one another," as Descartes suggested we do with any series of which we wish to become "much more certain," we not only "increase the power of our mind" over the known, as Descartes expected...')[3]. Or a mathematician: Euclid ('Euclidean auxiliary constructions are used to produce the wall drawings and in their descriptions');[4] Gödel ('He is one of those very few artists of the twentieth century who have managed to trigger impulses of recognition through the sense of sight, thereby bringing to attention important scientific laws such as the "uncertainty principle" of Werner Heisenberg and the "indeterminability of arithmetic theorems' of Kurt Gödel ..." ').[5] Or a psychologist concerned with 'genetic epistemology': Piaget ('It is only LeWitt's "reflective abstraction" that fully fits into these theories, only his work that can be said to articulate "the moment in artistic thinking when a structure opens itself to questioning and reorganises itself according to a new meaning which is nevertheless the meaning of the same structure, but taken to a new level of complexity" ').[6]

But it is this same LeWitt – LeWitt the Platonist, LeWitt the transcendental humanist, LeWitt the metaphysician, LeWitt the searcher for 'a universal meaning of art'[7] – who recently scandalised a feminist museum director into trying to censor the exhibition 'Eadweard Muybridge and Contemporary American Photography,' by excising the entry by LeWitt, which she found 'degrading and offensive,' rendering unto us, thereby, LeWitt the pornographer.[8] The LeWitt who made *Muybridge I* (1964), in an early homage to the man who 'has had a great impact on my thinking,' explained that 'this piece was done after some years of thought and experimentation and was the source of much of the serial work.'[9] So the serial work begins in the movement not of the celestial spheres and the lines and points of Euclid, but in the exposed human body and Muybridge's *Animal Locomotion*; and with an origin in Muybridge, LeWitt's concerns with seriality take off from a position organised not through reason or reasonableness, but tainted with the madness that is to be seen in Muybridge's obsessive need to carry his demonstration into the realm of what Hollis Frampton was to call 'encyclopaedic enormity,' leading Frampton to ask, 'What need drove him, beyond a reasonable limit of dozens or even hundreds of sequences, to make them by thousands?'[10]

And it is true that the viewer who must stoop to peer through the opening in the row of little black boxes of *Muybridge I* in order to see the interior image – one of a ten-sequence progression of a nude woman walking toward the camera, the last in the series producing only the slight mound of her belly, with her navel at the circular image's centre and the top of her pubic hair glimpsed at its lower edge – this viewer becomes doubly aware of a body: that of the image's and that of his or her own, just like the viewer of Duchamp's *Etant donnés* (although this work had not then been inaugurated in Philadelphia), who cannot but be conscious of being a looker looked-at, a viewer caught in the act.

The serial project begins, then, with a body seen and a desire to see, a desire

spoken in fact as a desire to see bodies. And that desire is not sublimated; it is not connected to rationality. From the first, LeWitt had been perfectly clear about this distance from reason. In his 'Sentences on Conceptual Art,' he began: 'Conceptual Artists are mystics rather than rationalists.' His fourth sentence describes the conceptualist's practice, but it could also be reporting on Muybridge's: 'Irrational thoughts should be followed absolutely and logically,' he wrote.[11]

III. It was Robert Smithson who contended, from the very beginning, that LeWitt's notion of 'concept' was, as he put it, 'enervated' by paradox. 'Everything LeWitt thinks, writes, or has made,' Smithson said, 'is inconsistent and contradictory. The "original idea" of his art is lost in a mess of drawings, figurings, and other ideas. . . . His concepts are prisons devoid of reason.'[12] And LeWitt could not but have agreed. He had made a distinction in his 'Sentences . . .' between concept and idea: 'The former implies a general direction while the latter are the components.' So the idea would be a kind of content, while the concept would serve as its form. And what sort of ideas did LeWitt conceive as the contents of his work? Here's an example from the communications he had with a gallery in Nova Scotia on the occasion of an exhibition in 1969: 'A work that uses the idea of error, a work that uses the idea of infinity; a work that is subversive, a work that is not original. . . .'[13]

In 1978, when I wrote about the Variations on Incomplete Open Cubes, I fastened on this notion – 'the idea of error' – or the other one about subversion, put forward as the self-admitted content of his work, in order to prise LeWitt's art loose from the whole litany about mathematical forms, deductive logic, axiomatic rigour, Platonic solids, metaphysics. . ., that seemed to have stuck to it.[14] It seemed incredibly hilarious that someone would write: 'This proximity to scientific thought [ie. Gödel and Heisenberg] is evidence of his co-operation with mathematicians and physicists at the University of Illinois, in his work Variations of Incomplete Open Cubes, in which all variations of a three-dimensional cube with different sides missing were accurately identified.'[15] The doggedness of LeWitt's maths, his childlike counting on his fingers in order to move through the 'proof' offered by this work with its one hundred twenty-two little white models arranged in a kind of insane imitation of order on their huge platform, was, I thought, utterly unlike the synthetic thinking ascribed to him, the vast generalisations made possible by true conceptual thought. Unlike the algebraic expression of the expansion of a given series, where the formulaic is used precisely to foreclose the working out of every term in the series, LeWitt's work insistently applies its generative principle in each of its possible cases. As I wrote then, 'The experience of the work goes exactly counter to 'the look of thought,' particularly if thought is understood as classical expression of logic. For such expression, whether diagrammatic or symbolic, is precisely about the capacity to abbreviate, to adumbrate, to condense, to be able to imply an expansion with only the first two or three terms, to cover vast arithmetic space with a few ellipsis points.'

And so in that context what occurred to me instead were those other models I knew to have been extremely important to LeWitt's artistic generation, models of 'reason' running amok, doing a kind of lunatic dance over an abyss of purposelessness, displaying either by manic hilarity or an almost autistic flatness a reason overwhelmed by emotional chaos. Schizoid reason. The reason of the narrator in Robbe-Grillet's Jalousie, who forces us to listen as he

tonelessly, obsessively, counts every banana tree, row after row, in the plantation in front of him. Or the reason of Beckett's *Malloy*, as he moves through the antic turn of 'thinking through' the 'problem' he has set himself: how to suck sixteen stones in succession without sucking any one twice if he only has four pockets out of which to pull and into which to replace each stone? LeWitt's fourth 'sentence' had got Malloy's solution just right: 'Irrational thoughts should be followed absolutely and logically,' he had said.

And there are other points where the irrational seems to poke through the fanatical order of LeWitt's structures, with their beauty and precision and spareness not unlike that of Beckett's prose, and to be wiggling its fingers at us. As the modular structures – those based on five modules, or even more insistently, those based on nine modules – move through their paces, they begin to generate increasingly zany profiles. Reason as the fantasy of a meccano set. Reason as a lace doily. This has culminated in a work like the 1986 *Untitled (Five Towers)*: reason as a high-rise development.

And then there are the wall drawings.

IV. In 1958 LeWitt made some sketches of Piero della Francesca's frescoes at Arezzo. One of them he chose to publish in the catalogue for a recent show of wall drawings; another he chose to photograph for his *Autobiography*.[16] The first of these is taken from that part of the cycle's Story of the True Cross where Saint Helena is on her knees worshipping the 'true' cross, which is to say the crucifix discovered on Golgotha which is proved – by the fact that it performs a miraculous resuscitation – to be the one Jesus died on. This is a very famous Piero with Helena surrounded by her retinue, a group of solemn, columnar figures, themselves every bit as much a set of Platonic solids as any of Lewitt's open cubes might be thought to be.

Indeed the reading of Piero is fixated, just as in LeWitt's case, on the idea of him as mathematician, as the writer of a treatise on perspective, as the artist devoted to its geometric laws. 'This mathematical outlook,' we read of Piero, 'permeates all his work. When he drew a head, an arm, or a piece of drapery, he saw them as variations or compounds of spheres, cylinders, cones, cubes, and pyramids, endowing the visible world with some of the impersonal clarity and permanence of stereometric bodies. We may call him the earliest ancestor of the abstract artists of our own time.'[17]

But this idea of perspective as doubly objective – on the one hand a system, made objective by means of its mathematical grounding, through which to order and organise objects, and on the other, the possibility of those objects displaying themselves in their very objectivity: as a set of stereometric bodies, 'variations or compounds of spheres, cylinders, cones, cubes, and pyramids' – this has been opened to challenge by a structuralist reading of Piero. It is one that is instructive, both about LeWitt's attraction to Piero in particular and to Tuscan fresco painting in general – an attraction that has infected much of his recent production – and about the matter in his work of the objective pole being flooded by a sense of its subjective opposite, as in *Autobiography* or *Untitled (Five Towers)* or *Muybridge I*. Because it is instructive, it will form something of a detour here (readers who are not interested should skip to Section Six).

The notion that perspective is an 'objective' system leaves out, from the structuralist point of view, the simple fact that it is constructed on a vector that

connects the viewing to the vanishing point, a vector, then, that points to or at the viewer, and in so pointing, designates the viewer as 'you.' As Louis Marin insists, in his analysis of the Arezzo frescoes, this pointing, or deictic axis establishes the subjective pole of every perspective alignment, a pole which not only picks out the viewer as 'you,' but establishes the time of viewing as 'now,' and its place as 'here.' In the structuralist sense, perspective opens not onto 'narrative' – or the modality of history – but onto 'discourse,' the live speech event.[18]

Thus, when faced with the narrative of the Arezzo frescoes, Marin began with the curious fact that the deictic connection is itself narrativised in the story the frescoes celebrate, since the fact of being there in a particular place and at a particular time, namely the Bacci Chapel on the 3rd of May, places the viewer in a liturgical relation to an event which is itself depicted in the frescoes – namely Saint Helena's finding of the True Cross – but a finding that is simultaneously a re-finding and thus a present that is also a past. Which is to say that to be witness to this event is simultaneously to be flipped back into historical time, since the cross itself, discovered 'today,' had already been encountered not once but four times previously, and thus wore its past somehow within it and perhaps at right angles to the deictic axis that links one to its discovery in the present.

This figure of the right angle is not chosen randomly here. Indeed Marin considered the lateral unfurling of writing, ignoring as it does the presence of the viewer and closing its space along the surface of the page, as transecting the trajectory of vision, piercing across it into depth. It was this right angle of reading-versus-viewing that formed the basis, for example, of the analysis he made of Poussin's *Et in Arcadia Ego* with its sliding of the deictics of perspective under the transversal parade of the inscription on the tomb in order to mask the immediacy of address in the present and to convert it into an utterance that can only come from the past.[19]

Now if the figure of the right angle has to be synthesised in the case of Poussin from the crossing of vision's axis by that of writing, it comes readymade in the instance of Piero, since the cross itself is the most absolute emblem of two, intersecting directions. Thus a cross that is present, which is simultaneously a cross that is past, can already be seen to carry this possibility for two opposing temporal vectors in the very weft of its simplest physical description. Which means that the cross is at one and the same time a figure – a cross – and a schema – a crossed axis; the first the object in space, the second what could be said to be a thought about that object, or the means by which that object is displaced – propelled from the spatial into the temporal: the cross one finds in the present that has already been discovered four times. The crossed axis as the structural operator of history or the conversion of present into past is thus not so much the object of the story – the True Cross – as it is its subject, a modality of consciousness of it.

And there is a further axial relationship to which a structuralist is particularly sensitive, namely the relation between what is often articulated as the horizontal plane of syntax – as the sentence unravels one word after another – and the vertical stacking of alternatives or substitutions for each term in the horizontal chain. Syntagm or the sequential unrolling of the sentence is thus intersected by paradigm, which implies the symbolical levels of the tale.

That the story of the cross involves a syntagmatic chain, as in the course of

its history before the Passion it undergoes its fourfold transformations from tree of knowledge to branch to tree, to beam, to bridge, only finally to be fashioned as the cross of the crucifixion, already prefigures, of course, the sense in which the cross itself is invested with paradigmatic values that transcode it into cosmological and allegorical levels of meaning. For Saint Augustine had explained that the axes of the cross map the four dimensions of the world; and because each of these physical dimensions are determined by the Passion – marking either the attachment of Christ's body to the cross or the cross's own attachment to the ground – each is metaphorically elaborated: the cross beam where Jesus's hands were stands for the good works accomplished through Christ, for example; or the securing to the ground symbolises the duty to carry out the sacraments. It is on this symbolic level as well that the cross is secured as pure sign, rising above its merely objective role in a narrative to operate beyond space or time in the perpetual present of the efficacy of belief as trace or relic invested with symbolic power.

Now the story of the True Cross is in a certain sense also the story of a point of view, one that can cut through the extraordinary physical transformations of the object, to perform an act of recognition which restructures the narrative of change and of time into the symbolic force of the cross's meaning, its true transformative power which operates for the believer in an eternal 'now.' Within the perspective system there is, obviously, a pole specifically reserved for a point of view; and this pole, occupied by the crystalline lens of the viewer's eye, is itself designated by Piero as cruciform in nature. Which is to say that if the perspectival lattice that maps geometrical space is able to connect to the visual apparatus of the beholder truly, it is because that apparatus – human vision – is also constructed by means of a grid: as the nerves that carry visual impulses cross at right angles through the centre of the eye. The truth of vision, set in place by this structural mirroring of nerve connections and visual rays, already serves as the basis, we could say, for vision's access to the truth, marked out here as one of recognition. Once again, then, there is an axial crossing operated less by an object in space than by a subject who, by assuming a point of view, performs the switch from syntagm to paradigm, from spatial object to miraculous relic, from figure to sign.

For Marin, the genius of the Arezzo frescoes is that Piero brings all these axes into co-ordination with one another, all these crossings – the present and the past; the sequence and the symbol; the object in space and the viewer's position on it – all these right angles which themselves intersect. For each right angle is simultaneously an object to be operated on and a subject or structural operator that performs these operations.

V. The axis of history (establishing the past) is intersected with the axis of belief (sited in the present); the axis of the object is crossed by that of the subject. Because of the nature of the work of art (three dimensions collapsed onto two; or in the case of sculpture, the object both a thing itself and, through a kind of mimicry, given over to an account of its viewer) these two axes or poles are often superimposed. But they are not the same.

Five Boxes with Stripes in Four Directions (1972) spells out this difference. Onto the surfaces of five stalwart prisms – the very personifications of the 'objective' – Lewitt has painted the strident black and white of parallel lines, some vertical, some horizontal, some on the bias; some sides bearing only one linear

direction, others bi- or even trifurcated into opposing zones. The optical pop of this striation, the moiré effect it sets up, its strange imitation of modelled light and shade, all this works to project the retinal disturbance occurring in the field of the viewer onto the field of the viewed. Subject collapsed onto object: the superimposition here deployed in the very vocabulary of linear oppositions LeWitt had used in his 1969 illustration for Samuel Beckett's playlet *Come and Go*. It was also the vocabulary he had just begun to explore in the burgeoning project of the wall drawings.

Beginning as they did in the black and white of very fine lines – employing the hardest of lead pencils – the wall drawings seemed to embody the disembodied, which is to say the space of ideation, of the diagram, the calculus, the ratiocinated. Even when coloured leads were employed, the faintness of the precise lines seemed to declare their allegiance to a world the viewer's body did not share. But towards the end of the 1970s, as the lines became bolder and the walls themselves became larger, their physical presence reinforced by being coloured in the declarative primaries of red, yellow, blue, it began to be clear that the drawings were conceived in a deictic relation to what the structuralists would call the conditions of discourse – 'you,' 'here,' 'now.'

And so the ends of the circuit that began in the 1958 sketches after Piero, and which is now elaborating itself in huge scale wall drawings, have been buckled in a series of works that are sometimes referred to as Tuscan and which, although executed in coloured ink washes over gesso, have taken on the look of fresco.

In this work LeWitt is true to the objective pole he has consistently honoured: he refuses to employ central-point perspective and instead projects all lines in the parallels of axonometric projection; he refuses to use any colours but those of black, white (therefore grey), red, yellow, and blue. But the subjective pole is clearly marked in the very ambiguities built into axonometric perspective – as nothing prevents concavities from flipping out into convexities – as it is also made present in the sensuous qualities of the colour films that turn the layers of simple primaries into the richest runs of Italianate hues.[20]

Most of all it is the scale of these works, in which the projected forms are often larger than any one wall that might bear them, which would promote the experience that they are being 'completed' out of the viewer's sight. The effect of this gigantism is to push the experience of the forms beyond the point at which they may be understood synthetically – mentally surveyed, so to speak – and to force a bodily engagement with them instead. The deictics whereby perspective points to the embodied viewer have been substituted by a sense of the viewer's body being acknowledged by the very scale of the wall. And the axonometrics of the drawing, far from maintaining itself as the ideal or ubiquitous point of view – the point of view from 'nowhere' – seems to fold this sense of the viewer's bodily presence into the field of the forms.

The porousness between LeWitt's two- and three-dimensional work, his sculptures (or structures) and his wall drawings, has been there from the start, announced perhaps by the fact that his earliest structures were low reliefs, tied for their very aesthetic life to the wall. Thus the *Complex Forms* that he has been making since the late 1980s grow out of the peculiar shapes that result from projecting even the simplest pyramidal prism by means of axonometric perspective as he has done in a variety of wall drawings, such as the one for the Galerie Pieroni in Rome in 1985, or *Continuous Forms with Colour Ink Washes Superimposed* at the Cleveland Museum of Art in 1987.

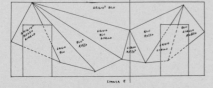

Sol LeWitt, diagram for wall drawing, 1987

VI. When Elizabeth Broun wrote to the organiser of the exhibition *Muybridge and Contemporary Photography*, justifying her decision to censor LeWitt's work, she said, 'I cannot in good conscience offer this experience to our visitors as a meaningful and important one. The past two decades of feminist writing has raised public consciousness about different types of viewing – about see-er and seen – that could not have been foreseen when LeWitt made the work so long ago.'[21]

The embodiment of the viewer is not simply the work of feminist consciousness-raising. It has been going on in all types of theoretical work for some time now, in the location of the reader in the text, for example, or in the articulation of the violence at the base of writing. In the visual arts the repression of the viewer's body had been the work of a modernist aesthetic that had vapourised that body in the service of 'opticality' or 'vision as such.' The return of the body was the achievement, at least in the States, of the Minimalist generation to which LeWitt belongs. Its theorisation has been less secure within art-critical writing, however, which has tended to take the geometricised version of Minimalism completely straight. Whatever else one thinks of Ms. Broun as a critic, she has at least located the axis without which LeWitt's work would fail to function and it is, indeed, that of see-er and seen. Or rather, it is the structural connection between the two.

Insofar as the grid is its 'concept,' the concept through which all of its 'ideas' are processed, the concept of LeWitt's art is that of a transformational matrix, in which the very co-ordinates that produce an object to be operated on simultaneously construct a subject or structural operator that performs these operations.

NOTES

1. Sol LeWitt, 'Paragraphs on Conceptual Art', *Artforum*, Summer 1967. Joseph Kosuth's claim is made in his 'History for...', *Flash Art*, November 1988, p.100.

2. Robert Rosenblum, *Sol LeWitt*, Museum of Modern Art New York, 1978, p.18.

3. Donald Kuspit, 'Sol LeWitt', *Arts*, April 1978, p.118.

4. Donald Kuspit, 'Sol LeWitt: The Look of Thought', *Art in America*, September 1975, p.44.

5. Ingrid Mössinger, *Sol LeWitt, Complex Forms, 1990, Wall Drawings*, Frankfurt am Main, 1990 n.p.

6. Lucy Lippard, *Sol LeWitt*, Museum of Modern Art New York, 1978, p.27.

7. All of these characterisations are to be found in Kuspit, 'Sol LeWitt: The Look of Thought'.

8. The exhibition, organised in 1991 by Jock Reynolds, director of the Addison Gallery of American Art and the Phillips Academy in Andover, Massachusetts, was to travel to the National Museum of American Art in Washington D.C., when Elizabeth Broun declared that LeWitt's work involved 'peering through successive peepholes and focusing increasingly on the pubic region [thereby invoking] unequivocal references to a degrading pornographic experience'. Her threat to take it out of the show led to the counter-threat by the exhibition's remaining artists that they would withdraw their work. Ms. Broun compromised by leaving the LeWitt on view but surrounding it by a thicket of cautionary and hortatory wall labels.

9. *Sol LeWitt*, Museum of Modern Art New York, p.77.

10. Hollis Frampton, 'Edweard Muybridge: Fragments of a Tesseract', *Artforum*, March 1973, p.52.

11. Sol LeWitt, 'Sentences on Conceptual Art', in Lucy Lippard, *Six Years: The Dematerialisation of the Art Object*, New York, Praeger, 1973, p.75.

12. Robert Smithson, 'A Museum of Language in the Vicinity of Art', *Art International*, March 1968, p.21.

13. Lucy Lippard, *Sol LeWitt*, Museum of Modern Art New York, 1978, p.24.

14. Rosalind Krauss, 'LeWitt in Progress', *October* no.2, Autumn 1978; reprinted in *The Originality of the Avant-Garde and other Modernist Myths* (Cambridge: MIT Press, 1985).

15. Mössinger, *op. cit.*

16. See, *Sol LeWitt, Spoleto USA*, Charleston: Gibbs Museum of Art, 1989, p.10.

17. H.W. Jansen, *The History of Art*, New York, Abrams, 1963, p.328.

18. Louis Marin, 'La Théorie narrative et Piero peintre d'histoire' in *Piero: Teoretico dell'arte*, ed. Omar Calabrese, Rome, 1985, p.55-84. The structuralist distinction between discourse and narrative (or historical writing) is made in Emile Benviste, *Problems in General Linguistics*, Miami, 1971, p.205-222.

19. See Louis Marin, 'Toward a Theory of Reading in the Visual Arts – Poussin's *The Arcadian Shepherds*' in *The Reader in the Text*, ed. Susan R. Suleiman, Princeton, 1980.

20. The colours are mixed directly on the wall, according to sequences of layers specified by LeWitt. Thus BBR (Blue Blue Red) produces a different shade of blue from BGB (Blue Grey Blue). Or the green that will be created by BBY (Blue Blue Yellow) will differ from that of GYG (Grey Yellow Grey).

21. As quoted in Michael Kimmelman, 'Peering into Peepholes and Finding Politics', *The New York Times*, July 21st 1991.

SOL LEWITT AND CHRISTOPHER COLUMBUS
David Elliott

Early in 1967 the editor of Artforum wrote to LeWitt that he wanted to avoid 'the notion that the artist is a kind of ape that has to be explained by the civilised critic' and encouraged him to write a piece which gave the background to his work.[1] LeWitt quoted these words in a seminal essay which resulted from this exchange, *Paragraphs on Conceptual Art*, which was published in the June issue. While recognising that such editorial policy 'should be good news to both artists and apes' he went on to set out a range of principles and ideas which still informs his work.

The idea that the artist creates a critical framework through which his or her work could be understood may be seen, in part, as a response to the abnegation of autonomy by some American artists to critics such as Clement Greenberg in the 1950s and '60s, although other artists such as Barnett Newman, Mark Rothko and Ad Reinhardt had written eloquently about their own work. And such a non-categorical non-imperative as Conceptual Art undoubtedly needed a conceptual framework through which it could be entered.

This retrospective catalogue of Lewitt's structures is part of a continuing process which reframes the conceptual framework of the artist whilst observing the integrity of both object and thought. Over a quarter of a century has passed since the Artforum essay was first published while, deep in the critical jungle, an historical perspective has started to slice through the thick undergrowth of quickly formed critical speculation.

In initially confronting the issues of how and why a work is made there can be no substitute for the artist's own voice. In the above essay and others, LeWitt set out the ideas which gave him the freedom to develop. He debunked the pernicious tendency of labelling art only to limit it: '... the idea or concept is the most important aspect of the work ... [it] is not necessarily logical Ideas are discovered by intuition.'[2] The risk of relying on intuition was mitigated by using a preset plan or game theory which was 'one way of avoiding subjectivity' – a tendency which diverted attention and energy away from content.[3]

LeWitt remains categorical about the importance of content: 'Art that emphasises content (such as mine) cannot be seen or understood in a context of form. This is a large and crucial difference. It cannot be said that what looks alike is alike. If one wishes to understand the art of our time one must go beyond appearance.'[4]

And what lies in the hinterland? What is the content?

The philosophy of a work 'is implicit in the work' yet is not 'an illustration of any system of philosophy'.[5] It is in the terminology of its time, the sixties, 'non-referential' as it does not refer to an area of thought or activity other than that which it embodies in itself as art. This does not imply that the work has become a tautology – a moebius strip, doomed to endless repetition – and there could be no stronger refutation of this than the evidence of the work in this exhibition. It merely suggests that the grammar and language of art creates its own content – uniquely in each work – even though decisions which relate to the process by which a work is realised may have been made according to a preset plan.

As well as in the idea itself, the centre of a work for LeWitt lies in its physical

mass or presence which is incontrovertible and which may be capable of satisfying or, alternatively, of challenging the taste or aesthetic values of anyone who happens to encounter it.

Such a conviction is materialist, but not in a strictly Marxist sense, and this is what distinguishes the structures, the drawings and the ideas of LeWitt – as well as those of some of his contemporaries – from the work of the Russian Constructivists.

In the hinterland of history LeWitt's ideas and work have been married to many different soul mates: Robert Rosenblum saw the shimmering colour grids of his drawings as echoes of the *nymphéas* of the late Monet and his 'musical' repetition of formal sequences as modern equivalents of the music of Ravel or Satie.[6] David Batchelor points to the Cubist precedents of his work as well as to Cubism's specifically American scion: constructed sculpture as in the work of David Smith in the 1940s. Rosalind Krauss reminds us of the relevance of Existentialism and Structuralism for the development of LeWitt's ideas; during the 1950s and early 1960s he was reading the *nouveaux romans* of Robbe-Grillet and others. She also maintains that the matrix which is pervasive throughout LeWitt's work is both a reflexive and a subversive element which, in fact, determines its content.[7]

During the early 1960s LeWitt was probably only peripherally aware of the relevance of Russian Constructivism to his purpose. The North American art world had a self-confidence and impetus which left little time for looking to the past. Also there was relatively little literature or detailed information on Russian art: Rodchenko had donated two canvases as well as photographs and works on paper to the Museum of Modern Art in New York during the thirties but these were isolated and not often seen. Gabo and Pevsner were the best known as they had exhibited at the Modern in 1948 and continued to exhibit at leading American Museums. In an interview in 1964 Donald Judd admitted admiration for their work as well as of Neo-Plasticism and Constructivism 'in retrospect', but he said that it had not been important in the formulation of his work – contemporary American influences had been vital.[8] In 1962 Camilla Gray's *The Great Experiment in Russian Art 1863–1922* was published in both London and New York with many large illustrations of works by Tatlin, Malevich and Rodchenko. A bout of historical revisionism ensued and in 1965 Barbara Rose changed the framework of modern American art criticism by writing, in an article on the new Minimalist aesthetic, about how 'On the eve of the First World War, two artists, one in Moscow [Kazimir Malevich], the other in Paris [Marcel Duchamp] made decisions that radically altered the course of art history.'[9]

Why do I think of the Laboratory Period of Russian Constructivism when I see the structures, read the texts and look through the artist's books of Sol LeWitt? His early structures have a rough home-made quality – far removed from the machine aesthetic – which reminds me of the Russian work but this is fortuitous, no direct link can be made. But they share a community of ideas, even attitudes, and a desire to examine and celebrate what LeWitt called the 'grammar of the total work.'[10]

Shortly after the Russian Revolution Rodchenko became the leader of the Moscow Constructivists and carried out a series of syntactical experiments in his paintings and constructions (made at the same time) which examined the components and basic languages of form. Series of paintings made between

1917 and 1921 were entitled consecutively: *The Motion of Projected Planes; The Isolation of Colour from Form; The Concentration of Colour from Form; Linearism; The Dissolution of the Surface*; and *Smooth Colour*.[11] From 1919 to 1921, combining intuition with a set method of working, Rodchenko moved away from cool paintings constructed out of straight line grids and mechanically drawn arcs and circles to a tormented brushstroke which denoted the dissolution of the picture surface to, finally, three monochrome canvases of red, blue and yellow. These were the last paintings he made for fourteen years; ideology had diverted him from the laboratory path.

At the same time he made a series of constructions from pieces of rough sawn wood, sometimes of equal length, nailed together. These were followed by a series of Hanging Constructions in which a geometrical form (circle, pentagon, elipse) was repeated in diminishing sizes and rotated concentrically around a central axis. Rodchenko set out to explore what Tatlin described as 'the culture of materials,' creating a new language for art which both reflected and served a society which had been transformed by Revolution. The tragedy was that force of circumstance brought the political, social and artistic revolutions to a rapid end to be replaced by the inhuman monolith of a Stalinist one party state. At first willingly, Rodchenko sacrificed the autonomy of his art in the belief that it should serve the masses. The divisions between art, design and architecture were swept away as the artist became a producer and designer of objects, products and buildings which had to have a practical use.

In the early 1960s many artists working in New York shared a similarly radical political perspective but within an oppositional rather than dominant framework. (Although the Constructivists were also regarded as radicals – 'leftists' – by the Communist State). The lack of formal hierarchy in what Kynaston McShine categorised as *Primary Structures* mirrored, but did not depict, a view of social relations.[12] The idea of non-referentiality severed links with history as well as with figuration. And the idea of the specificity of the artwork reinforced its conceptual and spatial integrity and saved it from blurring with other media. In 1967 LeWitt, who had worked in an architect's office, dealt with this issue: 'Architecture and three-dimensional art are of completely opposite natures. ... Art is not utilitarian. When three-dimensional art starts to take on some of the characteristics of architecture ... it weakens its function as art.'[13]

But in spite of the refusal to make art which was not art, ideological views were strongly held and stated. In 1966, when he showed his *Equivalents* for the first time at the Tibor de Nagy Gallery, Carl Andre described his work as 'atheistic, materialistic and communistic,' going on to explain: 'It's atheistic because it's without transcendent form, without spiritual or intellectual quality. Materialistic because it's made of its own materials without pretension to other materials. And communistic because the form is equally accessible to all men.'[14] No less radical than his contemporaries, LeWitt has been more guarded in equating ideology with his work, maintaining, in fact, a separation between the two; implying almost that Conceptual Art had become by definition a form of ideology in its own right. 'I don't know of any art of painting or sculpture that has any kind of real significance in terms of political content', he said in 1968 '... and when it does try to have that the result is pretty embarrassing. ... Artists live in a society that is not part of society....'[15] or again, in 1993, in answer to the question: '*Do you think that art should have a social*

or moral purpose? No. I think artists should have a social or moral purpose.'[16]

LeWitt does not condone a prescriptive relationship between politics and art. Both exist in their respective spheres but, as the art of compromise, politics can lead to a blurring of edges and therefore to the destruction of art. In thinking again about the structures of LeWitt, the laconic words of Aleksandr Rodchenko – a Russian predecessor of Conceptual Art – come into mind. They were written in 1919, long before the Stalinist Terror created an agenda of an entirely different kind: 'Christopher Columbus was neither a writer nor a philosopher – he was merely the discoverer of new countries.'[17]

NOTES

1. Sol LeWitt, 'Paragraphs on Conceptual Art', *Artforum* New York, June 1967.

2. Ibid.

3. Ibid.

4. LeWitt, 'Comments on an Advertisment Published in Flash Art', April 1973 reprinted in *Sol LeWitt*, Museum of Modern Art New York, 1978, p.174.

5. LeWitt, 'Paragraphs. . . .', op. cit.

6. Robert Rosenblum, 'Notes on Sol LeWitt', *Sol LeWitt*, Museum of Modern Art New York, 1978, pp.18, 20.

7. Batchelor's and Krauss's essays referred to here are published in this catalogue.

8. Brucer Glaser, 'Questions to Stella and Judd', *Art News*, New York, September, 1966 reprinted in Gregory Battcock (ed.), Minimal Art A Critical Anthology, New York, 1968, p.155.

9. Barbara Rose, *ABC ART*, Art in America, New York, October–November 1965 in Battcock, op. cit. p.274.

10. LeWitt, 'Paragraphs . . .', op cit.

11. See David Elliott, *Alexandr Rodchenko, Works on Paper 1914–1920*, London, 1991 for a detailed record of Rodchenko's development during these years.

12. An exhibition entitled *Primary Structures*, which included work by LeWitt, was organised by Kynaston McShine for the Jewish Museum in New York in 1966.

13. LeWitt, 'Paragraphs . . .', op. cit.

14. David Bourdon, 'The Razed Sites of Carl Andre', *Artforum*, New York, October, 1966 in Battcock, op. cit. p.107.

15. Lucy R. Lippard, 'The Structures, The Structures and the Wall Drawings, The Structures, the Wall Drawings and the Books', *Sol LeWitt*, Museum of Modern Art, New York, 1978, p.28.

16. Andrew Wilson, 'Sol LeWitt Interviewed', *Art Monthly*, London, March, 1993, p.8.

17. Elliott (ed.), *Alexander Rodchenko 1891–1956*, Oxford, 1979, p.8.

WITHIN AND BETWEEN – INNENRÄUME, ZWISCHENRÄUME
David Batchelor

Im Jahre 1965 entstand Sol LeWitts "Floor Structure, Black"[Kat. 6]. Die Konstruktion besitzt eine Länge von 72 inch (ca. 180 cm), ist unterteilt in fünf Würfel von jeweils 20 inch (ca. 50 cm) Kantenlänge und aufgebaut aus maschinell bearbeitetem Holz mit quadratischem Querschnitt, einheitlich mit einer schwarzen Lackschicht überzogen. Der Künstler bemerkte hierzu, daß er mit der Oberfläche einiger ummantelter Werke, die zuvor ausgestellt worden waren, nicht zufrieden gewesen sei, und daher: "Entschloß ich mich, die komplette Haut einfach wegzunehmen und die zugrunde liegende Struktur sichtbar zu machen. Dadurch wurde es notwendig, das Skelett so zu planen, daß die Teile eine gewisse Konsistenz aufwiesen. Gleichartige quadratische Module wurden für den Aufbau der Strukturen verwendet. Um die lineare, gerüstartige Eigenschaft zu betonen, wurden sie schwarz angestrichen."[1] Diese direkte Erklärung scheint dem klaren, unverschnörkelten Werk angemessen. Die die Struktur betreffenden Entscheidungen sind als Antworten auf praktische Probleme anzusehen, die bei vorangegangenen Arbeiten aufgetaucht waren.

LeWitts Absicht war, die Oberfläche "hart und industriell" aussehen zu lassen, eine Wirkung, die "durch die Holzmaserung negiert"[2] worden war. Die in der modularen Würfelstruktur gefundene Lösung wurde in der Folgezeit die Basis für ein sehr umfangreiches Oeuvre [Kat. 9, 10, 11, 14, 21, 22]. Gegen Ende 1965 wurden die Strukturen dann weiß lackiert (was die "Expressivität der früheren schwarzen Stücke etwas milderte"). LeWitt legte das Verhältnis zwischen dem Material des Gerüstes und dem beschreibenden Raum auf 8,5 : 1 fest. 1967–68 fertigte LeWitt seine Werke sowohl aus Aluminium und Stahl als auch aus Holz an.[3] Viele dieser Strukturen sind frei auf dem Boden stehende Arbeiten; andere sind gegen eine Wand gestellt oder in einer Ecke plaziert; einige hängen an Wänden, entweder als flache Reliefs oder sie ragen in den Ausstellungsraum hinein. Diese wandgebundenen Arbeiten gehen zurück auf LeWitts erste Reliefstrukturen aus den Jahren 1962–64 [Kat. 1, 2, 3, 4]. Sie beziehen sich insbesondere auf eine Relation, die in LeWitts Werk seit den frühen sechziger Jahren bis zum heutigen Tag deutlich ist: Die Beziehung zwischen Bild und Skulptur, zwischen zwei- und dreidimensionaler Projektion, zwischen Abbild und Objekt. Es ist jedoch nicht so, daß LeWitt durch die Untersuchung offener modularer Strukturen einfach die Verwendung geschlossener Formen aufgegeben hätte. Vielmehr ist "offen" und "geschlossen" bei LeWitt behandelt als eine weitere Relation, die er in seinen ersten systematisch angegangenen seriellen Arbeiten aus den Jahren 1966 und 1967 untersuchte [Kat. 7,8], genauso wie in seinen neueren Arbeiten [Kat. 17, 19].

Ein Schwerpunkt dieses Essays ist die Betrachtung dieser und anderer Relationen, wie sie sich in LeWitts Werk manifestieren. Es ist aber auch noch eine andere Art von Verhältnis zu berücksichtigen, das helfen könnte, einen annähernden Kontext zu sehen von Entstehung, Entwicklung, Prozessen und Bezügen in Sol LeWitts Strukturen. Alle Kunstwerke existieren, qua ihrer Definition in der Relation zu anderen Kunstwerken, vergangenen und gegenwärtigen. Ein Großteil der kritischen Signifikanz, die Kunstwerken beigemes-

sen wird, ist dadurch begründet, daß diesen Werken ein bedeutender Platz in der Geschichts-Narration zugesprochen wird. Man betrachte folgende Passage:

> "Die neue Konstruktions-Skulptur verweist, nahezu schon hartnäckig, auf ihre Ursprünge in der kubistischen Malerei: durch ihre Linearität und ihre linearen Feinheiten, durch ihre Offenheit, Transparenz und Schwerelosigkeit, durch ihre Neigung zur Fläche als Hauptanliegen, ganz Oberfläche in Form von Hülle zu sein . . . Raum ist dazu da, geformt, geteilt, umschlossen, aber nicht ausgefüllt zu werden. Die neue Skulptur tendiert dazu, Stein, Bronze oder Lehm zugunsten von industriellen Materialien wie Eisen, Stahl, Legierungen, Glas, Plastik, Zelluloid, etc., etc, aufzugeben, die mit Werkzeugen der Schmiede, Schweißer oder sogar der Zimmerleute bearbeitet werden. Einheitlichkeit von Material und Farbe ist nicht länger erforderlich, aufgetragene Farbe wird gebilligt. Die Unterscheidung von Schnitzen und Modellieren wird irrelevant: Ein Werk oder dessen Teile können gegossen, geschmiedet, geschnitten oder ganz einfach zusammengesetzt sein; es ist weniger gehauen als vielmehr konstruiert, aufgebaut, montiert, arrangiert. Genau daher hat das Medium eine neue Flexibilität bekommen, und darin sehe ich jetzt die Chance für die Skulptur, vielfältigere Ausdrucksmöglichkeiten zu erreichen als die Malerei.[4]

Dies ist die klarste Beurteilung der Ursprünge und Mittel LeWitts dreidimensionaler Werke, die man sich nur wünschen kann. Sein modulares Werk, wurzelnd in der stoischen Tradition des Kubismus, findet ein eigenes kritisches Profil, indem es die etablierten bildhauerischen Konventionen – Hauen und Modellieren – zugunsten des "Konstruierens" aufgibt. Das Problem dabei ist, daß der Text ohne einen einzigen Gedanken an LeWitts Werk geschrieben wurde. Nicht genug, daß er publiziert worden war, Jahre bevor LeWitt überhaupt irgendeine Struktur hergestellt hatte, von einem Kritiker, der in der Folgezeit keinerlei besonderes Interesse an dessen Produktion zeigte, nein, ein Werk wie das von LeWitt wurde sogar daraufhin als ein Abweichen des in diesem Essay ausgebreiteten historischen Weges aufgefasst. Der Autor war Clement Greenberg im Jahr 1948.[5]

LeWitt hat gelegentlich über seine eigene Arbeit und seine Arbeitsmethoden geschrieben, aber nie solche Fragen nach der Vorgeschichte diskutiert. Jedoch nennt er seine dreidimensionalen Arbeiten seit 1962 "Strukturen" und nicht "Skulpturen". Ein implizit gelieferter Hinweis, daß Wert darauf gelegt wird, diese Arbeiten von jenem Typus von Objekten zu unterscheiden, die wir mit dem Begriff "Skulptur" assoziieren. Sein Zeitgenosse Donald Judd bezog 1965 ähnlich Stellung, als er seinen Essay "Specific Objects" mit dem Satz einleitete: "Mindestens die Hälfte der besten neuen Werke aus den letzten Jahren ist weder Malerei noch Bildhauerei", sondern "dreidimensionale Arbeit".[6] So legt Greenberg einerseits eine Tradition von "Konstruktionsbildhauerei" fest, die zu erlauben scheint, LeWitts und Judds Werk einzuschließen, was er aber letztlich nicht tut; auf der anderen Seite schaffen LeWitt und Judd gerade "dreidimensionale Arbeiten", die in ihren Materialien und Methoden der Herstellung eine Verbindung zu früheren Typen konstruierter Skulptur suggerieren, eine Verbindung, die sie widerlegten. Wenn dies verwirrend erscheint, sollte aber zumindest klar sein, daß die Unterscheidung zwischen skulptur und Struktur etwas weitaus Spezifischeres bedeutet als ein

bloßer Wechsel von grundlegenden Techniken oder Materialien. Greenberg erkannte, daß in den 30er Jahren Hauen und Modellieren relativ stark verdrängt worden waren von den meisten Bildhauern. Er konnte auf eine Reihe "konstruierter" Arbeiten hinweisen, – von Brancusi und Picasso über Tatlin und Gonzalez bis zu David Smith – und damit die Ansicht untermauern, daß diese konstruierten Werke forgeschrittene Bildhauerei des 20. Jahrhunderts repräsentierten. [Abb. 1–3]. Schwer vorstellbar, daß Judd oder andere damit nicht hätten einverstanden sein können. Dadurch wird aber eines deutlich: Der Unterschied zwischen "Skulptur" und "Struktur" liegt irgendwo in der allgemein akzeptierten Kategorie der "Konstruktion" und nicht zwischen dieser und einer anderen Kategorie wie zum Beispiel "Hauen".

Im allgemeinen wird akzeptiert, daß während der frühen bis zur Mitte der 60er Jahre, LeWitt, Judd und andere (Frank Stella und Carl Andre zum Beispiel) sich von bestimmten vorherrschenden Formen malerischer Komposition und bildhauerischer Konstruktion zu distanzieren versuchten: Oder, genau und konkret gesagt, von der Art der Erfahrung, die diese Formen von Komposition und Konstruktion nach allgemeiner Ansicht verkörperten. LeWitt war bestrebt, ein "hartes und industrielles" Aussehen zu erreichen, was mit gewissen bearbeiteten Oberflächen und "Expressivität" unvereinbar war. Dabei war es natürlich nicht damit getan, lediglich Metall anstelle von Holz zu verwenden. Es waren sowohl die Kompositionen aus "gleichen, quadratischen Modulen", als auch bestimmte Oberflächenbehandlungen, bei denen dieses Aussehen zum ersten Mal erreicht wurde. In einem 1964 geführten und oft zitierten Interview betonen Judd und Stella nachdrücklich die Wichtigkeit, sich von dem zu lösen, was sie als "relationale" Kompositionen in der europäischen abstrakten Kunst bezeichneten. "Die Grundlage der ganzen Idee ist Ausgewogenheit", sagte Stella, "Man macht etwas in der einen Ecke und gleicht es dann durch etwas in der anderen Ecke aus."[7] Für Judd "liegt das große Problem darin, das Gefühl für das Ganze aufrechtzuerhalten" gegenüber von Einzelbezügen. Das Wesentliche ist nicht, daß ihre Arbeiten ohne Einzelbezüge auskamen, sondern daß sie die Form dieser Bezüge änderten und die Gewichtung zwischen den Teilen und dem Ganzen verschoben [Abb. 4–5]. Bezeichnenderweise wurden diese Bezüge sehr geordnet oder modular, entkleidet von plötzlichen Bewegungen und dramatischer Veränderungen in Form, Größe oder Farbe. Elemente im Werk selbst und Teilungen zwischen ihnen wurden mehr und mehr angeglichen und regelmäßig.

Für Judd war "relational-art" verbunden mit einer unglaubwürdig gewordenen Tradition europäischer Philosophie. Diese Vorstellung war etwas verschwommen, aber deutlich erkannte er in jener Kunst eine implizite Trennung zwischen ihrer sichtbaren Oberfläche und einer metaphysischen Substanz. Zumindest aber befand er, daß die kritische Sprache, die diese Werke umgab, schuld war, daß diese Art spekulativer Metaphysik zur Anwendung kam. Judd war bestrebt, diese mögliche rhetorische Reflexion aufzuheben durch seine singulare, ganz sich selbst genügsame Skulptur. Da er kein Material (z.B. Stein) verwendet, um auf ein anderes (z.B. Fleisch) zu verweisen, hat er auch jede Möglichkeit der Darstellung in seinem Werk ausgeschlossen. Auch Stella unterstrich seine Abneigung gegenüber der alten "humanistischen" Behauptung, daß es "neben der Farbe auf der Leinwand es immer noch etwas anderes gäbe". Sein Werk "basiere auf der Tatsache, daß nur was gesehen werden kann, auch da ist, … Was man sieht, ist, was man sieht". Malerei und Bild-

hauerei bedeuteten eine Tradition von Illusion und Repräsentation; da ihr Werk für die Eliminierung von Darstellung (Bild) stand, war es "weder Bild noch Skulptur", es war "ein Objekt".[8]

In der Gegenüberstellung "Skulptur", "Struktur" oder "dreidimensionale Arbeit" hat jeder dieser Hauptbegriffe noch eine Gruppe von sie definierenden Bei-Wörtern. "Skulptur" ist charakterisiert (von Judd und Stella) als "relational", bildhaft, humanistisch, handwerklich, expressiv, wohingegen das "dreidimensionale Werk" als singulär, wortgetreu, antihumanistisch, industriell und ausdruckslos bezeichnet wird. Sicherlich sind einige dieser Begriffe mehr beschreibend als andere – einige verweisen auf buchstäbliche Eigenschaften der Objekte (wie sie und woraus sie hergestellt sind), während andere mehr deren metaphorische Eigenschaften beschreiben (ihre Wirkungen, ihr Aussehen). In bestimmten Fällen ist es nicht so einfach, wörtliche von metaphorischen Eigenschaften zu unterscheiden. Judds dreidimensionale Arbeiten zum Beispiel sehen "industriell" aus, sind tatsächlich in einer Fabrik hergestellt, obwohl keine notwendige Beziehung zwischen Tatsache und Wirkung des Werkes besteht. Industrielle Fertigung kann das Aussehen von Handarbeit vortäuschen, und handgearbeitete Werke können so ausgeführt sein, daß sie anonym und als Masse produziert erscheinen. Einige Charakteristika von "Skulptur" und "Struktur" sind weniger wahre, wirkliche (buchstäblich oder metaphorisch) Eigenschaften dieser Werke, als vielmehr Eigenschafen im Vergleich mit anderen Vorgehensweisen. Ob etwas "ausgewogen" aussieht, hängt sehr stark davon ab, welche Alternativen es gibt. Nimmt man ein Werk von Anthony Caro [Abb.6] als Beispiel, um den Begriff zu veranschaulichen, so scheint der Begriff nicht auf eine Würfelstruktur LeWitts anwendbar zu sein [Kat.9 & 10]. Stellt man aber LeWitt neben ein "vereinzeltes" Werk von Andre oder Serra, dann könnte "ausgewogen" eine angemessenere Beschreibung für LeWitts Arbeit sein. Viele der Begriffe, die benutzt werden, um die Wirkung von Kunstgegenständen zu beschreiben, sind in diesem Sinne relativ und abhängig von möglichen Alternativen.

Ob gestische Malerei und 'ausgewogene' Kompositionen von Natur aus humanistisch sind, ist nicht die eigentliche Frage. Daß sie zu jener Zeit als solche wahrgenommen wurden, ist das Entscheidende. Ein allen gemeinsames Gefühl des Unbehagens gegenüber den vorherrschenden Konventionen künstlerischer Tätigkeit war ausreichend. Judd und Stella aber bauten, indem sie ihren Abschied von den Begriffen europäischer Kunst und des abstrakten Expressionismus signalisierten, gleichzeitig ein neues Verhältnis dazu auf. Das war ein notwendiger Schritt, denn genau mit diesem neuen Verhältnis erreichten sie, daß ihre eigenen Formen und Techniken die Bedeutung von Kunst erlangten. Wenn freie Zeichnungen und 'ausgewogene' Kompositionen angeführt wurden, um mit einer Art Humanismus zu korrespondieren, dann würden mit dem Lineal gezogene Linien und modulare Kompositionen zumindest ein Nicht-im Verhältnis-stehen zum Ausdruck bringen. Diese Art von Linien und Formen (und Materialien, Oberflächenbehandlungen, Farben etc.) markierten ein negatives Gebiet. Sie konstituierten eine Bewegung gegen das, was inzwischen zu einer verstärkt akademisch orientierten Konvention geworden war. In den späten fünfziger und frühen sechziger Jahren gab es wohl einen Konsens innerhalb einer Generation junger Künstler darüber, daß gewisse Formen der Kunst und Kritik formelhaft und maniert geworden waren. Wenn ihre eigene Erfahrung mit der Moderne oder ihre eigene Erfah-

rung mit anderer Kunst, zum Beispiel mit der von Pollock[9], angegriffen wurden, konnten sie nicht länger als positive Ressource gelten. Etablierte Wege des Voranschreitens zu negieren, ist jedoch nicht nur negativ. Diese Haltung weist in verschiedene Richtungen, produziert neue Formen, lädt uns ein, verschiedene Arten des Vergleichens anzustellen und fordert uns auf, Aspekte der Welt aus neuen Perspektiven zu betrachten.

Judds Sprache der sechziger Jahre ist die des absoluten Bruchs mit bisheriger Kunst. (Stella war weitaus umsichtiger, was die Unterschiede der eigenen Werke zur restlichen modernen Kunst anbelangte). Greenbergs Studie zur jüngsten Geschichte der Bildhauerei hingegen basiert völlig auf einem Gefühl der Kontinuität. In einem Punkt aber gab es Übereinstimmung: Werke, die mit dem Etikett 'Minimalismus' versehen wurden, (ein irreführender Ausdruck, den jeder benutzte, außer die Künstler selbst, deren Arbeiten er aber doch beschreiben sollte), galten nicht als traditioneller Bestandteil der Kategorie, die Greenberg als 'konstruiert' bezeichnete. Diese Tradition wurde in den ausbalancierten Werken Anthony Caros und anderer weitergeführt, nicht aber in den modularen Strukturen LeWitts, Judds oder Andres [Abb.7]. Für Greenberg war das das Entscheidende für die Tradition; für Judd war es das Problem mit ihr. Während der sechziger Jahre konnte man sich die letztgenannten Werke nur vorstellen als Bruch mit der Tradition, von welcher Seite aus auch immer betrachtet. Was aber damals als Bruch dargestellt wurde, könnte heute als folgerichtige Kontinuität gesehen werden, für welche die herrschende Sprache jedoch blind war.

So glaube ich, daß es zum Beispiel möglich ist, gerade – und vielleicht ganz besonders – in den kompromisslosesten modularen Strukturen aus der Mitte der sechziger Jahre (wie beispielsweise Arbeiten LeWitts oder Andres) nicht so sehr Überwindung, sondern eher die Entwicklung bestimmter Aspekte europäischer Vorkriegskunst zu sehen. Für Cezanne, Mondrian, Matisse und andere nahm das Prinzip der Ausgewogenheit eine zentrale Stellung in ihrem Werk ein – sowohl technisch als auch moralisch. Ausgewogenheit als ideales Verhältnis meinte in der Praxis den Versuch, die Hierarchie in der Malerei abzuschaffen. Hierarchie jedoch- nämlich eine Sache moralisch über oder unter eine andere zu stellen- scheint beinahe schon eine Vorbedingung für Malerei zu sein. Selbst die grundlegendsten Begriffe "Vorder-und Hintergrund" sind hierarchisch geordnet. Für Mondrian ist ein Bild nur dann frei von Interessen, Vorurteilen und bloßen Gewohnheiten des täglichen Lebens, wenn in ihm alle Elemente in einem Verhältnis von Gleichwertigkeit und Ausgewogenheit existieren. Vorder-Hintergrund abzuschaffen war Voraussetzung für Transzendenz, jenseits von bewußten und moralisierenden Lebensbezügen zu gelangen [Abb.8].

Die aus der Mitte der sechziger Jahre stammenden modularen Werke LeWitts und anderer führen das Prinzip der Gleichwertigkeit und Dezentriertheit noch um eine Stufe höher und in die dritte Dimension. Die Unterschiede sind wichtig. Gleichwertigkeit bedeutet hier eine exakte und vorbestimmte Relation im Werk und nicht eine Relation, die im Verlauf der Ausführung des Werkes erreicht wird. Es ist ein buchstäbliches Verhältnis zwischen identischen Elementen, nicht eine Feinabstimmung von nicht-identischen Elementen. Auch wenn dieser Art von Werken die Hauruck-Dramatik fehlt, und dieser Mangel sie in den Augen vieler Zeitgenossen daher kunstlos erscheinen ließ, ist das nicht gleichbedeutend mit einer Negation

vorangegangener Kunst. Vielmehr diente der Skeptizismus gegenüber dem Prinzip "Ausgewogenheit" dazu, das Thema Gleichwertigkeit neu zu formulieren, anstatt es abzuschaffen. Andre betitelte ganz bewußt seine "berüchtigte" Serie gebrannter Ziegelsteine aus dem Jahr 1966 "Equivalent I–VIII".

"Tradition" und "Neuheit" sind in der Kunst keine Gegensätze, aber, in Ermangelung eines Ausdrucks, dialektische Begriffe. Das Neue in der Kunst ist oftmals eine Umformulierung traditioneller Formen und Konzepte auf ungewöhnliche Art und Weise. Neuheit führt Tradition auf nicht-traditionellen Wegen weiter. Wenn eine neue Arbeit auftaucht, ist ihr herausragendstes Merkmal das, inwieweit sie sich vom Standard abhebt. Mit der Zeit, wenn das Neue in vertrautheit übergeht, mögen traditionellere Aspekte des Werkes nach und nach sichtbar werden. Das, würde ich behaupten, ist mit LeWitts Werk passiert. Während es zuerst losgelöst von künstlerischer Tradition erschien, ist nun seine Verbindung mit der Tradition sichtbarer. Sousehr es als Teil der Tradition von leichter, offener, linearer, konstruierter Bildhauerei erscheint, soweit scheint es von der Tradition entfernt zu sein, die Greenberg vor fünfundvierzig Jahren skizziert hat. Einige Bemerkungen LeWitts unterstützten diese Ambivalenz. Während einerseits der Ausdruck "Struktur" einen Bruch zur künstlerischen Tradition impliziert, bemerkte er andererseits in einer Diskussion "Ich würde gerne etwas herstellen, was ich, ohne mich zu schämen, Giotto zeigen könnte."[10] Ebenso ist Andre darauf bedacht, die Verbindung seiner eigenen Arbeit zu einer Art tiefgründigen, beinahe schon primitiven, kulturellen Tradition, nachdrücklich zu betonen.[11] Selbst Warhol, ein weiterer Künstler aus der gleichen Zeit, der eine "harte, industrielle" Optik anstrebte, begegnet uns nun weniger als Bedrohung denn als geschickter Vertreter etablierter Genres – als Maler von Porträts und besonders von Stilleben.

Es ist vielleicht die Präkonzeption der Komposition von LeWitt, Andre, Judd, Stella und anderen aus der Mitte der sechziger Jahre, die die größte Bedrohung der Konvention darstellten. Als Mondrian zwischen 1918 und 1919 einige Bilder malte, die auf der absolut regelmäßigen Einteilung der Leinwandfläche basierten [Abb.9], arbeitete er ebenso intensiv daran, das starre Format des Rasters aufzubrechen. Es wurden nicht nur Farben unregelmäßig aufgetragen, sondern auch an verschiedenen Stellen der Komposition Linien verbreitert, verdunkelt, aufgehellt, aufgeweicht und aufgelöst. Für Mondrian war die Kunst der vollkommenen Ruhe immer ein intuitiv erreichtes Einzelergebnis, etwas, das in jedem Werk von neuem entdeckt wurde (vorausgesetzt die Arbeit gelang). Das konnte man nicht vorab konzipieren und nach entsprechenden Anweisungen ausführen. Deshalb ließ sich das regelmäßige Raster mit dem Anspruch von reiner Kunst nicht vereinbaren, genauso, wie es zuvor mit der naturalistischen Malerei geschehen war. Wiederholung hätte vielleicht erfolgreich die Hierarchie abgeschafft, bedrohte aber im weiteren Verlauf ebenso die Malerei. Für Mondrian bestand die Aufgabe darin, für die abstrakte Kunst einen Weg zwischen Skylla und Charybdis, zwischen Hierarchie und Muster zu finden. Als erst einmal die symmetrische Struktur zugunsten einer flexibleren, unregelmäßigen Einteilung der Leinwand aufgegeben war, kehrte er nie mehr zum regelmäßigen Raster zurück. Was sich für Mondrian als Sackgasse darstellte, wurde für viele Künstler der sechziger Jahre zum fruchtbarsten Feld ihrer Erkundungen. Die Zusammenhänge mit präkonzipierten Rastern sollten nicht mehr vermieden, sondern untersucht werden.

Ein weiteres Problem war für Mondrian mit dem Raster verbunden.

Einerseits wurden Spuren von illusionistischer räumlicher Tiefe abgeschafft, aber gleichzeitig führte es zu einer anderen Art von Illusionismus – der lateraler Ausweitung –, indem das durchgehende Raster so erscheinen konnte, als ginge es über Leinwand und Rahmen hinaus. Dadurch, daß LeWitt und Andre das Raster für den realen Raum der Skulptur benutzten, umgingen sie viele – aber nicht alle – Probleme der unendlichen Ausbreitung. Es ist schwierig, sich ein Beispiel einer Skulptur vorzustellen, die impliziert, über ihre eigentlichen Grenzen hinauszugehen. Selbst die Venus von Milo endet sozusagen, wo sie aufhört. Wir vervollständigen die Figur nicht in unserer Vorstellung wie bei einer beschnittenen Fotografie oder einem Bild – zumindest nicht auf die gleiche Art und Weise. Gleichzeitig aber ist das Raster, definitionsgemäß, unendlich ausweitbar; es hat keine natürliche Grenze, weder in zwei noch in drei Dimensionen. Jede tatsächliche Begrenzung ist niemals durch das Raster selbst bedingt, sondern ihm auferlegt. Vielleicht liegt es an der Würdigung dieser Tatsache, daß sowohl LeWitt als auch Andre bisher eine beträchtliche Anzahl von auf Raster basierenden Strukturen in vielen verschiedenen Formaten und Größen hergestellt haben. Darüberhinaus haben sich beide im voraus gewisse physikalische und konzeptionelle Einschränkungen auferlegt und sind dann daran gegangen, die Möglichkeiten innerhalb dieser Grenzen zu untersuchen. LeWitts aus fünf und neun Modulen bestehende Strukturen sind allesamt Variationen innerhalb der Grenzen eines vorbestimmten, wenn auch imaginären Würfels [Kat.9, 10, 14]. Dennoch wird deutlich, daß Arbeiten wie diese nicht sämtliche vorstellbaren Möglichkeiten innerhalb der gezogenen Grenzen ausschöpfen. Vielmehr repräsentiert jede Struktur eine mögliche Entwicklung, aber eine, die nicht mehr oder weniger notwendig ist als irgendeine andere. Vielleicht ist das der Grund, daß diese Werke trotz ihrer Starrheit in Konzeption und Struktur so provisorisch und unfixiert erscheinen.

Es tritt vor allem bei den Serienstrukturen und Serienzeichnungen auf – Arbeiten, in denen alle möglichen Permutationen eines vorgegebenen Satzes von Strukturen, Linien oder Farben ausgearbeitet sind –, daß die Tendenz des Rasters, in die Unendlichkeit zu streben, kontrolliert (aber nicht überwunden) wird, indem es mit einem abgeschlossenen, endlichen System überlagert wird. In Serial Project No.1 ABCD, 1966–68 [Kat.7] nützt LeWitt sowohl die Beziehung zwischen zwei- und dreidimensionaler Darstellung, als auch die Relation zwischen offenen und geschlossenen Formen in einer konzeptionell präzisen, aber von der Wahrnehmung her sehr komplizierten, Gruppe von Permutationen aus. Aber auch hier ist das System etwas, das über das Raster gelegt ist – in diesem Fall sogar ganz buchstäblich –, um dessen Grenzen festzulegen; die Grenzen sind kein Bestandteil des eigentlichen Rasters. LeWitt findet nur dann die inhärenten Grenzen des Rasters, wenn er es zerlegt in modulare Einheiten und dabei Variationen unvollständiger offener Würfel bildet [Kat.12].

Es war jedoch das Thema der Vorgefaßtheit des Rasters, das wie eine Gräte im Hals künstlerischer Integrität steckte. Es stellte liebevoll gehegte Vorstellungen in Frage. Darüberhinaus schien die vorgefaßte Logik ein Kurzschluß zu sein für den Übergang zwischen Idee und Realisation in der Kunst, der im Atelier des Künstlers erfolgt. Das "ausgewogene" Werk, vor dem Stella zurückschreckte, und die Art bearbeiteter Oberfläche, die LeWitt zu negieren suchte, waren unauslöschlich geprägt von dem Versuch des Künstlers, diesen

Übergang zustandezubringen. Tatsächlich brachte die Vorgefaßtheit eine Art selbstauferlegter Entfremdung in die Atelierarbeit ein. Solch ein Werk würde nicht länger den harterkämpften Sieg über entfremdete Arbeit widerspiegeln, es würde die Entfremdung verkörpern. Vielleicht Mögen "Bruchstücke" der Kompositionen einen denkbaren einheitlichen menschlichen Ausdruck suggeriert haben. Die "Ganzheit" des minimalistischen Objekts wäre durch eine Aufteilung der Arbeit in eigenständige Elemente erreicht worden. Das Kunstwerk hätte eine andere Arbeitsweise zur Folge. Der Künstler wurde eingeteilt in einen Designer, der Pläne zeichnete und einen Arbeiter, der mechanisch die Anweisungen ausführt. So wie das Kunstwerk in einer Art Dezentriertheit seine Form erreicht hatte, war das Kunstwerk nun selbst dezentriert. Zumindest schien die höchst reduzierte Produktionsweise das zentrierte humanistische Ego zu gefährden, welches in "relationaler" Kunst zuhause war. Modulare Entwürfe können im Verlauf der Realisation nicht mehr entscheidend revidiert werden, und der Großteil der ästhetischen Entscheidungen wie Größe, Form, Komposition und Materialien müssen der Konstruktion vorausgehen. Betrachtet man die bevorzugten Oberflächenbehandlungen "minimalistischer" Strukturen – einheitlich, glatt, unverziert, ausdruckslos – fällt auf, daß die angemessensten Materialien diejenigen sind, die oft in industrieller Fertigung Verwendung finden: Stahlblech, Aluminium, maschinell bearbeitetes Holz. Nachdem erst einmal prinzipiell die formale Arbeitsteilung etabliert war, war es für viele Künstler nur noch ein kurzer und praktischer Schritt, die "structures" in Spezialwerkstätten von Fachkräften herstellen zu lassen. Bei dieser Arbeitsweise beginnt die Tätigkeit im Atelier weniger mit einer Skizze, als daß sie mit einem Diagramm aufhört. Im Atelier findet nur eine einzelne Phase im Produktionsprozeß der Kunst statt, es wird nicht Schauplatz einer "Heim-Industrie".

Seit Mitte der sechziger Jahre ließ Judd seine Metallstrukturen in Ingenieurwerkstätten herstellen. Sämtliche dreidimensionalen Arbeiten und Wandzeichnungen LeWitts werden oder können von Assistenten nach seinen präzisen Anweisungen ausgeführt werden. Während dies aber für Judd die praktische Lösung eines praktischen Problems zu sein scheint, hat LeWitt das Verhältnis von Idee und Ausführung zum Inhalt seiner Arbeit gemacht. Das ist ein wichtiger Unterschied, der zunehmend sichtbarer wurde in LeWitts Werk der späten sechziger Jahre. Dieser Unterschied könnte herangezogen werden, wenn es darum geht, "minimalistische" von einer entstehenden "konzeptionellen" Kunst zu unterscheiden. Die dreidimensionale Kunst von der Mitte der sechziger Jahre war bestrebt, repräsentierende Darstellung zugunsten von Objekthaftigkeit aufzugeben oder zu unterdrücken – wenigstens in Judds und Stellas Charakterisierung der Dinge. Von der Konzeptkunst könnte man sagen, daß sie das Problem umgekehrt hat, indem sie durch Hinterfragen der Bedingungen von Darstellung das Objekt abschaffte (oder abzuschaffen drohte).

Sicherlich bedeutete Konzeptkunst "vieles" für viele Menschen. Das meiste ist bestimmt von einer Art kritischem Selbstbewußtsein, was die wechselseitigen Beziehungen verschiedener Darstellungsmodi betrifft – ganz besonders visueller und verbaler Modi. Art & Language bezogen ihren Namen aus diesem Verhältnis; Joseph Kosuth, Lawrence Weiner, On Kawara, LeWitt und andere machten Arbeiten aus dem Raum heraus zwischen Abbildung und Beschreibung. In einigen Arbeiten der Konzeptkunst wurde dieses Verhältnis

durch eine Geschichte zwischen "Idee" und Realisation behandelt, wobei die Idee Vorrang gegenüber der Realisation hatte. In seinen "Paragraphs on Conceptual Art" von 1967 sagte LeWitt nur folgendes: "In der Konzeptkunst ist die Idee oder das Konzept der wichtigste Aspekt der Arbeit."[12] Die Verwirklichung eines Objektes oder eines Bildes ist demnach die optionale Weiterführung der originalen Idee.

Das radikale Herunterspielen des visuellen oder objektiven Charakters von Kunst hatte sicherlich einen hohen kritischen Wert zu der Zeit, als eine zunehmend "verknöcherte", emotionale Kritik vorherrschte. Daß die "Idee" über die "Ausführung" gestellt wurde, implizierte jedoch nicht gleichzeitig, daß die Idee allein schon notwendigerweise gut sei. Im Gegenteil – in LeWitts Werk waren die Ideen gewöhnlich "lächerlich einfach".[13] Das Ziel LeWitts war nicht, Kunst mit hochbedeutenden Ideen aufzuladen, sondern herauszufinden, ob sie auch dann noch interessant aussähe bzw. darüber nachzudenken wäre, wenn sie einem "lächerlich einfachen" Ausgangspunkt entspränge und auf weitgehendst mechanische Weise ausgeführt wäre. Das heißt, könnte Kunst ohne die vertrauten Krücken aus wichtigen Themen und hart erarbeiteten Resultaten noch weiter bestehen, und wenn ja, wie würde sie aussehen? Ganz ähnlich ist es mit der seriellen Erweiterung von Werken, dem Ausschöpfen jeglicher vorstellbarer Anordnung einer gegebenen Gruppe von Formen. Sie haben mehr Geistesverwandtschaft mit dem Aufbau eines Kartenhauses als mit der Erhöhung von Kunst zu einer Art quasi-wissenschaftlichen Fragestellung. In den frühen Werken der Konzeptkunst gibt es diesen leichten Geruch von diskreter Anarchie. Ein manisches Grinsen schaut hinter den präzisen Formen, einfachen Regeln und ordentlichen Entwicklungsreihen LeWitts hervor. Da herrscht Wohlgefallen an der Kopflastigkeit, die oft dadurch entsteht, daß "schlichte" Anweisungen sorgfältig ausgearbeitet werden. "Ordentlich" ist in diesem Fall nicht synonym mit "rational". LeWitts Linien, Rastern und seriellen Entwicklungen liegt keine tiefsinnige platonische Ordnung zugrunde, lediglich eine "lächerlich einfache" Idee und einige willkürliche Entscheidungen. "Irrationalen Gedanken sollte man absolut und logisch folgen", bemerkte LeWitt in seinen "Sentences on Conceptual Art" im Jahre 1969.[14] In diesem Sinne hat LeWitts Werk der späten sechziger Jahre etwas gemeinsam mit Burens binärer Unterteilung des Bildraumes in senkrecht angeordnete Streifen von 6,7cm Breite und seiner unerschütterlichen Verpflichtung gegenüber dieser völlig willkürlichen Entscheidung [Abb.10]. Entsprechend wurde die Entscheidung über das Verhältnis und die Farbe bei den modularen Strukturen von LeWitt beschrieben als "eine willkürliche Entscheidung, die jedoch immer benutzt wurde, nachdem sie einmal entschieden war."[15]

Die Hauptkomponenten von LeWitts zweidimensionalen Arbeiten um 1968 sind Linien und Wörter. Jedes seiner früheren Wandbilder ist begleitet von einer genauen wörtlichen Beschreibung seiner Elemente und seiner Herstellungsverfahren. Das angesprochene Verhältnis in der Konzeptkunst zwischen Idee und Ausführung ist bisweilen interpretiert worden als Bevorzugung von Wörtern gegenüber Bildern. Das ist bei LeWitts Wörtern nicht der Fall. Sie sind keine Erklärungen der Zeichnungen, sondern Anweisungen und Beschreibungen, die parallel dazu verlaufen. Die Wörter sind ebenso wie die Linien ein Ausdruck der Idee, die, wie LeWitt sagt, "unausgesprochen bleibt".[16] In mehreren Büchern, die LeWitt in den siebziger Jahren

46

veröffentlichte, werden Wörter und Linien benutzt, um sich gegenseitig zu beschreiben und vorzuzeigen. In einer Arbeit von 1970 gibt die Zeichnung genau das wieder, was der Text sagt – sechstausendzweihundertfünfundfünfzig Linien –, es würde jedoch einen großen Aufwand verursachen, diese Information aus der Zeichnung allein zu gewinnen [Abb.11]. Obwohl der Text es in einer Zeile sagt, sagt er längst nicht alles, es gibt viele Aspekte der Zeichnung (Länge der Linien, Ihre Plazierung, Farbe, Verlauf, etc.) die er nicht offenbart. Derselbe Text könnte eine beliebige Anzahl von verschiedenen Zeichnungen hervorbringen, genauso wie dieselbe Zeichnung jede beliebige Anzahl von gleich wahren aber verschiedenen Texten erzeugen könnte. In dem gewählten Beispiel suggeriert die Anordnung der Zeichnung auf dem Blatt, daß das Bild dem Text vorausging. In anderen Werken jedoch – zum Beispiel "Ten Thousand Lines, 5" Long, Within a 7" Square" von 1971 – ist eindeutig das Gegenteil der Fall [Abb.12]

"The Location of Lines" ist ein kleines quadratisches Buch, welches 1974 entstand. In diesem und einer Reihe verwandter Bücher, Zeichnungen und Grafiken aus ungefähr derselben Zeit, plaziert LeWitt eine Linie entlang der genauen textlichen Beschreibung ihrer Lokalisation. Die ersten beiden Linien des Buchs zeigen eine einfache horizontale Linie [Abb.13] und ihre Beschreibung: "Eine Linie von der Mitte der linken zur Mitte der rechten Seite." Zwischen den beiden herrscht eine Art Symmetrie – sie haben ungefähr die gleiche Form und Größe und beanspruchen jeweils die gleiche Zeit. Die Konventionen des Lesens suggerieren, daß der Text auf der linken Seite erzählerisch dem Bild auf der rechten Seite vorausgeht. Im weiteren Verlauf des Buches entwickelt sich aber eine extreme Asymmetrie zwischen Text und Bild. Die letzte Seite zeigt eine kurze diagonale Linie [Abb.14], aber deren Beschreibung auf der vorangegangenen Seite beläuft sich auf einhundertfünfzig Wörter:

Eine Linie zwischen den zwei Punkten, wo zwei Paare von Linien die erste Linie kreuzen würden, wenn die erste Linie des ersten Paares gezeichnet wäre von einem Punkt auf halber Strecke zwischen dem Zentrum des Blattes und der oberen linken Ecke zu einem Punkt auf halber Strecke zwischen dem Mittelpunkt der unteren Seite und einem Punkt auf halber Strecke zwischen dem Zentrum des Blattes und der unteren linken Ecke; die zweite Linie des ersten Paares von einem Punkt auf halber Strecke zwischen dem Mittelpunkt der oberen Seite und der oberen linken Ecke zu einem Punkt auf halber Strecke zwischen dem Zentrum des Blattes und der unteren linken Ecke; die erste Linie des zweiten Paares vom Mittelpunkt der Oberseite zu einem Punkt auf halber Strecke zwischen dem Mittelpunkt der rechten Seite und einem Punkt auf halber Strecke zwischen dem Zentrum des Blattes und der unteren rechten Ecke; die zweite Linie des zweiten Paares von der oberen rechten Ecke zum Zentrum des Blattes.

Die Asymmetrie hier ist sowohl quantitativ als auch qualitativ. Trotz aller Präzision klingt die Beschreibung verrückt. Es ist fast unmöglich, ihr zu folgen, ganz im Gegensatz zur Linie selbst, die im Vergleich auf absurde Weise simpel erscheint. Die Genauigkeit der Beschreibung ist ebenso eine Art Wahnsinn. Oder eine Art Poesie. Vor allem aber erzeugt der Text wenig Gefühl dafür, wie das Bild aussehen könnte. Was in einem kurzen Augenblick gezeigt werden kann, ist fast unmöglich in einem Absatz zu sagen. Und was in diesen

Arbeiten angedeutet wird, ist nicht, daß Bilder in Worte gekleidet werden können, sondern daß sie ihren ganz eigenen Bereich haben. Eine einzelne Linie oder ein kurzer Satz kann eine Art Aporie hervorrufen, wenn sie in einen anderen symbolischen Modus versetzt werden. In diesen Werken ist die Trennlinie zwischen Wort und Bild, zwischen Ursache und Wirkung verschlungen. Keine Hierarchie zwischen Wort und Bild kann hier vermutet oder aufrecht erhalten werden. Der kausale Raum zwischen Wort und Bild ist so instabil wiedergegeben wie der optische Raum einer Leinwand von Mondrian – außer daß in diesem Fall das Fehlen einer Hierarchie nicht zwangsläufig Gleichwertigkeit garantiert. Darüberhinaus wird gezeigt, daß die "Idee" keine Existenz außerhalb der Expression hat, jede Expression nur einen besonderen Aspekt der "Idee" offenbart, nie reine Essenz vor ihrer möglichen Form ist.

1974 führte LeWitt Strukturen und Fotografien in seinen Dialog zwischen Linien und Buchstaben ein. Variations of Incomplete Cubes [Kat.12] besteht aus dem deskriptiven Titel und einer Sequenz aus 122 isometrischen Projektionen, 122 Strukturen und 122 Fotografien, die alle die vollständige Entwicklung von drei- zu elfteiligen unvollständigen Würfeln abbilden. Das Werk hat etwas gemeinsam mit Werken von Joseph Kosuth, der in seinem "One and Three Frames" zum Beispiel eine fotografische Abbildung und ein abstraktes Wörterbuch einem ausgewählten echten Bilderrahmen gegenüberstellt. [Abb.15] Es gibt aber auch bedeutende Unterschiede, am auffälligsten zu sehen in Dimension und Ausmaß des Werkes von LeWitt. Der Verweis in LeWitts Werk ist außerdem rein abstrakt (eine geometrische Form anstelle eines konkreten Objekts) und immer abwesend – der Würfel ist immer nur implizit da, um im Kopf des Betrachters vervollständigt zu werden. Zusätzlich gilt, daß Kosuths Werk seinen Ursprung im Readymade hat – zwei der drei Formen sind "vorgefundene" (in einem Laden und in einem Wörterbuch) – während LeWitt seine eigene Form im Entstehungsprozess findet. LeWitts Werk erzählt seine eigene Entwicklung in mehreren einzelnen, aber ineinandergreifenden Stimmen. Es muß noch einmal gesagt werden, und das ist der auffallendste Unterschied, daß LeWitts Werk, trotz aller Ordnung und Präzision, am Rande des Chaos zu stehen scheint. Alle "Incomplete Open Cubes" umfassen 366 separate Elemente, neun Labels und ein Buch, welches die Diagramme und Label kombiniert. Verglichen damit erscheint der dreiteilige Kosuth wie aus dem Lehrbuch entnommen.

Die Beziehungen zwischen Text, Diagramm, Struktur und Fotografie sind in den "Incomplete Open Cubes" weniger zweideutig als die Beziehungen zwischen Wort und Bild in den oben erwähnten Zeichnungen. In einer strikt seriellen Weiterführung nach diesem Muster setzt das dreidimensionale Werk die Existenz einer Art Landkarte voraus und die Fotografien dokumentieren offensichtlich einen präexistenten Satz von Strukturen. Wenn aber das Konzept der "unvollständigen offenen Würfel" der Ausführung vorausgeht, und das Ziel ist, ein Werk zu schaffen, in dem die vollendete Form im voraus vom Künstler gegeben ist (ohne ihm notwendigerweise bekannt zu sein), dann ersetzt das kaum sämtliche Entscheidungen, die die sichtbare Form des fertigen Werks betreffen. Viele Aspekte – wie zum Beispiel Breite, Farbe und Oberfläche der Gitter, die insgesamte Größe und Plazierung der Würfel etc. – sind im Konzept schlichtweg nicht enthalten. Sie gehören allein in den Bereich der Ausführung. Und wie bei vielen von LeWitts Serienzeichnungen aus

dieser Periode, also Arbeiten, in denen die normalerweise mit "relationaler" Kunst verbundenen Entscheidungen durch strenge Regeln eliminiert wurden, die die Ausführung bestimmten, negieren die Ergebnisse kaum – wenn überhaupt – die Autonomie des Visuellen. Sie bemühen sich im Gegenteil fast immer mehr darum, die Unreduzierbarkeit des Bildes zu demonstrieren, vorzuführen, daß es niemals auf eine Anzahl Wörter verringert werden kann, ohne daß ein bedeutender Rest übrig bleibt, um zu zeigen, daß der Text niemals das Bild vollständig beschreiben kann. Gleichzeitig, obwohl das Bild strikt mit den Anforderungen des Textes übereinstimmen mag, ist es natürlich niemals eine simple Abbildung: So gut wie nie ist es auch nur annähernd möglich, von der ausgeführten Version auf das zugrunde liegende Konzept zu schließen. Was man sieht, ist, was man sieht: Es ist anders als das Gesagte oder Geschriebene (Leser von Ausstellungskatalogen bemerken das).

Konzeption und Wahrnehmung sind in LeWitts zwei- und dreidimensionalem Werk ein immens fruchtbares Verhältnis eingegangen, ein Verhältnis, das selbst in neueren Strukturen noch weiterträgt. Die "Complex Forms and Pyramids" [Kat.15, 16, 17, 19] sind überwiegend unregelmäßig und vielfach facettiert und dadurch scheinbar unmöglich als klares konzeptionelles Schema darzustellen. Jede einzelne jedoch entspringt bei LeWitt einem überraschend einfachen Diagramm [Abb.14–15]. In diesen Karten stellen die diagonal durch das Raster laufenden Linien den Grundriß der Form dar und das kleine Kreuz markiert die Spitze, wo sich die Flächen treffen. Die einzig zusätzliche Information, die zur Herstellung der Figur notwendig ist, betrifft die Höhe der Spitze über der Basis. In diesen Arbeiten ist die Kluft zwischen Konzept und physischer Form extrem, viel größer als im Fall der "Incomplete Open Cubes". Das Diagramm bestimmt präzise die Form der sichtbaren Flächen des Werks, erlaubt aber relativ wenig Rückschlüsse darauf, wie es genau aussehen wird. Das Resultat ist einerseits sehr bestimmt von seinem Plan und gleichzeitig relativ unabhängig davon.

Dieses paradoxe Verhältnis zwischen konzeptioneller und physischer Form – diese determinierte Autonomie – ist ein Merkmal, das vielen Strukturen LeWitts gemeinsam ist. Die ab 1966 entstandenen komplexen modularen Würfelstrukturen [Kat.9, 10, 21, 22] basieren oft auf einfachen Reihungen. Sie sind konzeptionell geordnet. Der Rundgang des Betrachters um die Struktur wird unterbrochen von flüchtigen Wahrnehmungen. Schatten fallen von einem Gitter auf das andere, weichen dadurch die strenge Geometrie der Werke auf. Quadratische und hexagonale Kanäle tauchen an Punkten auf, um Schächte in die Struktur zu schneiden, verteilen sich dann und kommen an anderen Stellen wieder hervor. Das Konzept mag der Schöpfer der endgültigen Form sein, ihr Meister ist es nicht.

Der Punkt ist nicht, daß LeWitt nach dem Planungsstadium die Kontrolle über sein Werk aufgibt. Durch Experimente und Erfahrungen lernt man einzuschätzen, welche ungefähren Wirkungen in der einen oder anderen Struktur vermutlich entstehen. Die ausgeführte Form einer Serie hat zwangsläufig einigen Einfluß auf den Entwurf der folgenden Gruppe von Werken. Wirkungen werden zu Ursachen. Teilweise zeichnen sie verantwortlich für das Gefühl inhaltlicher und formaler Einheit, das sich seit dreißig Jahren durch die Strukturen und Zeichnungen von LeWitt zieht.

Die Arbeitsteilung in LeWitts Werk findet abgestuft statt, ist gewissermaßen flexibel. Das Ziel ist nicht, die Funktionsweise eines Systems vorzufüh-

ren, sondern Kunst hervorzubringen, von der er sich "nicht schämen würde, sie Giotto zu zeigen." Es gibt noch eine weitere Ebene der Einheit in LeWitts Werk der letzten drei Jahrzehnte. Sie liegt im Geist des Werkes, ein Geist, den ich nur als stille aber freudvolle Befragung bezeichnen kann. Diese Befragung bezieht sich auf eine Reihe abstrakter Beziehungen – Beziehungen zwischen Idee und Ausführung, Entwurf und Wahrnehmung, Plan und Struktur, Wort und Bild, Bild und Objekt, Struktur und Skulptur, Rationalität und Irrationalität, Ordnung und Unordnung, Tradition und Neuheit. Es geht bei seinem Werk weniger um diese Beziehungen, darum, daß diese Beziehungen im Werk verkörpert sind. Sie sind alle gekennzeichnet durch verschiedene Formem der Reflexivität, was seinen Arbeiten eine bestimmte Leichtigkeit, Offenheit und Substanz verleiht. Die Knoten aus Vorurteil und Gewohnheit, die diese Beziehungen an fixierten Stellen bilden, sind gelöst. Die Freude am Werk ist die Freude, Erwartung mit Erfahrung zu besiegen, wie es auch sein soll. Eine Welt, in der es nicht gestattet ist, Erfahrungen jenseits der Erwartungen zu machen, ist Tyrannei.

ANMERKUNGEN

1. Sol LeWitt, Kommentar zu seinem Werk in *Sol LeWitt*, Museum of Modern Art, New York, 1958, S.57.

2. Sol LeWitt, *ebd.*, S.53.

3. Sol LeWitt, *ebd.*, S.59.

4. Clement Greenberg, 'The New Sculpture', 1948, in *Art & Culture*, Thames & Hudson, 1973, S.142. (Am Ende des Essays werden zwei Daten genannt: 1948 und 1958. Es ist nicht sicher, ob der hier zitierte Abschnitt von der ersten oder revidierten Fassung stammt, aber das Argument bleibt bestehen.)

5. Vergleiche Greenbergs 'Recentness of Sculpture', Wiederabdruck in Battcock (Hrsg.) *Minimal Art: a critical anthology*, Dutton, New York, 1968, S.180–186. Der Essay war ursprünglich für den Ausstellungskatlog *Amerikanische Skulptur der Sechziger Jahre*, Los Angeles County Museum of Art, 1967, veröffentlicht.

6. Donald Judd, 'Specific Objects,' *Arts Yearbook 8*, 1965. Wiederabdruck in *Donald Judd: Complete Writings 1959–1975*, Nova Scotia, 1975, S.181–190.

7. 'Questions to Stella and Judd', ein Interview mit Bruce Glaser, gesendet von WBAI–FM, New York, Februar 1964; veröffentlicht in *Art News*, September 1966. Wiederabdruck in Battcock, *ebd.*, S.148–164.

8. 'Questions to Stella and Judd,' *ebd.*, S.157–8.

9. Für eine tiefergehende Diskussion der Zeit siehe Charles Harrison, *Essay on Art & Language*, Blackwell, Oxford und Cambridge, Mass.,Kapitel 1 und 2.

10. LeWitt, 'Excerpts from a Correspondence, 1981–83', in *Sol LeWitt: Wall Drawings 1968–1984*, S.

11. Siehe '*3000 Years: Carl Andre interviewed by David Batchelor*', *Artscribe*, Nr.78, Sommer 1989, S.62–63.

12. Sol LeWitt, 'Paragraphs on Conceptual Art', *Artforum*, vol.5 Nr.7, Juni 1967, S.79–83, Wiederabdruck in diesem Band, S.79–83.

13. Sol LeWitt, 'Paragraphs on Conceptual Art', *ebd*.

14. Sol LeWitt, 'Sentences on Conceptual Art', *Art-Language*, vol.1 Nr.1, Mai 1969, S.11–13, Wiederabdruck in diesem Band, S. Für einen faszinierenden Abriß der Beziehung zwischen Rationalität und Irrationalität in LeWitts seriellem Werk siehe Rosalind Krauss, "LeWitt in Progress", 1977, in *The Avant Garde and other Modernist Myths*, S.244–258.

15. Sol LeWitt, in *Sol LeWitt, ebd.*, S.59.

16. Sol LeWitt, *Paragraphs on Conceptual Art, ebd.*, S.00.

DIE LEWITT MATRIX
Rosalind Krauss

1. Im Jahre 1980 veröffentlichte Sol LeWitt seine *Autobiographie*. Das Werk besteht zu über hundert Seiten aus Fotografien, die jeden Quadratzentimeter, jedes Detail der New Yorker Dachgeschoßwohnung, in welcher LeWitt zu diesem Zeitpunkt arbeitete und lebte, bis in den letzten Winkel hinein abbilden. Oder mehr noch: Das Inventar wird als Folge eines neunteiligen Gitters gezeigt, wobei jede Buchseite in neun perfekte Bildquadrate gegliedert ist, der Platz jedes einzelnen Bildes wiederum festgelegt durch ordnende, breite weiße Streifen, die diese Bilder in ihrem durchgehenden, sich gnadenlos ausbreitenden geometrischen Rahmen einschließen. Während diese Schilderung des Lebensraumes voranschreitet – über die Einzelheiten der Zimmerdecke aus gepreßtem Blech, über jeden hängenden Topf oder Pfanne, in den Schrank hinein mit seinen Kleidersäcken, über die auf dem Boden liegenden Schuhpaare, mitten durch das Blattdickicht der Zimmerpflanzen hindurch, vorbei an jedem einzelnen Stuhl und Tisch, entlang all der Regale mit ihren Büchern in sauberen Reihen, oder der Tonbänder, gerahmt als kristalline Schichten – werden die Gegenstände allmählich überholt von der Matrix, die sie an ihrem Platz hält, von dem Raster, welches sie fixiert und abflacht, von der Methode, die sie aussondert als unzählige Exemplare unzähliger kategorischer Räume und dadurch das Leben in ein klassifizierendes System verwandelt.

In diesem Sinne steht *"Autobiography"* am Ende einer Verlaufskurve, die in den frühen Siebzigern begann, als LeWitt die Schemata für verschiedene seiner seriellen Ausbreitungen veröffentlichte, zum Beispiel den *"Incomplete Open Cubes"* (1974), oder die *"Five Cubes on Twenty-Five Squares with either Corners or Sides Touching"* (1977) mit über 900 Beispielen ihrer möglichen Permutationen. In diesen Fällen schien das Mittel der Darstellung – die gerasterte Seite – ein leises formales Echo der ausgestellten geometrischen Werke zu sein. Genauso wie LeWitts *"PhotoGrids"* (1977) in der Wiedergabe des Gitters als vorgefertigter Einheit das Thema der Fotografien mit dem System ihrer Darstellung – die verdrängte Wiederkehr der Stadt kontinuierlich in Form von Gittern, Maschen, Grills, Gerüsten, Gardinenwänden etc. – zu vermählen schien, Vorder- und Hintergrund sich einander widerspiegelnd, Rahmen und Gerahmtes in gegenseitiger Würdigung.

Mit *"Autobiography"* war etwas Neues eingetreten, etwas, was sich schon im Jahr zuvor angedeutet hatte, als eine fotografische Bestandsaufnahme der sichtbaren Überbleibsel an den Wänden eines zehn Block großen Viertels in Manhattans Lower East Side zu LeWitts Projekt für *"Artforum"* wurde. Von nichts in diesem Chaos – den Sprechblasen der Graffitis, die SHERLOCK buchstabieren oder KISS verkünden; den Schildern für Lisa's Social Club oder die United League Speaking Tour; der mauerhohen Spinne; den wahnsinnig präzisen Bildern von Zylinder und Gehstock; den zerrissenen Plakaten, dem rätselhaften Emblem – kann gesagt werden, es passe sichtbar zu dem Raster. Auf diese Weise sondert sich das "System" – das Raster, welches das Bild stützt – ab, als das eine Ende einer Bipolarität, deren anderes Ende das gegebene Objekt ist. Und in dieser Struktur, welche System und Objekt einander gegenüberstellt, ist System gleichgesetzt mit Subjekt, mit dem Subjekt, mit

Subjektivität, mit dem Selbst. Von "*Incomplete Open Cubes*" zu "*Autobiography*". Vom System als Objekt zum System als Selbst.

2. Joseph Kosuth ist darauf versessen, uns von der Konzeptkunst zu erzählen. Sogar der Begriff stammt von ihm, teilt er uns bescheiden mit, und vergißß dabei die viel frühere Eröffnungssalve von LeWitts manifestähnlichen "*Paragraphs on Conceptual Art*".[1] Kosuth hat sich die Einführung dieser Vorstellung auch noch angeeignet, indem er erklärt, daß sie Kunst miteinbeziehe, die in philosophische Untersuchung verwandelt sei, Kunst, die sich auf die Fragestellung konzentriere, wie semiotische Systeme ihre Bedeutung erlangten, wobei er mit der Sprache an sich beginnt, bevor er zur kulturellen Erzeugung von Bedeutung übergeht.

Andererseits hat praktisch keiner seiner Apologeten jemals angezweifelt, daß LeWitt ein Philosoph war: Kant ("Wenn irgendjemand die strukturelle Schönheit von … Kants Schriften wahrnehmen könnte und sich dann anschickte, sie als ausschließlich bildliche Metaphern wiederzuerschaffen, wäre das sicherlich LeWitt"[2]); Descartes (Indem wir "sie überfliegen 'in einem kontinuierlichen und ununterbrochenen Akt des Denkens,' reflektieren 'über ihre gegenseitigen Beziehungen,' wie Descartes mit jeder Serie zu verfahren vorschlug, derer wir uns 'viel mehr vergewissern' wollen, 'wächst nicht nur die Kraft unseres Denkens' über das Bekannte hinaus, wie Descartes erwartete…"[3]). Oder ein Mathematiker: Euclid ("euklidische Hilfskonstruktionen werden verwendet in der Herstellung der Wandzeichnungen und ihrer Beschreibung"[4]); Gödel ("Er ist einer der wenigen Künstler des zwanzigsten Jahrhunderts, die es geschafft haben, über den optischen Sinn Impulse des Erkennens auszulösen und dabei auf so wichtige wissenschaftliche Gesetze aufmerksam zu machen wie die 'Unschärferelation' Werner Heisenbergs und die 'Unbestimmbarkeit arithmetischer Theoreme' Kurt Gödels…"[5]). Oder ein Psychologe, der sich mit "genetischer Epistomologie" beschäftigt: Piaget ("Einzig LeWitts 'reflektive Abstraktion' paßt völlig zu diesen Theorien, nur von seinem Werk kann behauptet werden, es artikuliere den 'Augenblick im künstlerischen Denken, wenn sich eine Struktur den Fragen öffnet und sich einer neuen Bedeutung entsprechend wieder organisiert, die dennoch die Bedeutung derselben Struktur ist, lediglich auf eine neue Ebene der Komplexität gehoben.' "[6]). Es ist aber derselbe LeWitt − LeWitt der Platoniker, LeWitt der transzendentale Humanist, LeWitt der Metaphysiker, LeWitt auf der Suche nach "einer universalen Bedeutung der Kunst"[7] −, der vor kurzem bei einer feministischen Museumsdirektorin solchen Anstoß erregte, daß sie versuchte, die Ausstellung "Eadweard Muybridge and Contemporary American Photography" zu zensieren, indem sie LeWitts Beitrag, den sie entwürdigend und anstößig fand, ausschließen wollte und uns dabei LeWitt den Pornographen darbot.[8] Der gleiche LeWitt, welcher "Muybridge I" (1964) in einer frühen Homage an den Mann, der "großen Einfluß auf mein Denken hatte" schuf, erklärte, daß "dieses Stück nach einigen Jahren Überlegung und des Experimentierens entstanden war und die Grundlage für einen Großteil des seriellen Werkes darstellte."[9] So beginnt also das serielle Werk nicht mit der Bewegung von himmlischen Sphären und Euklidschen Linien und Punkten, sondern mit dem entblößten menschlichen Körper und Muybridges "Animal Locomotion"; und durch diesen Ursprung in Muybridge entwickelt sich LeWitts Beschäftigung mit Serialität aus einer Position heraus, die nicht von Verstand oder Vernunft herrührt, sondern behaftet ist mit dem Wahn-

53

sinn, den man in Muybridges fanatischem Verlangen beobachten kann, seine Vorführung in das Reich dessen zu tragen, was Hollis Frampton "enzyklopädische Enormität" nannte und Frampton zu der Frage veranlaßte, "welches Verlangen ihn dazu trieb, über ein vernünftiges Maß von Dutzenden oder selbst Hunderten von Sequenzen hinaus, Tausende davon zu machen?"[10]

Es ist wahr, daß dem Betrachter, der sich bücken muß, um durch die Öffnung in der Reihe kleiner schwarzer Schachteln von "Muybridge I" zu spähen, um das darin befindliche Bild zu sehen – eines aus der zehnteiligen Sequenz einer auf die Kamera zugehenden nackten Frau, von der das letzte der Serie nur noch den sanften Hügel ihres Bauches zeigt, mit dem Nabel im Mittelpunkt des kreisförmigen Bildes und dem angeschnittenen oberen Ansatz der Schambehaarung an der Unterkannte –, diesem Betrachter der Körper gleich zweifach bewußt wird: einmal der des Bildes und zum anderen sein oder ihr eigener, genau wie im Fall des Betrachters von Duchamps "Etant donnés" (obwohl diese Arbeit noch nicht in Philadelphia eingeweiht worden war), der nicht umhin kommt, sich als angegaffter Gaffer vorzukommen, als ein auf frischer Tat ertappter Zuschauer.

Das serielle Projekt beginnt also mit einem angeschauten Körper und einem Verlangen, zu sehen, ein Verlangen, welches tatsächlich ein Verlangen ist, Körper anzuschauen. Und dieses Verlangen ist nicht sublimiert; es hängt nicht mit Rationalität zusammen. Von Anfang an äußerte sich LeWitt sehr deutlich über diese Distanz zur Vernunft. In seinen "Sentences on Conceptual Art" begann er: "Konzeptkünstler sind mehr Mystiker als Rationalisten". Seine vierte Sentenz beschreibt die Vorgehensweise des Konzeptualisten, könnte aber auch von der Muybridges berichten: "Irrationalen Gedanken sollte man absolut und logisch folgen", schrieb er.[11]

3. Es war Robert Smithson, der von Anfang an behauptete, daß LeWitts Auffassung von "Konzept", wie er formulierte, vom Paradoxen "geschwächt" sei. "Alles, was LeWitt denkt, schreibt oder macht", sagt Smithson, "ist uneinheitlich und widersprüchlich. Die "ursprüngliche Idee" seiner Kunst geht in einem Durcheinander von Zeichnungen, Proben und anderen Ideen verloren . . . Seine Konzepte sind Gefängnisse bar jeglicher Vernunft."[12] Und LeWitt hätte da nur zustimmen können. Er hatte in seinen "Sentences . . ." einen Unterschied zwischen Konzept und Idee gemacht: Ersteres impliziert eine allgemeine Richtung, Letztere sind die Bestandteile." Die Idee wäre also eine Art Inhalt, während das Konzept als deren Form diente. Welche Art von Ideen stellte sich LeWitt als Inhalt seines Werkes vor? Hier ist ein Beispiel aus den Gesprächen, die er mit einer Galerie in Nova Scotia anläßlich einer Ausstellung im Jahre 1969 führte: "Ein Werk, das die Idee des Irrtums benutzt; ein Werk, das die Idee der Unendlichkeit verwendet; ein Werk, das subversiv ist; ein Werk, das nicht original ist"[13]

Im Jahre 1978, als ich über die "Variations on Incomplete Open Cubes" schrieb, hakte ich an dieser Bemerkung ein – "die Idee des Irrtums" oder an der anderen über Subversion, die als selbst zugegebener Inhalt seines Werkes angegeben wurde –, um LeWitts Kunst von der ganzen Litanei mathematischer Formen, deduktiver Logik, axiomatischer Strenge, fester platonischer Nahrung und Metaphysik . . . zu befreien, die an ihm zu kleben schien. Es schien unglaublich lächerlich, daß jemand schrieb: "Diese Nähe zu wissenschaftlichem Gedankengut [z.B. Gödels und Heisenbergs] ist der Beweis seiner Zusammenarbeit mit Mathematikern und Physikern an der University of

Illinois bei seinem Werk "Variations of Incomplete Open Cubes", in welchem alle Variationen eines dreidimensionalen Würfels mit unterschiedlich fehlenden Seiten genau identifiziert wurden."[14] Dieses Beharren auf LeWitts Mathematik – das kindliche Abzählen an den Fingern, um den "Beweis" zu führen, der in dem Werk mit seinen einhundertzweiundzwanzig kleinen weißen Modellen steckte, welche auf der riesigen Plattform in einer Art krankhafter Nachahmung von Ordnung zusammengestellt waren – dies war, so dachte ich, in keiner Weise das synthetische Denken, waren nicht die durch wahres konzeptionelles Denken möglich gemachten breiten Verallgemeinerungen, welche ihm nachgesagt wurden. Anders als der algebraische Ausdruck für die Ausbreitung einer gegebenen Reihe, wo die Formel benutzt wird, um die Position eines jeden Gliedes in der Reihe genauestens vorauszubestimmen, wendet LeWitts Werk nachdrücklich sein generatives Prinzip in jedem der möglichen Fälle an. Wie ich damals schrieb, "bewegt sich die Wahrnehmung des Werkes genau dem 'Aussehen des Denkens' entgegen, besonders wenn Denken als klassischer Ausdruck von Logik verstanden wird. Weil es nämlich bei solchem Ausdruck, gleichgültig ob in Form eines Diagramms oder symbolisch, genau um die Fähigkeit geht, abzukürzen, kurz zu umreißen, einzuschmelzen, in der Lage zu sein, eine Ausbreitung nur anhand der ersten zwei oder drei Glieder zu implizieren, weiten arithmetischen Raum mit einigen wenigen Ellipsenpunkten auszufüllen."

Was mir also in diesem Zusammenhang einfiel, waren jene anderen Modelle, von denen ich wußte, daß sie besonders wichtig für LeWitts Künstlergeneration gewesen waren – Modelle von Amok laufender "Vernunft", die eine Art Veitstanz am Abgrund der Zwecklosigkeit aufführten und dabei entweder in manischer Ausgelassenheit oder beinahe autistischer Flachheit eine von emotionalem Chaos überwältigte Vernunft vorführten. Schizoide Vernunft. Die Vernunft des Erzählers in Robbe-Grillets "Jalousie", der uns zwingt zuzuhören, wenn er klangleer und fanatisch, Reihe für Reihe, jede Bananenstaude in der vor ihm liegenden Plantage zählt. Oder die Vernunft von Becketts Malloy, wenn er die Posse schildert, das "Problem", welches er sich selbst gestellt hat, "zu durchdenken": Wie kann man sechzehn Steine in Folge lutschen, ohne einen einzigen zweimal zu lutschen, wenn man nur vier Taschen hat, aus denen man jeden Stein herausholen und wieder zurückstecken kann? LeWitts vierte Sentenz hatte Malloys Lösung absolut trefflich beschrieben: "Irrationalen Gedanken sollte man absolut und logisch folgen", hatte er gesagt.

Es gibt noch weitere Stellen, an denen das Irrationale hinter der fanatischen Ordnung der Strukturen LeWitts – in ihrer Schönheit, Präzision und Kärglichkeit der Prosa Becketts nicht unähnlich – hervorzuschauen und mit seinen Fingern auf uns zu zeigen scheint. Indem die fünfteiligen, oder gar noch eindringlicher, die neunteiligen modularen Strukturen ihrem Entfaltungsmuster folgen, beginnen sie verstärkt, clownhaft alberne Umrisse zu entwickeln. Vernunft als die Fantasie eines Satzes Bauwerkzeug. Vernunft als ein Spitzendeckchen. Dies ist in einem Werk wie "Untitled (Five Towers)" von 1986 zu einem Höhepunkt gelangt: Vernunft als Hochhausensemble.

Und dann gibt es da noch die Wandzeichnungen.

4. Im Jahre 1958 fertigte LeWitt einige Zeichnungen von Piero della Francescas Fresken in Arezzo an. Eine davon wählte er für den Katalog einer kürzlich gezeigten Ausstellung der Wandzeichnungen aus; eine andere foto-

grafierte er für seine "Autobiography".[16] Die erste der Zeichnungen ist ein Ausschnitt aus dem Bildzyklus der Legende vom heiligen Kreuz, in dem die heilige Helena auf ihren Knien das "wahre" Kreuz anbetet. Dieses Bild sagt aus, daß das auf Golgatha gefundene Kruzifix jenes ist, an dem Jesus starb – bewiesen dadurch, daß es eine wundersame Wiederbelebung hervorruft. Dieses Bild von Piero, mit Helena umgeben von ihrem Gefolge, einer Gruppe feierlicher, säulenhafter Figuren, ist sehr berühmt und jedes Detail so sehr ein ein Satz von platonischer Festkörpern wie LeWitts offene Würfel, die dafür gehalten werden könnten.

Tatsächlich ist die Lesart Pieros festgelegt, ebenso wie in LeWitts Fall, durch die Vorstellungen von ihm als einem Mathematiker, als dem Verfasser einer Abhandlung über Perspektive, als dem Künstler, der sich den geometrischen Gestzmäßigkeiten widmet. "Diese mathematische Haltung durchdringt sein ganzes Werk. Wenn er einen Kopf zeichnete, einen Arm oder ein Stück Gewand, sah er die Gegenstände als Variationen oder Zusammenfügungen von Kugeln, Zylindern, Kegeln, Würfeln und Pyramiden, und stattete die sichtbare Welt mit der unpersönlichen Klarheit und Dauerhaftigkeit stereometrischer Körper aus. Wir können ihn durchaus als frühesten Urahnen der abstrakten Künstler unserer eigenen Zeit bezeichnen."[17]

Diese Vorstellung von Perspektive aber als doppelt objektiv – einerseits ein System, objektiviert durch sein mathematisches Fundament, auf welchem Ordnungen und Objekte organisiert sind, und auf der anderen Seite die Möglichkeit dieser Objekte, sich als Menge stereometrischer Körper in ihrer ureigensten Objektivität darzustellen, als "Variationen oder Zusammensetzungen von Kugeln, Zylindern, Kegeln, Würfeln und Pyramiden" –, diese Vorstellung ist durch eine strukturalistische Deutung Pieros der Anfechtung preisgegeben worden. Es ist eine aufschlußreiche Deutung, sowohl in bezug auf LeWitts Zuwendung zu Piero im besonderen, als auch zu toskanischer Malerei ganz allgemein – eine Zuwendung, die einen Großteil seiner neueren Arbeiten beeinflußt hat –, eine Deutung, bei der es um die Sache in seinem Werk geht, darum, daß der objektive Pol von seinem gewissen Gegenteil überflutet wird, wie das in "Autobiography" oder "Untitled (Five Towers)" oder "Muybridge I" deutlich wird. Da dies so aufschlußreich ist, soll hier noch ein kleiner Exkurs gemacht werden (nicht interessierte Leser sollten den Text bis zu Abschnitt 6. überspringen).

Die Bemerkung, Perspektive sei ein "objektives" System, unterschlägt, von einem strukturalistischen Gesichtspunkt aus, die einfache Tatsache, daß sie auf einem Vektor aufbaut, der den Blickmit dem Fluchtpunkt verbindet, ein Vektor also, der auf den Betrachter zeigt und mit diesem Zeigen den Betrachter als "Du" bestimmt. Louis Marin besteht in seiner Analyse der Fresken von Arezzo darauf, daß dieses Zeigen oder diese deiktischen Achsen den subjektiven Pol jeder perspektivischen Ausrichtung festlegt, einen Pol, der nicht nur den Betrachter als "Du" herausgreift, sondern den Betrachtungszeitpunkt als "jetzt" definiert und ihren Ort als "hier". Im strukturalistischen Sinne führt Perspektive nicht zur "Erzählung" – oder der Modalität von Geschichte –, sondern zum "Diskurs", dem Ereignis lebendiger Sprache.[18]

Als er daher mit der Erzählung der Arezzo Fresken konfrontiert wurde, begann Marin mit der merkwürdigen Tatsache, daß die deiktische Verbindung selbst zum Erzählstoff in der Geschichte wird; ein Erzählstoff, den die Fresken feiern, da nämlich seine bloße Anwesenheit an einem bestimmten Ort

zu einer bestimmten Zeit, nämlich der Bacci Kapelle am 3. Mai, den Betrachter in eine liturgische Beziehung zu einem Ereignis setzt, welches seinerseits in den Fresken dargestellt ist – das Ereignis der heiligene Helena, die das wahre Kreuz findet. Das Finden ist jedoch gleichzeitig ein Wiederfinden und somit eine Gegenwart, die ebenso Vergangenheit ist. Was heißen soll, Zeuge dieses Geschehens zu sein bedeutet gleichzeitig in historische Zeit überzuwechseln, da das Kreuz selbst, "heute" entdeckt, bereits nicht nur einmal, sondern schon viermal entdeckt worden war und somit seine Vergangenheit gewissermaßen in sich trug; vielleicht verbindet uns das, bei rechtem Winkel zu den deiktischen Axen, mit seiner Entdeckung in der Gegenwart.

Dieses Bild mit dem rechten Winkel ist nicht zufällig hier gewählt. Tatsächlich betrachtete Marin das seitliche Aufrollen der Schrift, wie es damit die Anwesenheit des Betrachters ignoriert und den Raum entlang der Oberfläche des Blattes schließt, als Durchtrennen der Blickbahn, darüber hinaus in die Tiefe bohrend. Es war eben dieser rechte Winkel von Lesen-versus-Betrachtung, der beispielsweise die Basis für die Analyse von Poussins "Et in Arcadia Ego" darstellte, mit seinem Abrutschen der Deiktik der Perspektive unter die quer verlaufende Wiedergabe der Grabinschrift; dies dient dazu, die Unmittelbarkeit der Anrede in der Gegenwart zu verdecken und sie in eine Äußerung umzuwandeln, die nur aus der Vergangenheit kommen kann.[19]

Wenn nun das Bild des rechten Winkels bei Poussin aus der Kreuzung der Sichtachse und der Achse des Geschriebenen zusammengesetzt werden muß, besteht es im Beispiel Piero schon als ein vorgefertigtes Ganzes, da das Kreuz das absoluteste Emblem zweier sich kreuzender Richtungen ist. Ein Kreuz also, das gegenwärtig aber gleichzeitig auch vergangen ist, kann bereits gesehen werden als Ausdruck dieser Möglichkeit, zwei entgegengesetzte zeitliche Vektoren in einem Schußfaden gemäß seiner einfachsten physikalischen Beschreibung zu befördern. Das bedeutet, daß das Kreuz zu ein und derselben Zeit ein Bild – ein Kreuz – und ein Schema – gekreuzte Achsen – ist; das Erste das Objekt im Raum, das Zweite, welches bezeichnet werden könnte als Gedanken über das Objekt, oder als das Mittel, mit dem das Objekt gezeigt wird – angetrieben vom Räumlichen zum Zeitlichen: das Kreuz, welches man in der Gegenwart findet, ist bereits viermal entdeckt worden. Die gekreuzten Achsen als strukturaler Betreiber der Geschichte oder die Umkehrung von Gegenwart in Geschichte ist daher nicht so sehr das Objekt der Geschichte – dem wahren Kreuz – als ihr Subjekt, eine Modalität des Bewußtseins von ihr.

Un da gibt es noch eine weitere axiale Beziehung, für die ein Strukturalist sehr empfindlich ist, nämlich die Beziehung dessen, was oftmals die horizontale Syntaxebene genannt wird – wie der Satz sich Wort für Wort entwirft – und das vertikale Stapeln von Alternativen und Ersatzwörtern für jeden Ausdruck in der horizontalen Kette. Syntagmatik, oder das sequentielle Aufrollen eines Satzes, überschneidet sich also mit Paradigmatik, welche die symbolischen Ebenen der Geschichte impliziert.

Daß die Erzählung vom Kreuz eine syntagmatische Kette enthält, wie es im Verlauf seiner Geschichte vor der Passion eine vierfache Transformation durchläuft, vom Baum der Erkenntnis zum Ast, zum Baum, zum Balken, zur Brücke, nur um schließlich als Träger für die Kreuzigung gestaltet zu werden, nimmt natürlich das Bewußtsein bildlich vorweg, in welchem das Kreuz selbst mit paradigmatischen Werten ausgestattet wird, die es verschlüsselt in kosmologische und allegorische Bedeutungsebenen befördert. Der heilige

Augustin hatte ja bereits erklärt, daß die Achsen des Kreuzes die vier Himmelsrichtungen bezeichneten; und weil jede dieser physischen Richtungen durch die Leidensgeschichte bestimmt ist – indem sie entweder die Verbindung des Körpers Christi ans Kreuz oder die Verbundenheit des Kreuzes an den Boden markiert –, ist jede auch metaphorisch ausgearbeitet: Der Balken, an welchem Jesu Hände befestigt waren, steht zum Beispiel für die guten Taten, die Christus vollbracht hat; oder die strikte Erdverbundenheit symbolisiert die Pflicht, die Sakramente auszuführen. Auch auf dieser symbolischen Ebene geschieht es, daß man sich des Kreuzes als reinem Zeichen versichert, indem es innerhalb der Erzählung aus der Rolle des bloß Objektiven schlüpft, um jenseits von Raum und Zeit in der immer wiederkehrenden Gegenwart der Wirksamkeit des Glaubens als Hinweis oder als Reliquie mit symbolischen Kräften zu wirken.

In gewisser Weise ist die Geschichte vom wahren Kreuz auch die Geschichte eines Blickpunktes, der über die ausserordentliche physische Transformation hinausgeht, um eine Erkenntnisleistung zu vollbringen, welche die Erzählung von Veränderung und Zeit in die symbolische Kraft der Bedeutung des Kreuzes umwandelt, in ihre wahre transformative Macht, die für den Gläubigen in einem ewigen "jetzt" wirksam ist. Innerhalb des Systems der Perspektive ist offensichtlich ein Pol für den Blickpunkt reserviert; und dieser Pol, besetzt von der kristallenen Augenlinse des Betrachters, ist von Piero als Kreuzform in der Natur bezeichnet. Das bedeutet, wenn das perspektivische Gitter, welches geometrischen Raum kartographiert, fähig ist, sich wahrhaft mit dem Sehapparat des Betrachters zu verbinden, dann ist das nur deshalb möglich, weil der Apparat – menschliches Sehen – ebenso auf einem Raster basiert: Weil nämlich die Nerven, welche die Sehimpulse weitergeben, senkrecht zur Augenachse stehen. Die Wahrheit des Sehens, festgelegt durch dieses strukturelle Gegenüberstellen von Nervenverbindungen und Sehstrahl, dient bereits, so könnte man sagen, als Basis für den Zugang des Sehens zur Wahrheit, der hier als einer der Erkenntnis dargestellt wurde. Noch einmal: Es gibt eine achsiale Kreuzung, die weniger von einem Objekt im Raum bestimmt wird, als von einem Subjekt, welches, unter der Annahme eines Blickpunktes, den Wechsel von Syntagmatik zu Paradigmatik vollzieht, vom räumlichen Objekt zu einer wundersamen Reliquie, von der Figur zum Zeichen.

Für Marin besteht das Geniale der Fresken von Arezzo darin, daß Piero alle diese Achsen miteinander in Beziehung setzt, all diese Kreuzungen – Gegenwart und Vergangenheit; Sequenz und Symbol; das Objekt im Raum und die Position des Betrachters zu ihm – all diese rechten Winkel, die sich selbst wiederum schneiden. Weil jeder rechte Winkel gleichzeitig ein Objekt ist, auf welches eingewirkt wird, und ein Subjekt oder struktureller Betreiber, der diese Wirkungen durchsetzt.

5. Die Achse der Geschichte (,welche die Vergangenheit bestimmt,) wird gekreuzt von der Achse des Glaubens (,die in der Gegenwart angesiedelt ist); die Achse des Objekts schneidet sich mit der des Subjekts. Auf Grund der Natur des Kunstwerks (drei Dimensionen auf zwei zusammengefallen; oder wie im Fall der Skulptur, sowohl ein eigenes Ding, als auch, durch eine Art von Mimikry, der Beurteilung durch den Betrachter übergeben) überlagern sich diese zwei Achsen oder Pole häufig. Sie sind aber nicht dasselbe.

Das Werk "Five Boxes with Stripes in Four Directions" (1972) macht diesen Unterschied deutlich. Auf die Oberflächen von fünf stämmigen Pris-

men – den absoluten Verkörperungen des "Objektiven" – malt LeWitt das grelle Schwarz-Weiß paralleler Linien, einige vertikal, einige horizontal, einige schräg; einige Seiten nur in einer linearen Richtung, andere sind zwei- oder dreifach gegabelt in entgegengesetzte Zonen. Der optische Knall dieser Streifenbildung, der Moiréeffekt, den es auslöst, seine merkwürdige Nachahmung modellierten Lichts und Schattens, all das bewirkt, daß die im Bereich des Betrachters auftretende Netzhautstörung auf den Bereich des Betrachteten projeziert wird. Subjekt zusammengefallen auf das Objekt: Die Überlagerung hier eingesetzt mit dem reinsten Vokabular der linearen Kompositionen, die LeWitt 1969 in seiner Illustration für Samuel Becketts kurzes Schauspiel "Come and Go" verwandt hatte. Es war ebenso das Vokabular, welches er gerade in dem keimenden Projekt der Wandzeichnungen auszuloten begonnen hatte.

Als sie anfangs nur aus sehr feinen schwarzen und weißen Linien bestanden – nur der härteste Bleistift wurde eingesetzt – schienen die Wandzeichnungen das Körperlose zu verkörpern, was heißen soll, den Raum der Ideenbildung, des Diagramms, der Analysis, des logischen Denkens. Selbst dann noch, als Farbkreiden eingesetzt wurden, schien die Blassheit der präzisen Linien ihre Zugehörigkeit zu einer Welt zu erklären, welcher der Köper des Betrachters nicht angehörte. Gegen Ende der siebziger Jahre aber, als die Linien dicker und die Wände selbst größer wurden, deren physische Gegenwart betont wurde, indem sie mit den Primärfarben rot, gelb und blau bemalt waren, wurde klar, daß die Zeichnungen in einem deiktischen Verhältnis konzipiert waren zu dem, was Strukturalisten die Bedingungen des Diskurses nennen würden – "Du", "hier", "jetzt".

So haben sich die Enden des Kreislaufs, welcher in den Skizzen von 1958 nach Piero begann und sich nun in riesigen Wandzeichnungen ausarbeitet, zusammengeschlossen in einer Serie von Werken, die manchmal toskanisch genannt werden und die, obwohl sie in farbigen Tintenlasuren auf Kreidegrund ausgeführt sind, das Aussehen von Fresken angenommen haben.

In diesem Werk bleibt LeWitt dem objektiven Pol, den er allezeit geehrt hat, treu: Er weigert sich, die Zentralperspektive anzuwenden und projeziert alle Linien entlang der Parallelen der axonometrischen Projektion; er weigert sich, irgendeine andere Farbe außer Schwarz, Weiß (und daher Grau), Rot, Gelb und Blau zu benutzen. Der subjektive Pol aber ist deutlich markiert in genau diesen Zweideutigkeiten, die der axonometrischen Perspektive inhärent sind – da keine Einwölbung hindert, in Auswölbungen umzuspringen. Das wird ebenso deutlich in den sinnlichen Qualitäten der Farbfilme, welche Lagen von einfachen Primärfarben in die reichsten Verläufe italianisierter Farbtöne verwandelt.[20]

Vor allem aber wird das deutlich in der Größe der Werke, wobei die projezierte Form oft größer ist als jede Wand, die sie tragen könnte und deshalb den Eindruck erweckt, sie würde außerhalb der Sichtweite des Betrachters "vollendet". Die Absicht dieses Gigantismus ist es, die Wahrnehmung der Formen hinter den Punkt zu verschieben, an dem sie noch synthetisch verstanden – sozusagen geistig überblickt – werden können und stattdessen eine physische Auseinandersetzung mit ihnen zu erzwingen. Die Deiktik des Verweisens der Perspektive auf den verkörperlichten Betrachter ist ersetzt durch das Gefühl, daß der Körper irgendjemands durch die schiere Größe der Wand anerkannt werde. Und die Axonometrie der Zeichnung, die weit davon entfernt ist, sich

als idealer oder allgegenwärtiger Blickpunkt zu erhalten – der Blickpunkt aus dem "nirgendwo" – scheint dieses Gefühl der physischen Präsenz des Betrachters in das Feld der Formen abzuwenden.

Die Porösität zwischen LeWitts zwei- und dreidimensionalem Werk, seinen Skulpturen (oder Strukturen) und seinen Wandzeichnungen, ist von Anfang an vorhanden gewesen, angekündigt vielleicht durch die Tatsache, daß seine frühesten Strukturen Flachreliefs waren, für ihr sehr ästhetisches Leben an die Wand gebunden. Die Complex Forms, die er seit den späten Achtzigern herstellt, erwachsen aus den eigenartigen Formen, die daraus resultieren, sogar die einfachsten pyramidalen Prismen mit den Mitteln axonometrischer Perspektive zu projezieren, wie er es in einer Reihe von Wandzeichnungen getan hat, zum Beispiel für die Galerie Pieroni in Rom im Jahre 1985, oder "Continuous Forms with Colour Ink Washes Superimposed" im Cleveland Museum of Art im Jahre 1987.

6. Als Elizabeth Broun an den Organisator der Ausstellung "Muybridge and Contemporary Photography" schrieb, mit der Rechtfertigung ihrer Entscheidung, LeWitts Werk zu zensieren, sagte sie: "Ich kann nicht guten Gewissens diese Erfahrung unseren Besuchern als eine bedeutungsvolle und wichtige anbieten. Die vergangenen beiden Jahrzehnte feministischer Literatur haben das öffentliche Bewußtsein für die unterschiedlichen Arten des Sehens geschärft – für Betrachter und Betrachtetes –, was nicht voraussehbar war, als LeWitt das Werk vor so langer Zeit schuf."[21]

Die Verkörperlichung des Betrachters ist nicht einfach das Werk feministischer Bewußtseinserweiterung. Das geschieht in jeder Art theoretischer Arbeit schon seit geraumer Zeit, in der Lokalisierung des Lesers im Text zum Beispiel oder in der Artikulation von Gewalt am Fuße des Schreibens. In der bildenden Kunst war die Unterdrückung des Körpers des Betrachters das Werk einer modernistischen Ästhetik, die den Körper aufgelöst hatte im Dienste der "Perspektive" oder "Sehkraft als solcher". Die Rückkehr des Körpers war, zumindest in den Staaten, das Verdienst der minimalistischen Generation, zu welcher LeWitt gehört. Seine Theoretisierung ging jedoch in der kunstkritischen Literatur, die dazu tendiert, die geometrisierte Version des Minimalismus vollkommen ernst zu nehmen, weniger sicher vonstatten. Was immer man sonst noch von Ms. Broun als Kritikerin halten mag, so hat sie doch wenigstens die Achse lokalisiert, ohne die LeWitts Werk nicht funktionieren würde, und die tatsächlich die von Betrachter und Betrachtetem ist. Oder vielmehr, sie ist die strukturelle Verbindung zwischen den beiden.

Insoweit das Raster ihr "Konzept" ist, das Konzept in dem all ihre "Ideen" verarbeitet werden, ist das Konzept von LeWitts Kunst das einer verwandelnden Matrix, in welcher die Koordinaten, die ein Objekt erzeugen, auf welches eingewirkt wird, gleichzeitig ein Subjekt oder einen strukturellen Betreiber konstruieren, der diese Wirkungen durchsetzt.

ANMERKUNGEN

1. Sol LeWitt, 'Paragraphs on Conceptual Art', *Artforum*, Sommer 1967. Josephs Kosuths Behauptung ist aufgestellt in seiner 'History for . . .', *Flash Art*, November 1988, S.100.

2. Robert Rosenblum, *Sol LeWitt*, Museum of Modern Art New York, 1978, S.18.

3. Donald Kuspit, 'Sol LeWitt', *Arts*, April 1978, S.118.

4. Donald Kuspit, 'Sol LeWitt: The Look of Thought', *Art in America*, September 1975, S.44.

5. Ingrid Mössinger, *Sol LeWitt, Complex Forms, 1990, Wall Drawings*, Frankfurt am Main, 1990, o.S.

6. Lucy Lippard, *Sol LeWitt*, Museum of Modern Art New York, 1978, S.27.

7. Alle diese Bezeichnungen erscheinen in Kuspit, 'Sol LeWitt: The Look of Thought'.

8. Die Ausstellung, 1991 von Jock Reynold, dem Direktor der Addison Gallery of American Art und der Phillips Academy in Andover, Massachusetts, organisiert, sollte in das Museum of American Art in Washington D.C. weiterreisen, als Elizabeth Broun erklärte, LeWitts Werk schliesse ein, 'durch aufeinanderfolgende Gucklöcher hindurchzulinsen und dabei mehr und mehr auf die Schamregion zu zielen [und dabei] eindeutige Beziehungen zu einem demütigenden pornographischen Erlebnis [herzustellen].' Ihre Drohung, es aus der Ausstellung zu entfernen, führte zu einer Gegendrohung der übrigen Künstler der Ausstellung, daß sie ihre Arbeiten widerrufen würden. Ms. Broun ging einen Kompromiß ein, indem sie den LeWitt in der Ausstellung beließ, ihn aber mit einem Dickicht von warnenden und ermahnenden Schildern umgab.

9. *Sol LeWitt*, Museum of Modern Art New York, S.77.

10. Hollis Frampton, 'Edweard Muybridge: Fragments of a Tesseract', *Artforum*, März 1973, S.52.

11. Sol LeWitt, 'Sentences on Conceptual Art', in Lucy Lippard, *Six Years: The Dematerialisation of the Art Object*, New York, Praeger, 1973, S.75.

12. Robert Smithson, 'A Museum of Language in the Vicinity of Art', *Art International*, März 1968, S.21.

13. Lucy Lippard, *Sol LeWitt*, Museum of Modern Art New York, 1978, S.24.

14. Rosalind Krauss, 'LeWitt in Progress', *Oktober* Nr.2, Herbst 1978; Wiederabdruck in *The Originality of the Avant-Garde and other Modernist Myths* (Cambridge: MIT Press, 1985).

15. Mössinger, *ebd.*

16. Siehe *Sol LeWitt, Spoleto USA*, Charleston: Gibbs Museum of Art, 1989, S.10.

17. H.W. Jansen, *The History of Art*, New York, Abrams, 1963, S.328.

18. Louis Marin, 'La Théorie narrative et Piero peintre d'histoire' in *Piero: Teoretico dell'arte*, Hrsg. Omar Calabrese, Rom 1985, S.55–84. Die strukturalistische Unterscheidung zwischen Diskurs und Erzählung (oder historischem Schreiben) wird gemacht in Emile Benviste, *Problems in General Linguistics*, Miami 1971, S.205–222.

19. Siehe Louis Marin, 'Toward a Theory of Reading in the Visual Arts – Poussins *The Arcadian Shepherds*' in *The Reader in the Text*, Hrsg. Susan R. Suleiman, Princeton 1980.

20. Die Farben werden direkt an der Wand gemischt in einer Folge von Lagen, wie sie LeWitt angegeben hat. Daher erzeugt BBR (Blau Blau Rot) einen anderen Ton von Blau als BGB (Blau Grau Blau). Oder das Grün, welches von BBY (Blau Blau Gelb) erzeugt wird, wird sich von dem eines GYG (Grau Gelb Grau) unterscheiden.

21. Zitiert nach Michael Kimmelmann, 'Peering into Peepholes and Finding Politics', *The New York Times*, 21. Juli 1991.

CATALOGUE OF WORKS IN THE EXHIBITION

1. *WALL STRUCTURE*
 1962
 oil on canvas and painted wood
 29 × 16 × 6 in (73.5 × 40.6 × 15.2 cm)
 The LeWitt Collection, courtesy of the Wadsworth
 Athenaeum, Hartford, Connecticut
 (illustration no. 5)

2. *WALL STRUCTURE*
 1962
 oil on canvas and painted wood
 24 × 24 × 6 in (61 × 61 × 15.2 cm)
 The LeWitt Collection, courtesy of the Wadsworth
 Athenaeum, Hartford, Connecticut
 (illustration no. 7)

3. *WALL STRUCTURE*
 1963
 oil on canvas and painted wood
 62 × 62 × 25 in (73.7 × 40.6 × 15.2 cm)
 Collection Sondra and Charles Gilman Jr.
 (illustration no. 13)

4. *EARLY WOOD STRUCTURE*
 1964
 painted wood
 $8 \times 7\frac{1}{4} \times 7\frac{1}{4}$ in (20.6 × 18.4 × 18.4 cm)
 LeWitt Collection, Chester, Connecticut
 (illustration no. 12)

5. *MUYBRIDGE II (SCHEMATIC REPRESENTATION)*
 1964
 painted wood with ten compartments, each containing
 photographs by Barbara Brown, Los Angeles, and flashing
 lights.
 $9\frac{1}{2} \times 10\frac{1}{2} \times 96$ in (24.2 × 26.7 × 243.9 cm)
 The LeWitt Collection, courtesy of the Wadsworth
 Athenaeum, Hartford, Connecticut
 (illustration no. 18)

6. *STANDING OPEN STRUCTURE, BLACK*
 1964
 painted wood
 $96 \times 5\frac{1}{2} \times 25\frac{3}{4}$ in (243.8 × 64.7 × 65.4 cm)
 The LeWitt Collection, courtesy of the Wadsworth
 Athenaeum, Hartford, Connecticut
 (illustration no. 35)

7. *FLOOR STRUCTURE, BLACK*
 1965
 painted wood
 20 × 20 × 72 in (50.8 × 50.8 × 182.8 cm)
 National Gallery, Washington, Vogel Collection
 (illustration no. 34)

8. *SERIAL PROJECT NO. 1, SET C*
 1967
 baked enamel on steel
 9 × 33 × 33 in (22.8 × 83.8 × 83.8 cm)
 Private Collection, Paris, courtesy Daniel Varenne
 Gallery, Geneva
 (illustration no. 56)

9. *THREE PART VARIATIONS ON THREE DIFFERENT
 KINDS OF CUBES*
 1967
 steel and enamel
 48 × 98.4 × 15.7 in (123 × 250 × 40 cm)
 Private collection
 (illustration no. 64)

10. *FIVE MODULAR STRUCTURES (SEQUENTIAL
 PERMUTATIONS ON THE NUMBER FIVE)*
 1972
 white painted wood
 5 pieces, each 58 × 38.5 × 58 in (62 × 98 × 62 cm)
 Scottish National Gallery of Modern Art, Edinburgh
 (illustration no. 86)

11. *ALL VARIATIONS OF INCOMPLETE OPEN CUBES*
 1974
 installation including 122 painted wood sculptures
 on a painted wood base and 122 framed photographs
 and drawings on paper
 each sculpture: 8 × 8 × 8 in (20 × 20 × 20 cm)
 base: 12 × 120 × 126 in (30.5 × 304.8 × 320 cm)
 each frame: 14 × 26 in (35.5 × 66 cm)
 Jeffrey Deitch, New York
 (illustration no. 87)

12. *5 OPEN GEOMETRIC FIGURES IN A ROW*
 1978
 white painted wood
 12 × 96 × 12 in (30.4 × 243.8 × 30.4 cm)
 courtesy Lisson Gallery, London

14. *MAQUETTE FOR OUTDOOR PIECE, LAS
 CRUCES, NEW MEXICO (FIRST PROPOSAL)*
 1980
 painted wood maquette
 13 × 21 × 11 in (33.3 × 53.3 × 27.9 cm) with base
 LeWitt Collection, Chester, Connecticut
 (piece in situ: illustration nos. 131, 132)

15. *MAQUETTE FOR MEMORIAL TO THE MISSING JEWS*
1987
painted wood
9.5 × 28¼ × 12 in (24 × 71 × 30 cm)
Large version included in Skulptur Projekte,
Munster, Germany. Now in the collection of the City of
Hamburg, Germany.
LeWitt Collection, Chester, Connecticut (Large version in
situ: illustration no. 153)

16. *COMPLEX FORM #8*
1988
white painted wood
120 × 72 × 272 in (304 × 182.8 × 690.8 cm)
LeWitt Collection, Chester Connecticut
on loan to the Westfälisches Landesmuseum für Kunstund
Kulturgeschichte, Münster
(illustration no. 129)

17. *PROPOSAL FOR PIECE NOT BUILT (WORKING TITLE)*
c. 1988
grey painted wood maquette
34¾ × 15¼ × 15.25 in (88.2 × 39.3 × 39.3 cm)
with base. (Actual size: 360 × 144 × 144 ins)
LeWitt Collection, Chester, Connecticut

18. *MAQUETTE FOR CINDERBLOCK PYRAMID*
1989
cemented painted cinderblock
19½ × 20 × 20 in (50 × 51 × 51 cm)
courtesy Lisson Gallery, London

19. *HORIZONTAL SERIAL PIECE (OPEN GEOMETRIC STRUCTURE) #III*
1990
white painted wood
38½ × 38½ × 171½ in (97.7 × 97.7 × 435.6 cm)
courtesy Lisson Gallery, London
(illustration no. 83)

20. *HORIZONTAL SERIAL PIECE (OPEN GEOMETRIC STRUCTURE) #V*
1990
white painted wood
38½ × 38½ × 171½ in (97.7 × 97.7 × 435.6 cm)
courtesy Lisson Gallery, London
(illustration no. 82)

21. *MAQUETTE FOR CINDERBLOCK PIECE*
1991
painted wood
each 33½ × 12 × 11½ in (85 × 30.5 = × 29 cm)
LeWitt Collection, Chester, Connecticut

22. *MAQUETTE FOR CINDERBLOCK PIECE*
1991
painted wood
each 33½ × 12 × 11½ in (85 × 30.5 × 29 cm)
LeWitt Collection, Chester, Connecticut

23. *MAQUETTE FOR CINDERBLOCK PIECE*
1991
painted wood
27¾ × 11 × 11 in (70.5 × 28.5 × 28.5 cm)
LeWitt Collection, Chester, Connecticut

24. *MAQUETTE FOR CINDERBLOCK PIECE*
1991
painted wood
40 × 20 × 20 in (101.5 × 51 × 51 cm)
LeWitt Collection, Chester, Connecticut

25. *BLOCK (MAQUETTE FOR PIECE IN THE SCULPTURE GARDEN OF THE ISRAEL MUSEUM, JERUSALEM)*
1991
painted wood maquette
21 × 20 × 20 in (53.3 × 50.8 × 50.8 cm) with base
(actual size: 160 × 128 × 128 in)
LeWitt Collection, Chester, Connecticut
(Large version in situ: illustration no. 143)

26. *FOUR-SIDED PYRAMID*
1991
painted aluminium
72 × 60 × 51 in (183 × 152.5 × 130 cm)
courtesy Lisson Gallery, London
(illustration no. 103)

27. *FIVE-SIDED PYRAMID*
1991
painted aluminium
72 × 60 × 51 in (183 × 152.5 × 130 cm)
courtesy Lisson Gallery, London

28. *EIGHT-SIDED PYRAMID*
1992
painted aluminium
76 × 74 × 74 in (193 × 187 × 187 cm)
courtesy Lisson Gallery, London
(illustration no. 104)

29. *1 2 3 4 5 4 3 2 1*
1992
painted wood maquette
72 × 12 × 12 in (184 × 30.5 × 30.5 cm)
LeWitt Collection, Chester, Connecticut

SOL LEWITT STRUCTURES 1962 – 1993

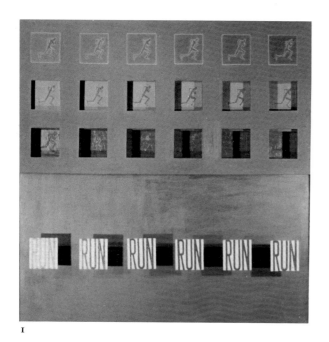

1

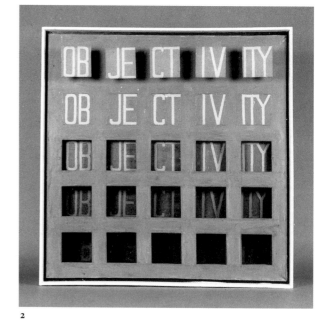

2

3

4

1. *RUN I – IV* 1962
 Oil on canvas and painted wood (red,
 yellow, blue)
 $63\frac{1}{2} \times 63\frac{1}{2} \times 3\frac{1}{2}$ in
 ($161.3 \times 161.3 \times 8.9$ cm)

2. *OBJECTIVITY* 1962
 Painted wood (red, dark yellow, blue)
 $48 \times 48 \times 9$ in ($122 \times 122 \times 22.9$ cm)

3. *LOOK, LOOK* 1962
 Painted wood (red, yellow, blue)
 $17 \times 19\frac{1}{2} \times 8$ in
 ($43.2 \times 49.6 \times 20.4$ cm)

4. *WALL STRUCTURE, BLUE* 1962
 Oil on canvas and painted wood
 $62\frac{1}{4} \times 62\frac{1}{4} \times 9\frac{3}{4}$ in
 ($158.1 \times 158.1 \times 24.8$ cm)

5. *WALL STRUCTURE* 1962
 Oil on canvas and painted wood
 $21 \times 21 \times 6$ in ($53.3 \times 53.3 \times 15.2$ cm)

6. *DOUBLE WALL PIECE* 1962
 Oil on canvas and painted wood
 two parts: each $50 \times 24 \times 10$ in
 ($127 \times 61 \times 25.4$ cm)

7. *WALL STRUCTURE* 1962
 Oil on canvas and painted wood
 $50 \times 18 \times 10$ in ($127 \times 45.8 \times 25.4$ cm)

8. *FLOOR STRUCTURE* 1962
 Oil on canvas and painted wood
 (silver, black)
 $74 \times 17\frac{1}{2} \times 17\frac{1}{2}$ in
 ($188 \times 44.4 \times 44.4$ cm)

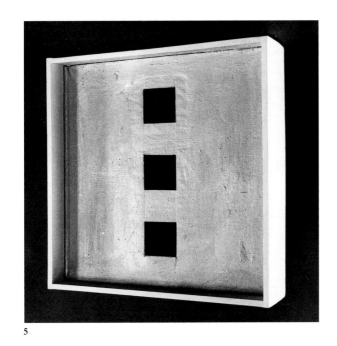

5

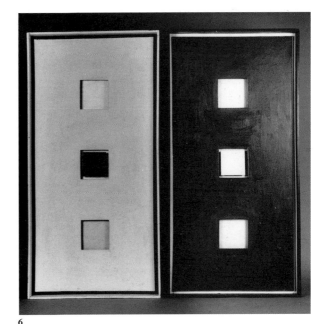

6

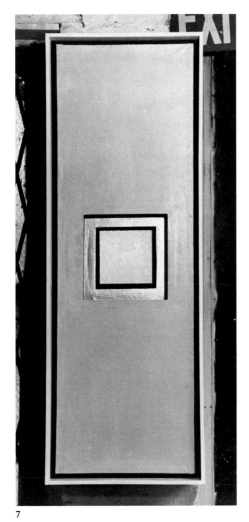

7

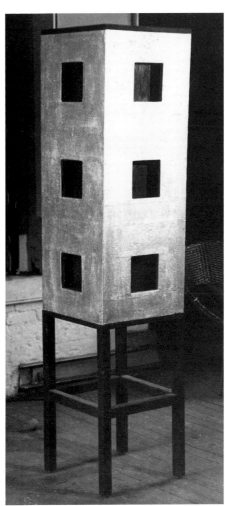

8

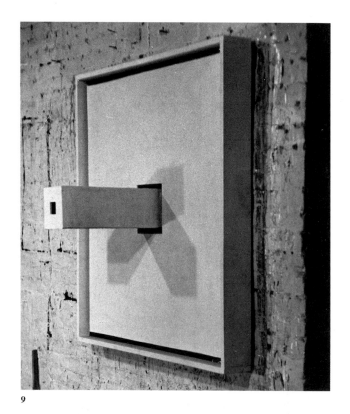

9

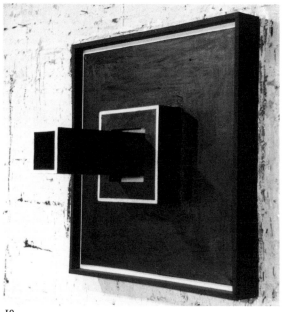

10

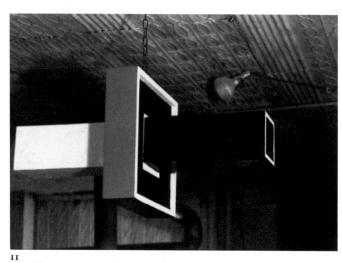

11

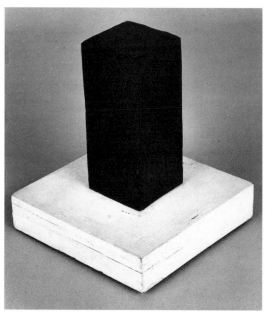

12

9. *WALL STRUCTURE, WHITE* 1962
 Oil on canvas and painted wood
 45 × 44½ × 19½ in
 (114.3 × 113 × 49.5 cm)

10. *WALL STRUCTURE, BLACK* 1962
 Oil on canvas and painted wood
 39 × 39 × 23½ in (99.1 × 99.1 × 59.7 cm)

11. *HANGING STRUCTURE* 1962
 Oil on canvas and painted wood
 17½ × 17½ × 37 in
 (44.4 × 44.4 × 94 cm)

12. *EARLY WOOD STRUCTURE* 1964
 Oil on wood
 8 × 7¼ × 7¼ in (20.6 × 18.4 × 18.4 cm)
 (Cat.no.4)

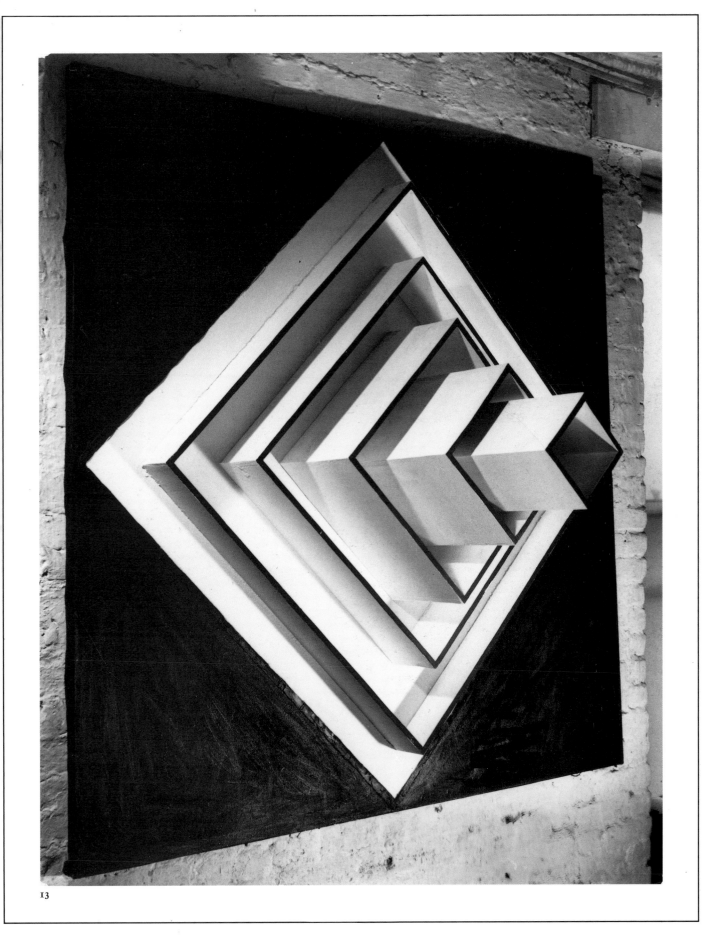

13

13. *WALL STRUCTURE* 1963 62 × 62 × 25 in (157.5 × 157.5 × 63.5 cm)
 Oil on canvas and painted wood (Cat.no.13)

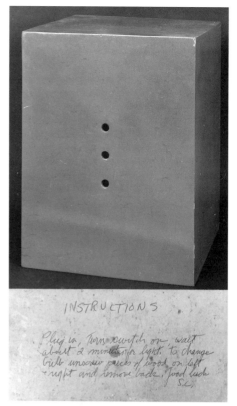

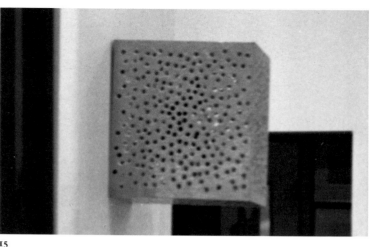

15

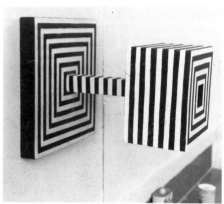

INSTRUCTIONS

Plug in, turn switch on wait about 2 minutes for light. To change bulb unscrew pieces of wood on left + right and remove back. Good luck S.L.

14

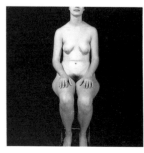

16

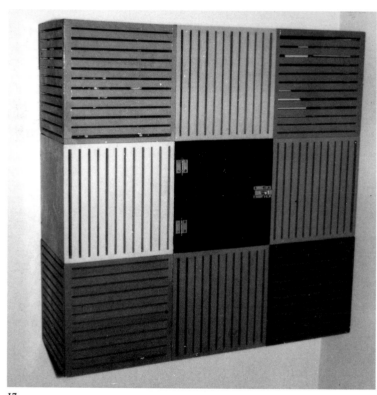

17

18

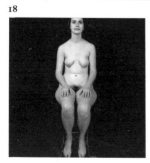

14. *LIGHT CUBE* 1961–62
Painted wood (red) with photograph and light bulb
$15\frac{1}{2} \times 12 \times 12$ in (39 × 30 × 30 cm)

15. *CUBE WITH RANDOM HOLES CONTAINING AN OBJECT (SCULPTURE BY GRACE WAPNER)* 1964
Painted wood (red)
$12 \times 12 \times 12$ in (30.5 × 30.5 × 30.5 cm)

16. *WALL STRUCTURE (WITH STRIPES)* c.1963
Painted wood
$13\frac{1}{2} \times 13\frac{1}{2} \times 16\frac{1}{2}$ in (34.2 × 34.2 × 41.9 cm)

17. *WALL STRUCTURE IN NINE PARTS, EACH CONTAINING A WORK OF ART BY OTHER ARTISTS* 1963
Painted wood
$36 \times 36 \times 12$ in (91.4 × 91.4 × 30.5 cm)

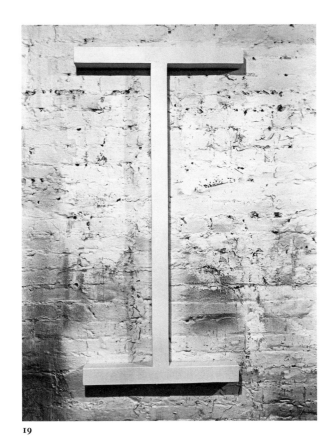

19

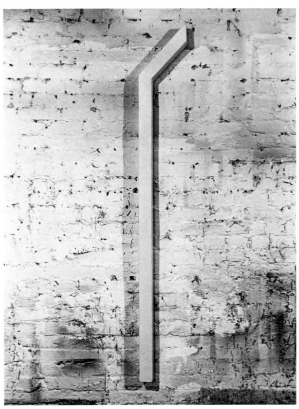

20

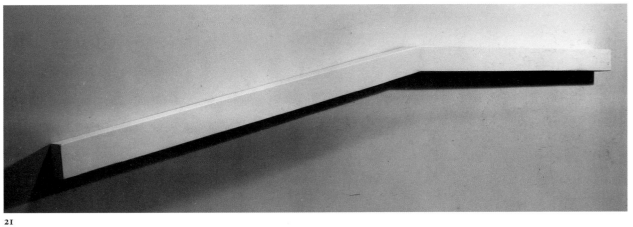

21

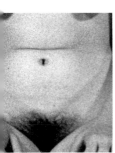

18. *MUYBRIDGE II (SCHEMATIC
REPRESENTATION)* 1964
Painted wood with ten compartments, each
containing photographs by Barbara Brown, Los
Angeles, and flashing lights $9\frac{1}{2} \times 10\frac{1}{2} \times 96$ in
($24.2 \times 26.7 \times 243.9$ cm) (Cat.no.5)

19. *WALL PIECE I* 1965
Painted wood
$40 \times 18 \times 2$ in
($101.6 \times 45.7 \times 5.1$ cm)

20. *WALL PIECE* 1964
Painted wood
$66 \times 12 \times 2$ in
($167 \times 30.5 \times 5.1$ cm)

21. *WALL PIECE* 1965
Painted wood
$2 \times 2 \times 72$ in
($5.1 \times 5.1 \times 182.9$ cm)

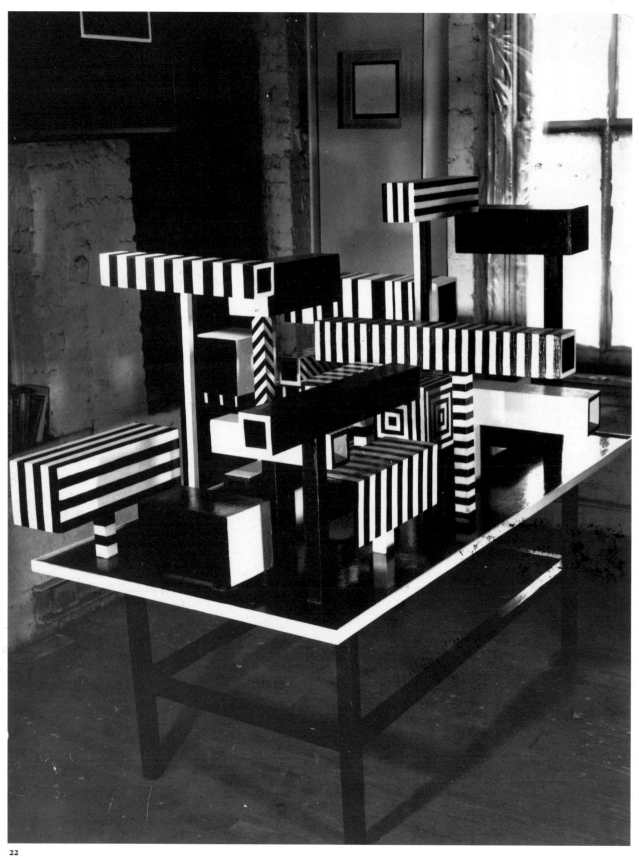

22

22. *TABLE STRUCTURE (WITH
 STRIPES)* 1963 Painted wood
72 × 30 × 20 in (182.9 × 76.2 × 50.8 cm)

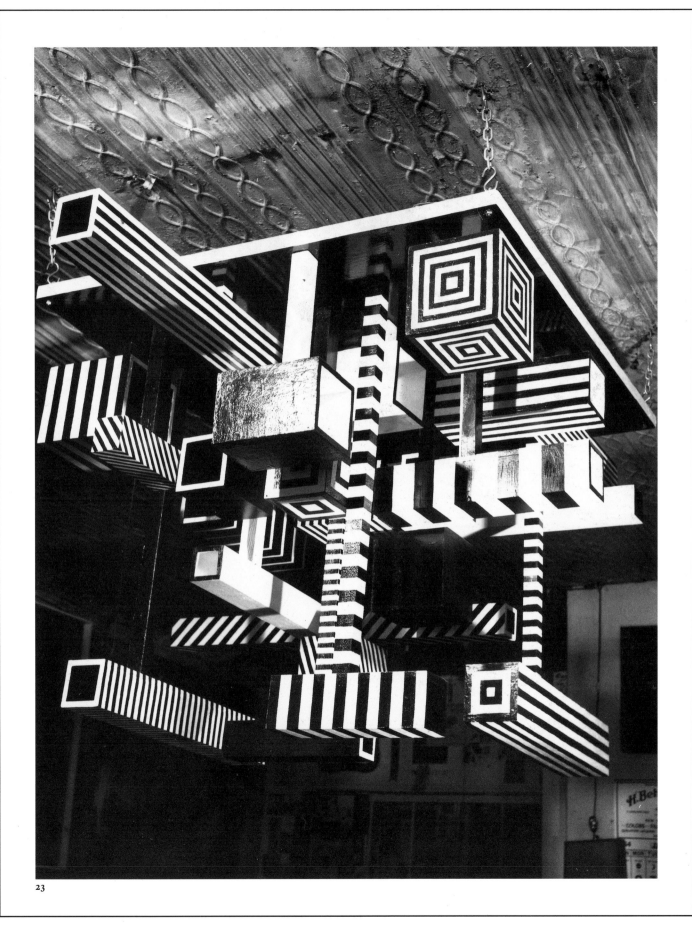

23

23. *HANGING STRUCTURE (WITH
STRIPES)* 1963 Painted wood
55 × 55 × 30 in (139.7 × 139.7 × 56.2 cm)

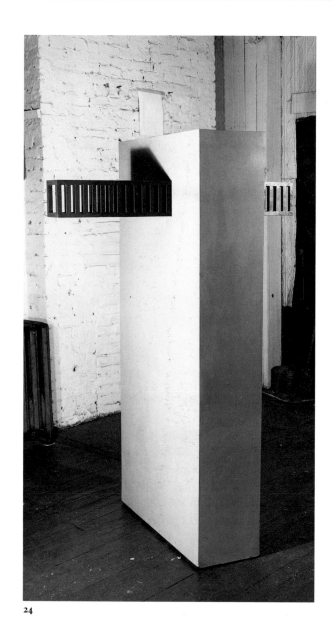

24

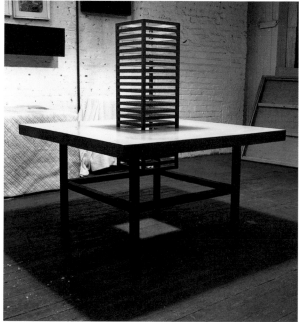

25

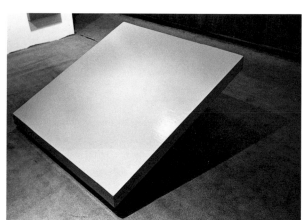

26

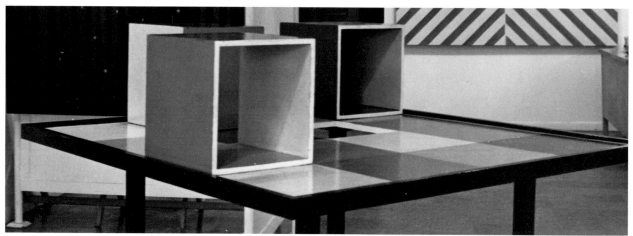

27

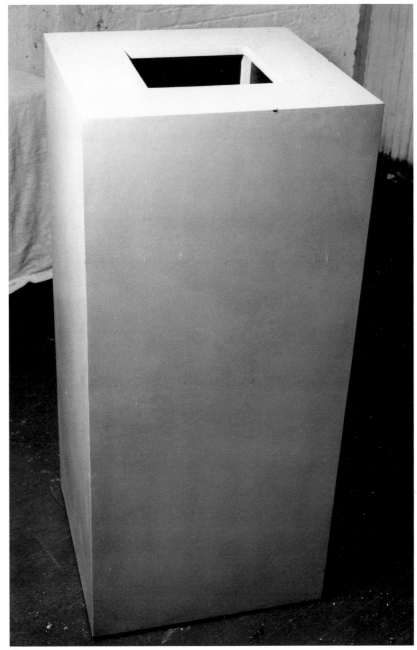

28

24. *FLOOR STRUCTURE* 1963
Painted wood (orange with blue)
(also steel version, white)
72 × 48 × 30 in (182.9 × 122 × 76.2 cm)

25. *TABLE STRUCTURE* 1963
Painted wood
48 × 48 × 55 in (122 × 122 × 139.7 cm)

26. *FLOOR STRUCTURE (SLANTED PIECE)* 1963
Painted wood (yellow)
48 × 48 × 2 in (122 × 122 × 5.1 cm)

27. *TABLE WITH THREE CUBES: ONE WITH ONE SIDE REMOVED; ONE WITH TWO SIDES REMOVED; ONE WITH NO SIDES REMOVED* 1963
Painted wood
Table: 28 × 40 × 40 in
(71.1 × 101.6 × 101.6 cm)
Cubes: 12 × 12 × 12 in
(30.5 × 30.5 × 30.5 cm)

28. *FLOOR STRUCTURE* 1963
Painted wood (yellow)
55 × 28 × 28 in (139.7 × 71.1 × 71.1 cm)

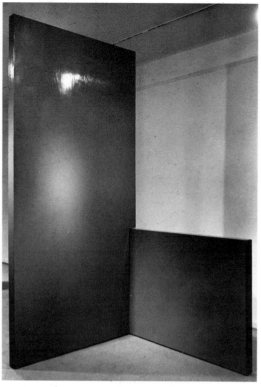

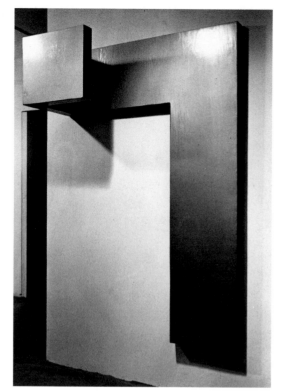

29

30

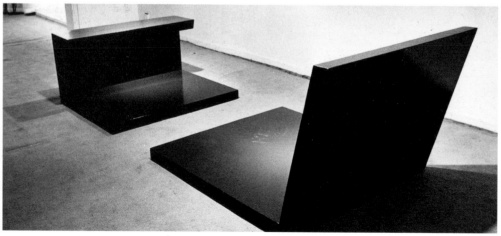

31

29. *FLOOR STRUCTURE* 1965
 Painted wood (orange vertical; blue
 horizontal)
 96 × 96 × 48 in (243.9 × 243.9 × 122 cm)

30. *WALL STRUCTURE* 1965
 Painted wood (silver) (also steel version)
 72 × 48 × 12 in (182.9 × 122 × 30.5 cm)

31. *DOUBLE FLOOR
 STRUCTURE* 1964
 Painted wood (green)
 30 × 48 × 144 in (76.2 × 122 × 365.8 cm)

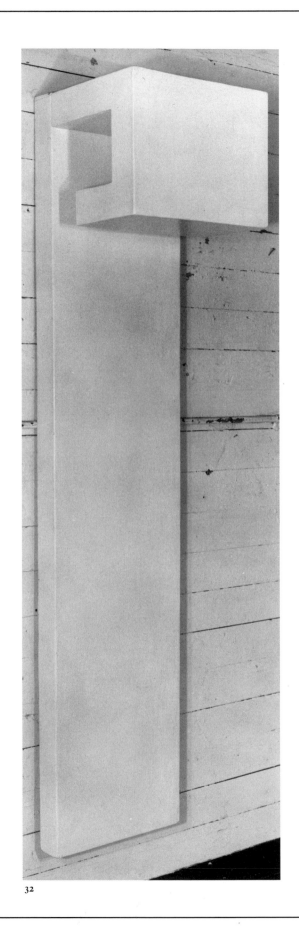

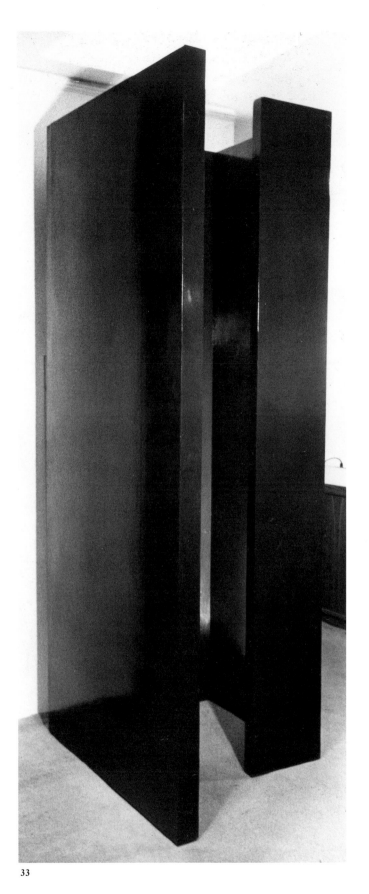

32

33

32. *WALL STRUCTURE* 1965
Painted wood (also steel version)
72 × 16 × 12 in (182.9 × 40.6 × 30.5 cm)

33. *FLOOR/WALL STRUCTURE* 1964
Painted wood (dark brown)
96 × 32 × 42 in (243.9 × 81.3 × 106.7 cm)

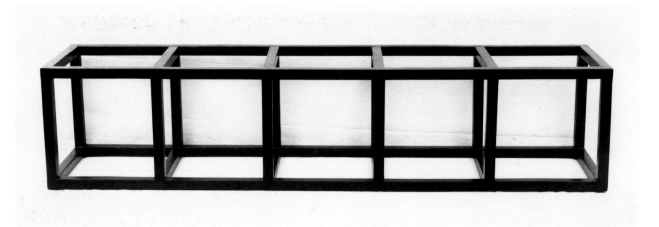

34

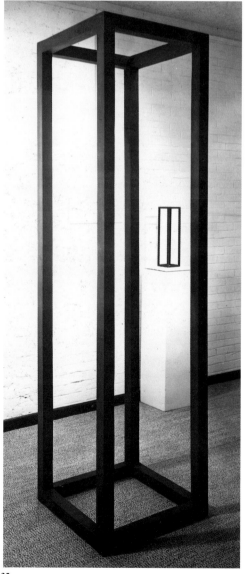

35

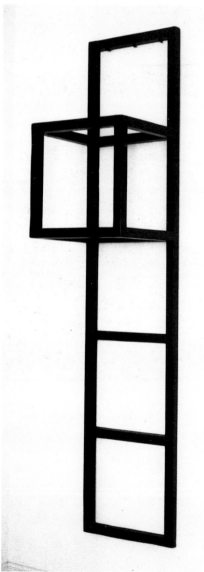

36

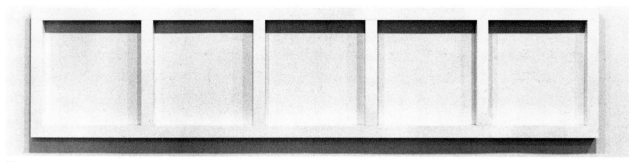

37

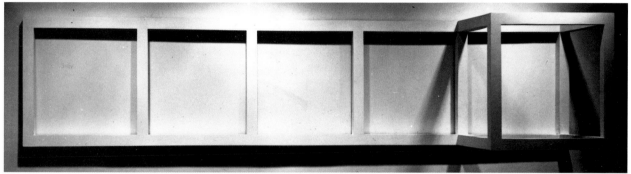

38

39

40

34. *FLOOR STRUCTURE,*
BLACK 1965
Painted wood 20 × 20 × 72 in
(55.8 × 55.8 × 182.9 cm)
(Cat.no.34)

35. *STANDING OPEN STRUCTURE,*
BLACK 1964
Painted wood (also steel version)
96 × 25½ × 25¾ in
(243.9 × 64.8 × 65.4 cm)
(Cat.no.35)

36. *WALL STRUCTURE: FIVE*
MODULES WITH ONE CUBE,
BLACK 1965
Painted wood
72 × 12 × 12 in (182.9 × 30.5 × 30.5 cm)

37. *WALL STRUCTURE* 1969
Painted wood (also steel version)
16¾ × 76½ × 1½ in
(42½ × 194 × 4 cm)

38. *MODULAR WALL PIECE WITH*
CUBE 1965
Painted wood (also steel version)
18 × 84 × 18 in (45.8 × 213.4 × 45.8 cm)

39. *WALL/FLOOR PIECE (THREE*
SQUARES) 1966
Painted steel (also wood version)
Each square: 48 × 48 in
(121.9 × 121.9 cm)
Another steel version, each square:
40 in × 40 in (101.6 × 101.6 cm).

40. *FLOOR STRUCTURE* 1965
Painted wood (black)
48 × 84 × 84 in
(122 × 213.4 × 213.4 cm)
(Also: 10 × 14¾ × 14¾ in
(25.5 × 37.5 × 37.5 cm)

Also: 8 × 14½ × 14½ in
(22.5 × 36.5 × 36.6cm)

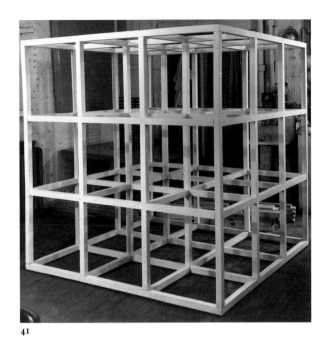

41

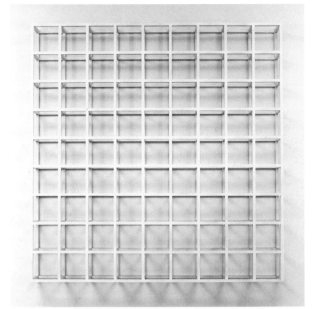

42

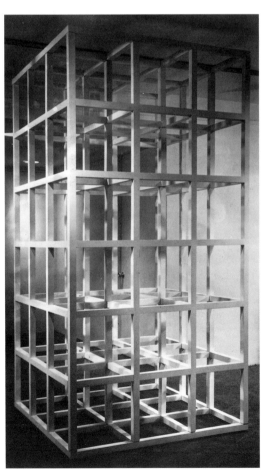

43

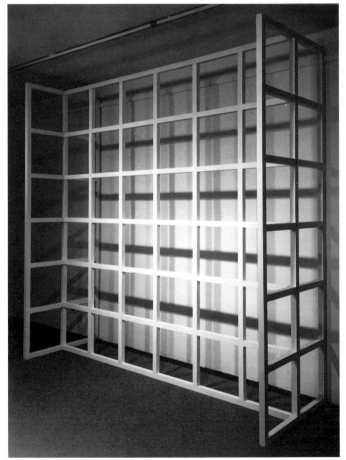

44

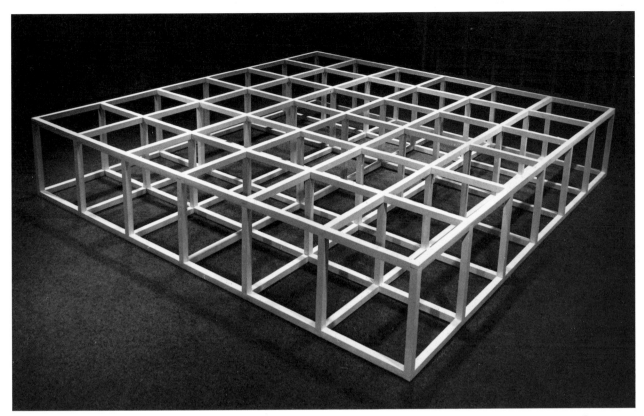

45

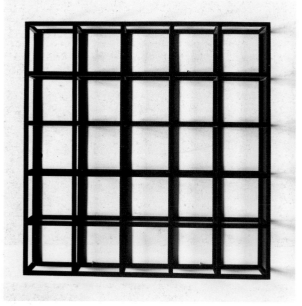

46

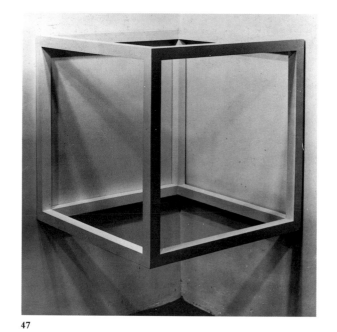

47

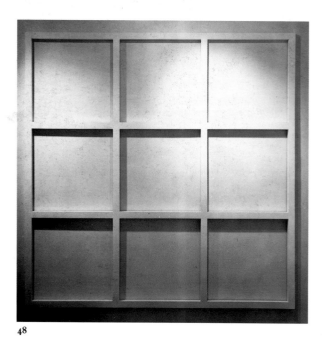

48

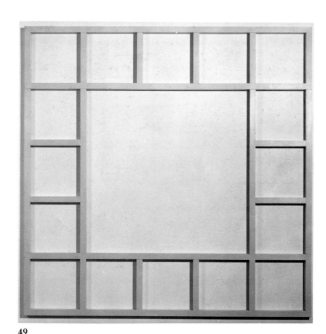

49

46. *WALL STRUCTURE, BLACK* 1966
Painted wood
(also steel version)
$43\frac{1}{2} \times 43\frac{1}{2} \times 9\frac{1}{2}$ in
($110.3 \times 110.3 \times 24$ cm)

47. *OPEN CUBE/CORNER PIECE* 1965
Baked enamel on steel
$48 \times 48 \times 48$ in
($121.9 \times 121.9 \times 121.9$ cm)

48. *WALL GRID (3 × 3)* 1966
Painted wood (also steel version)
$71 \times 71 \times 7$ in
($180.3 \times 180.3 \times 17.8$ cm)

49. *WALL STRUCTURE* 1972
Painted steel
$76 \times 76 \times 1\frac{1}{2}$ in
($193 \times 193 \times 3.8$ cm)

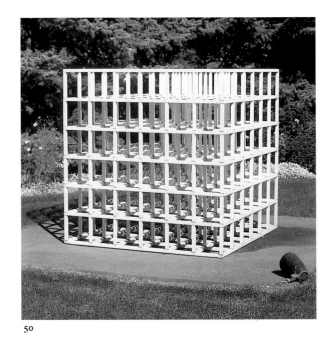

50

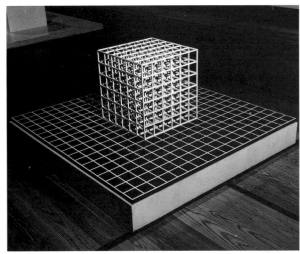

51

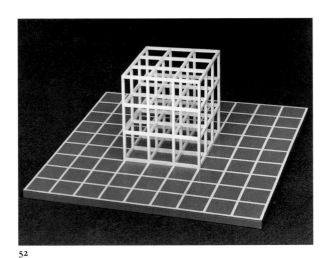

52

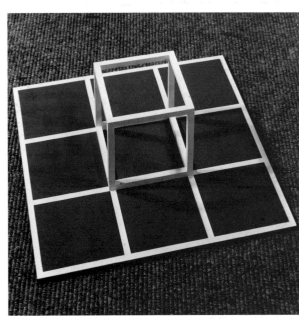

53

50. *MODULAR CUBE* 1966
Baked enamel on aluminium
60 × 60 × 60 in
(152.4 × 152.4 × 152.4 cm)
also: 58 × 58 × 58 in
(147.4 × 147.4 × 147.4 cm)

51. *MODULAR CUBE/BASE* 1968
Painted steel
Cube: $19\frac{1}{2}$ × $19\frac{1}{2}$ × $19\frac{1}{2}$ in
(49.9 × 49.9 × 49.9 cm)
Base: 1 × $45\frac{3}{4}$ × $45\frac{3}{4}$ in
(2.5 × 116.2 × 116.2 cm)

52. *MODULAR CUBE/BASE* 1968
Painted steel
Base: 1 × $45\frac{3}{4}$ × $45\frac{3}{4}$ in
(2.5 × 116.2 × 116.2 cm)

53. *CUBE/BASE* 1969
Painted steel
Cube: $3\frac{1}{2}$ × $3\frac{1}{2}$ × $3\frac{1}{2}$ in
(9 × 9 × 9 cm)
Base: $\frac{1}{4}$ × 10 × 10 in
(.6 × 25 × 25 cm)
Edition of 25

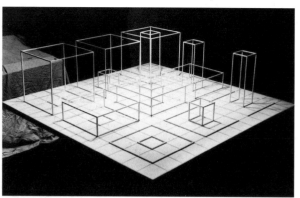

54

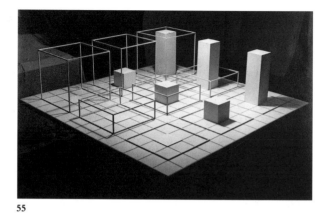

55

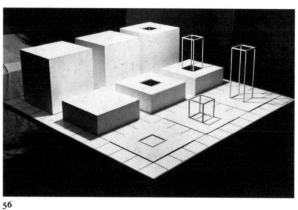

56

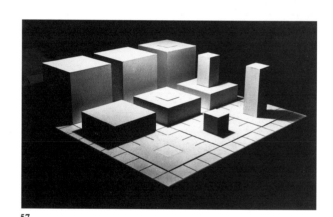

57

54. *SERIAL PROJECT SET A* 1966
Baked enamel on aluminium
$15\frac{1}{2} \times 55\frac{1}{2} \times 55\frac{1}{2}$ in
$(39 \times 141 \times 141$ cm$)$

55. *SERIAL PROJECT SET B* 1966
Baked enamel on aluminium
$15\frac{1}{2} \times 55\frac{1}{2} \times 55\frac{1}{2}$ in
$(39 \times 141 \times 141$ cm$)$

56. *SERIAL PROJECT SET C* 1966
Baked enamel on aluminium
$15\frac{1}{2} \times 55\frac{1}{2} \times 55\frac{1}{2}$ in
$(39 \times 141 \times 141$ cm$)$
(Cat.no.56)

57. *SERIAL PROJECT SET D* 1966
Baked enamel on aluminium
$15\frac{1}{2} \times 55\frac{1}{2} \times 55\frac{1}{2}$ in
$(39 \times 141 \times 141$ cm$)$

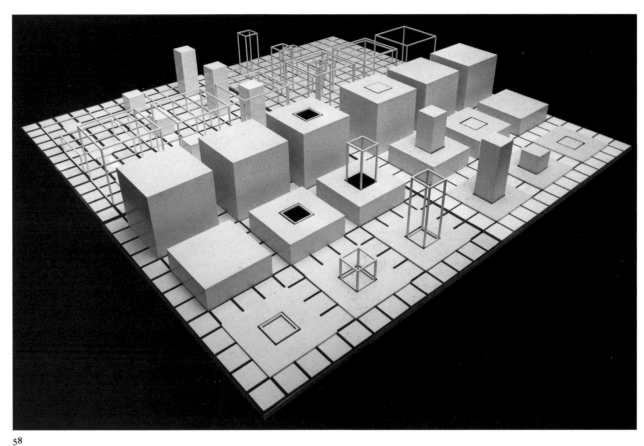

58

8. *Installation of SERIAL PROJECT SET A,*
SERIAL PROJECT SET B,
SERIAL PROJECT SET C and SERIAL
PROJECT SET D at Kunsthalle Bern, 1972.

SERIAL PROJECT #1 (ABCD)
COMPOSITE 1966
Steel
Baked enamel on aluminum
24 × 144 × 144 in
(61 × 365.8 × 365.8 cm)

SERIAL PROJECT #1 (ABCD)
COMPOSITE (ROW) 1983
White painted wood
$32\frac{1}{2}$ × $226\frac{3}{4}$ × $226\frac{3}{4}$ in
(82.5 × 575.9 × 575.9 cm)

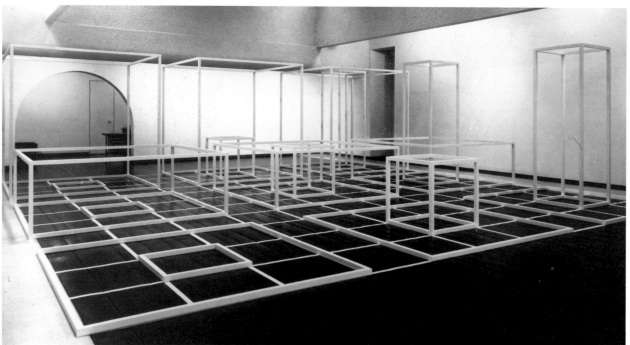

59

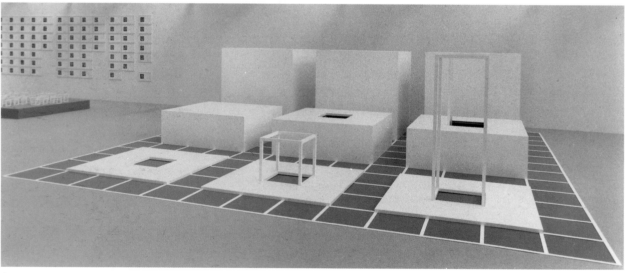

60

59. *SERIAL PROJECT #1 (SET A)* 1966
Baked enamel on steel
81 × 320 × 320 in (202.5 × 800 × 800 cm)

60. *SERIAL PROJECT #1 (SET C)* 1966
Baked enamel on aluminium
90½ in × 355 in × 355 in
(230 × 900 × 900 cm)

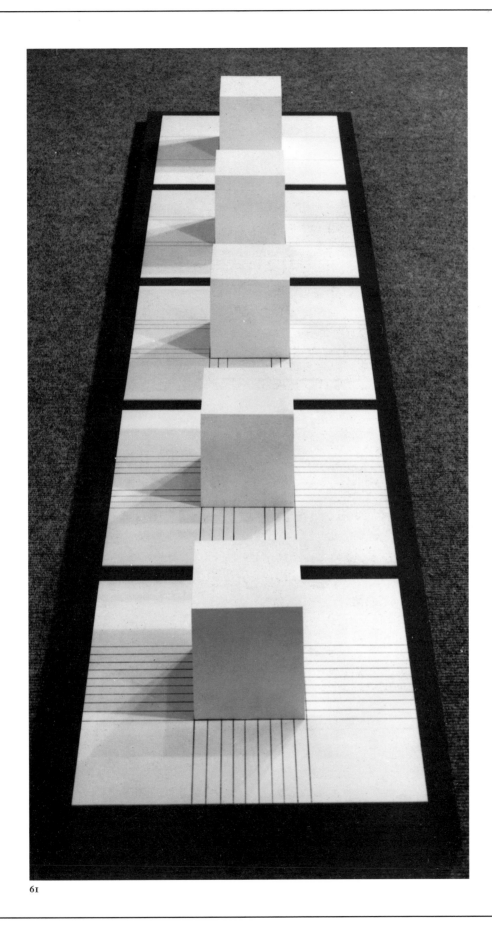

61

61. *CUBES WITH HIDDEN CUBES* 1966
White painted plastic and wood
5 × 14 × 67 in (12.7 × 35.6 × 170.2 cm)

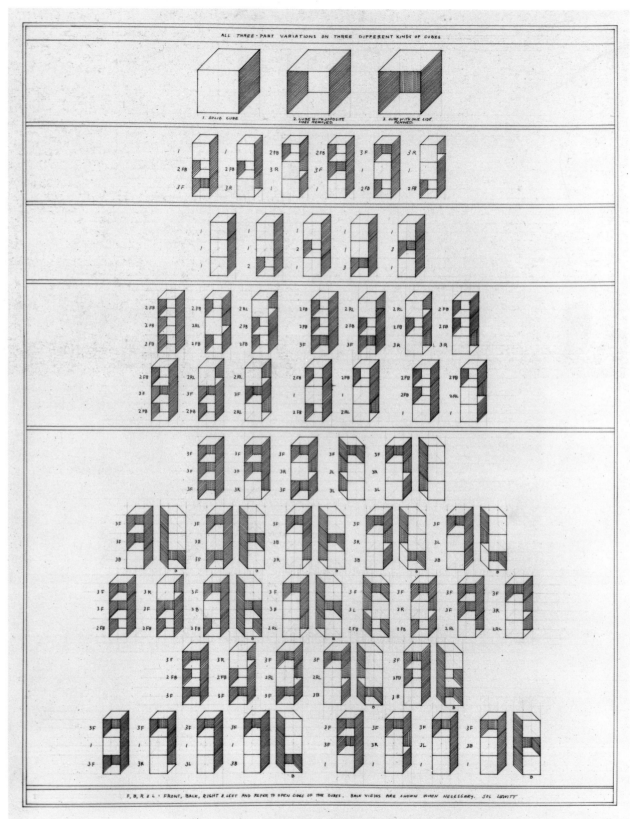

62. *ALL THREE PART-VARIATIONS ON THREE
DIFFERENT KINDS OF CUBES* 1969
Ink and pencil on paper 29 × 23 in (73.5 × 58.4 cm)

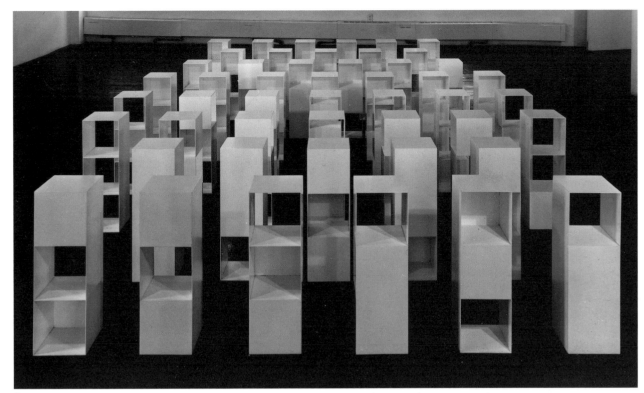

63

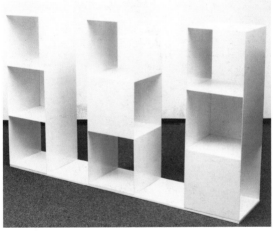

64

63. *47 THREE-PART VARIATIONS ON THREE DIFFERENT KINDS OF CUBES* 1967
Aluminium. 45 × 300 × 195 in
(104.3 × 762 × 495.3 cm)

64. *THREE PART VARIATIONS ON THREE DIFFERENT KINDS OF CUBES* 1967
Baked enamel on steel 48 × 187 × 14¾ in
(119.4 × 474.9 × 37. = cm)
(Cat.no.9)

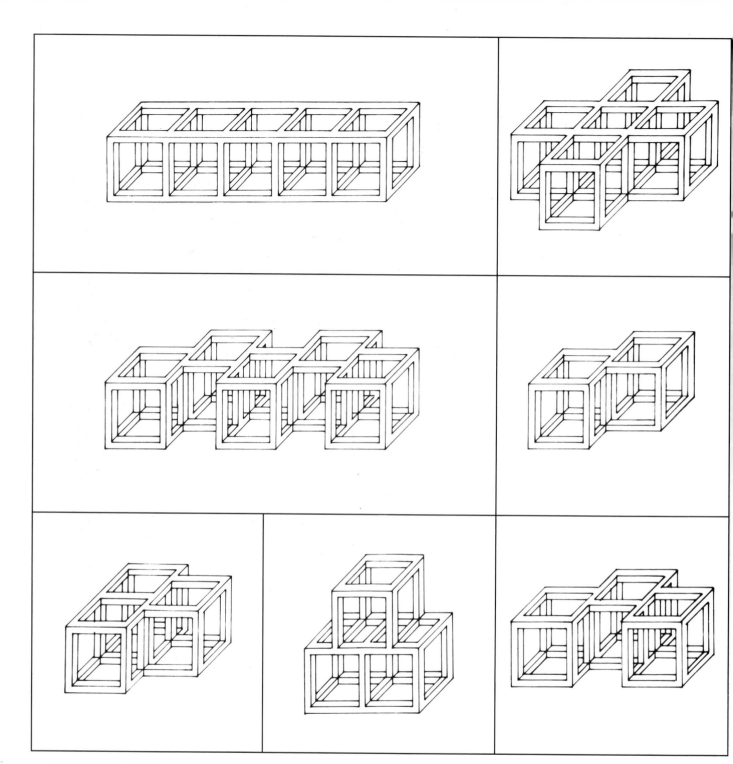

65. *DRAWING FOR SEVEN*
 STRUCTURES 1977
 Ink on paper
 15 × 16½ in (38.3 × 41.8 cm)

Structures:
Top left: 1970, Collection Storm King Art
Centre, Mountainville, New York
Top Right: Centre Georges Pompidou, Paris
Centre Left: Musée de Grenoble, France;
Centre Right: Tate Gallery
Bottom Left: Albright-Knox Art Gallery,
Buffalo, New York
Bottom Centre: Crex Collection,
Schaffhausen, Switzerland
Bottom Right: Moderna Museet, Stockholm

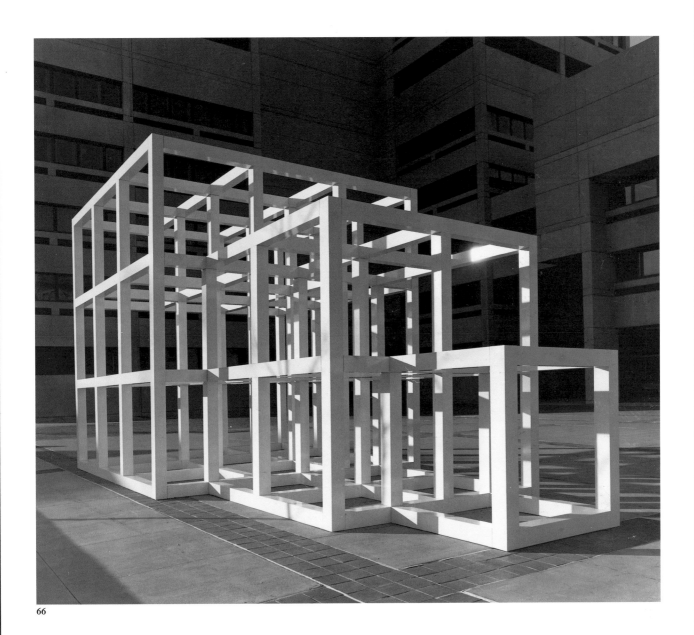

66

66. *1 2 3* 1978
Baked enamel on aluminium

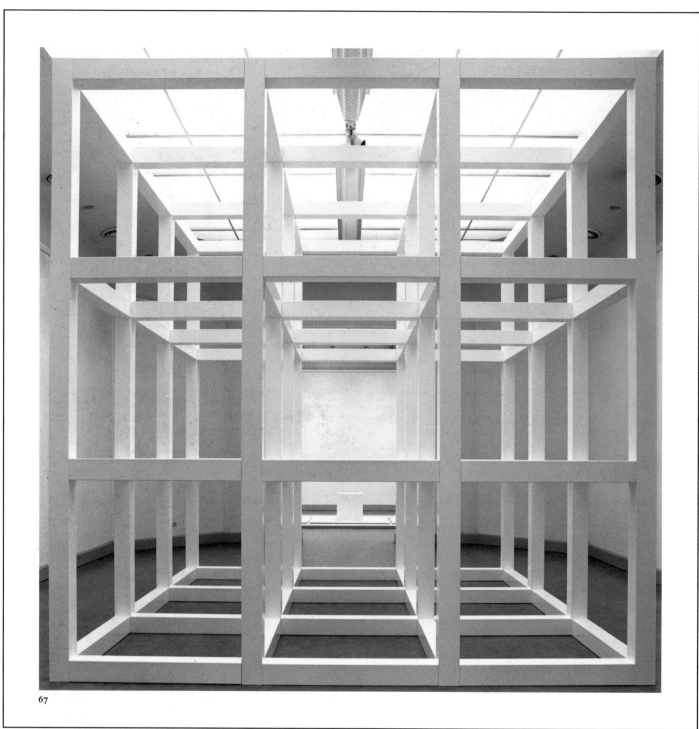

67. *3 × 3 × 3* 1969–83
 Baked enamel on aluminium
 $175\frac{1}{2} \times 175\frac{1}{2} \times 175\frac{1}{2}$ in
 (446 × 446 × 446 cm)

68. *6 UNIT CUBE* 1976
 Baked enamel on aluminium
 120 × 186 × 186 in
 (304.8 × 472.4 × 472.4 cm)

69. *CUBE* 1969
 Baked enamel on steel
 63 × 63 × 63 in
 (160 × 160 × 160 cm)

70. *3 × 3 × 1* 1983
 Baked enamel on aluminium
 60 × 176 × 176 in
 (152.4 × 447 × 447 cm)

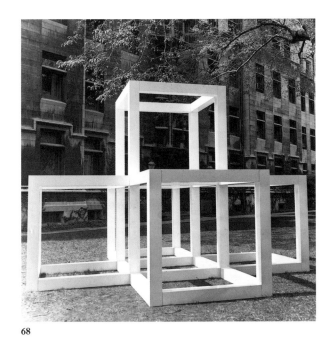

68

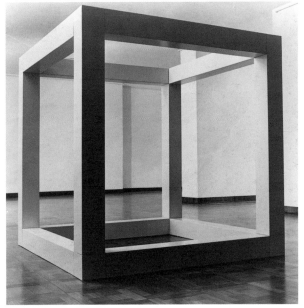

69

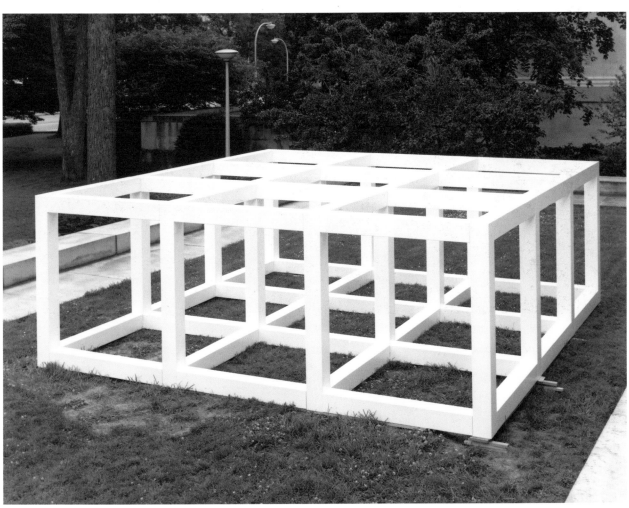

70

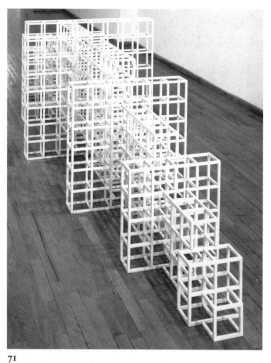

71

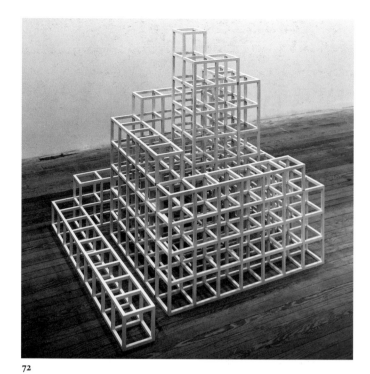

72

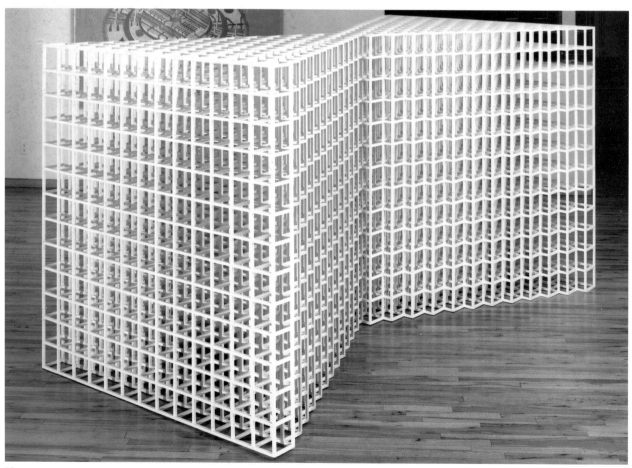

73

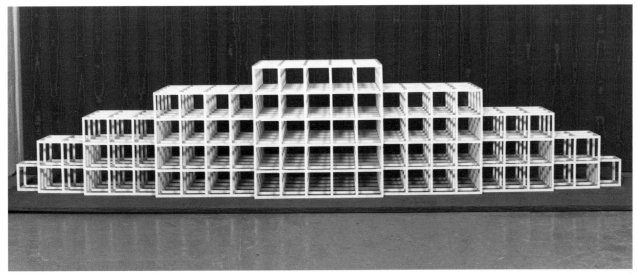

74

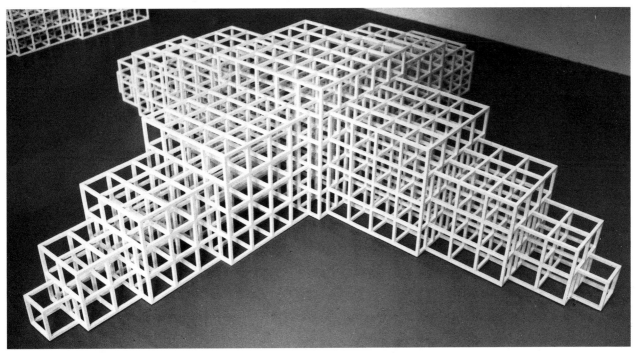

75

71. *HALF-OFF 1 2 3 4 5 6 7 8 7 6 5 4 3 2 1*
 1980
 Baked enamel on aluminium
 $38\frac{1}{2} \times 38\frac{1}{2} \times 187$ in
 ($97.7 \times 97.7 \times 474.9$ cm)

72. *SPIRAL 1 2 3 4 5 6 7 8 9* 1980
 Baked enamel on aluminium
 43.4 in \times 43.4 in \times $43\frac{1}{2}$ in
 ($110.4 \times 110.4 \times 110.4$ cm)

73. *13/11* 1985
 Baked enamel on aluminium
 $60 \times 176 \times 176$ in
 ($152.4 \times 447 \times 447$ cm)

74. *1 2 3 4 5 4 3 2 1* 1987
 White painted wood
 $19 \times 93\frac{1}{2} \times 19$ in
 ($48.5 \times 238 \times 48.5$ cm)

75. *1 2 3 4 5 4 3 2 1 (+)* 1987
 White painted wood
 $96 \times 96 \times 20$ in
 ($243.8 \times 243.8 \times 50.8$ cm)

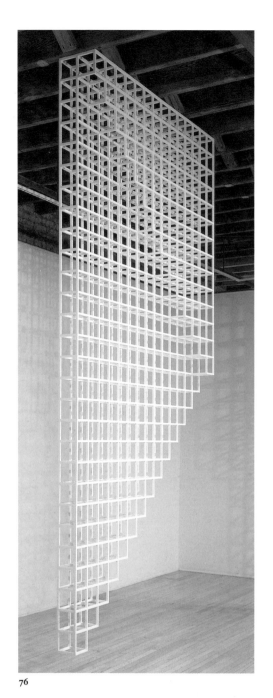

76

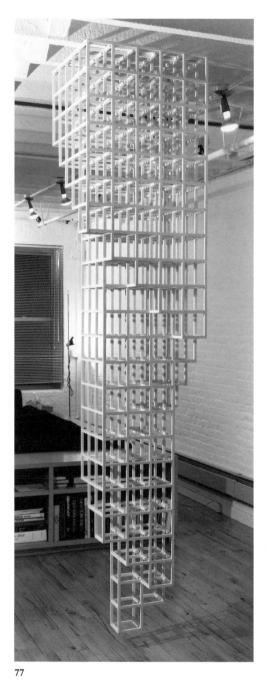

77

76. *HANGING STRUCTURE 28 B* 1989
White painted wood
$133\frac{1}{4} \times 10 \times 67$ in
($338.4 \times 25.4 \times 170.1$ cm)

77. *HANGING STRUCTURE* 1987
White painted wood
$114 \times 24\frac{1}{4} \times 24\frac{1}{4}$ in
($289.5 \times 61.6 \times 61.6$ cm)

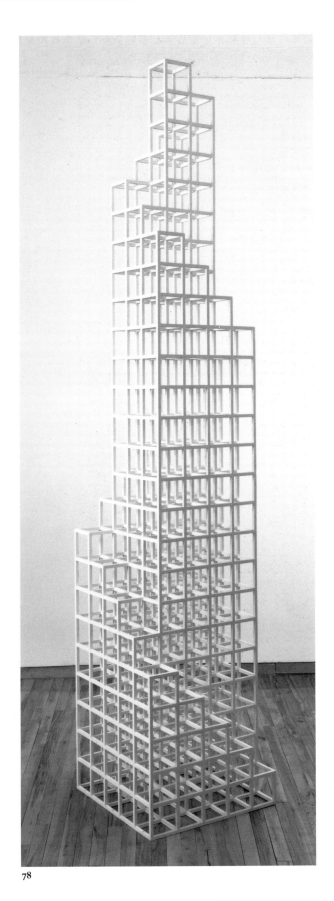

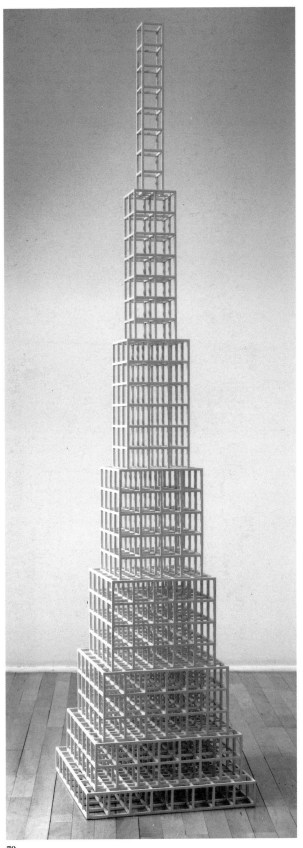

78

79

78. *INVERTED SPIRALLING TOWER* 1988
White painted wood
$119\frac{3}{4} \times 24\frac{1}{2} \times 24\frac{1}{2}$ in ($304.1 \times 62.2 \times 62.2$ cm)

79. *8 × 8 × 1* 1989
Baked enamel on aluminium
$82 \times 18 \times 18$ in ($208.2 \times 45.7 \times 45.7$ cm)

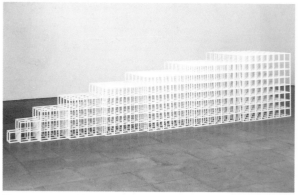

80

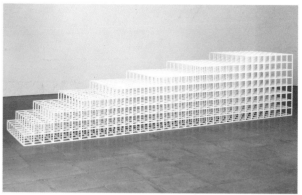

81

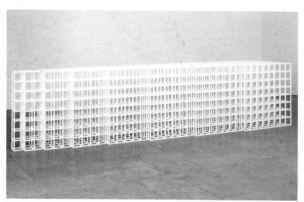

82

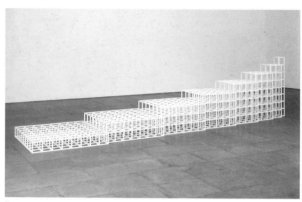

83

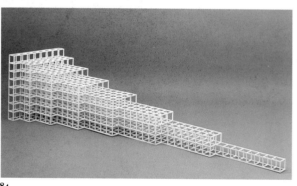

84

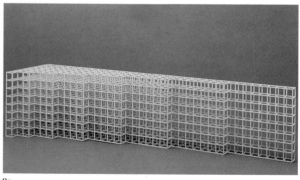

85

80. *OPEN GEOMETRIC STRUCTURE*
 IV 1990
 White painted wood
 $38\frac{1}{2} \times 171\frac{1}{2} \times 38\frac{1}{2}$ in
 ($97.7 \times 435.6 \times 97.7$ cm)

81. *OPEN GEOMETRIC STRUCTURE*
 I 1990
 White painted wood
 $38\frac{1}{2} \times 171\frac{1}{2} \times 38\frac{1}{2}$ in
 ($97.7 \times 435.6 \times 97.7$ cm)

82. *OPEN GEOMETRIC STRUCTURE*
 V 1990
 White painted wood
 $38\frac{1}{2} \times 171\frac{1}{2} \times 38\frac{1}{2}$ in
 ($97.7 \times 435.6 \times 97.7$ cm)
 (Cat.no.20)

83. *OPEN GEOMETRIC STRUCTURE*
 III 1990
 White painted wood
 $38\frac{1}{2} \times 171\frac{1}{2} \times 38\frac{1}{2}$ in
 ($97.7 \times 435.6 \times 97.7$ cm)
 (Cat.no.19)

84. *HORIZONTAL PROGRESSION*
 #1 1991
 Baked enamel on aluminium
 $18\frac{1}{4} \times 81\frac{1}{2} \times 18\frac{1}{4}$ in
 ($46.4 \times 207 \times 46.4$ cm)

85. *HORIZONTAL PROGRESSION*
 #5 1991
 Baked enamel on aluminium
 $18\frac{1}{4} \times 81\frac{1}{2} \times 18\frac{1}{4}$ in
 ($46.4 \times 207 \times 46.4$ cm)

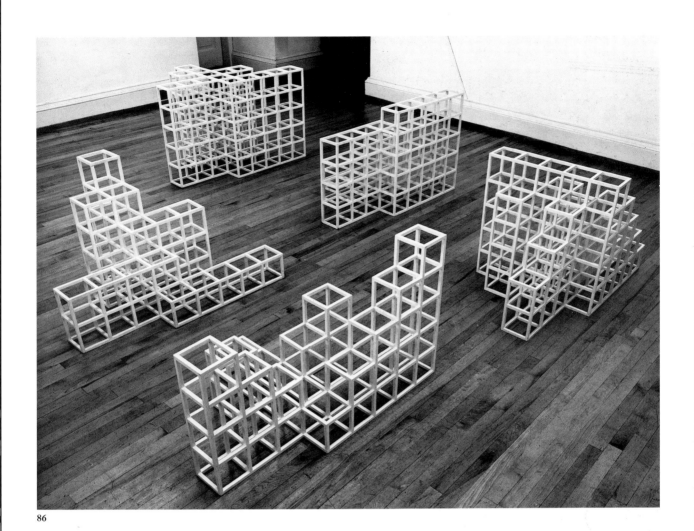

86

86. *FIVE MODULAR STRUCTURES
(SEQUENTIAL PERMUTATIONS
ON THE NUMBER FIVE)* 1972
White painted wood
5 pieces, each 58 × 38½ × 58 in
(62 × 98 × 62cm)
(Cat.no.10)

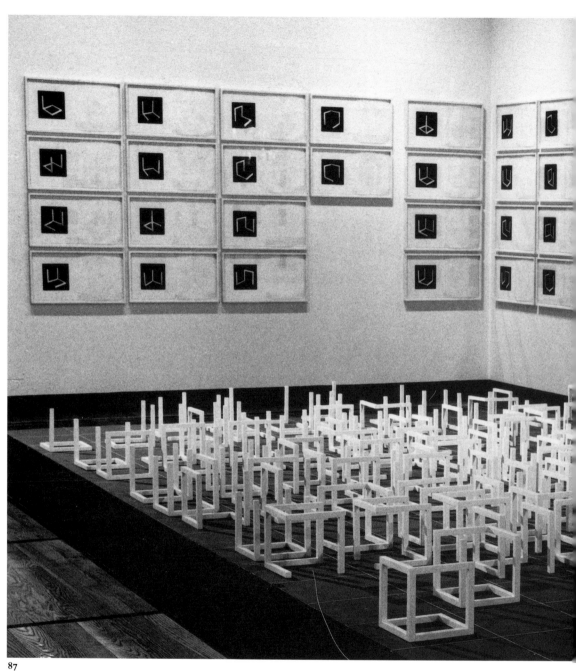

87

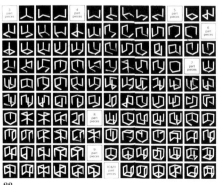

88

88. *SCHEMATIC DRAWING FOR
 INCOMPLETE OPEN CUBES* 1974
 Ink on paper
 12 × 12 in (30.5 × 30.5 cm)

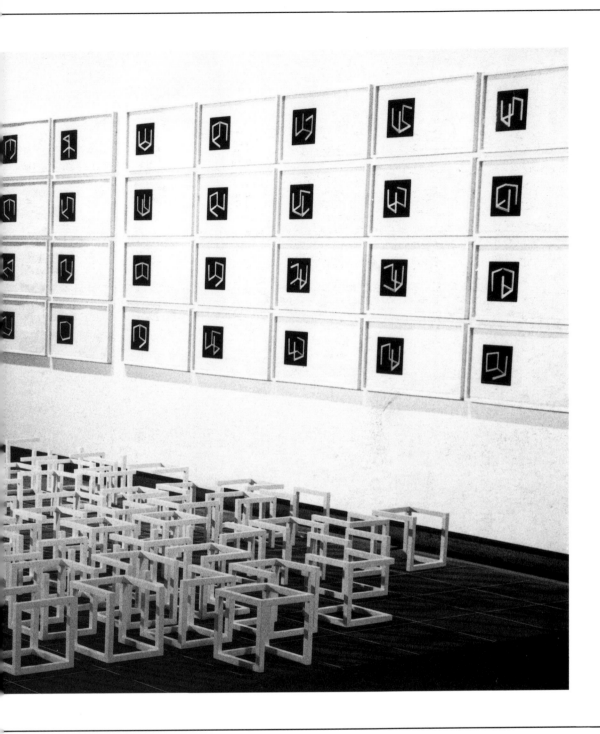

87. *INCOMPLETE OPEN CUBES*
1974
Installation including 122 painted wood
structures on a painted wood base and
122 framed photographs and drawings
on paper
Each structure: 8 × 8 × 8 in
(20 × 20 × 20 cm)
Base: 12 × 120 × 126 in
(30.5 × 304.8 × 320 cm)
Each frame: 14 × 26 in (35.5 × 66 cm)
(Cat.no.11)

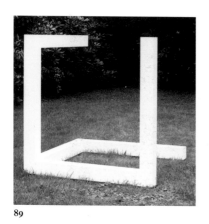

89

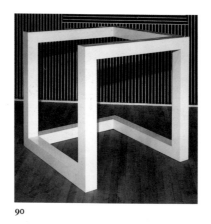

90

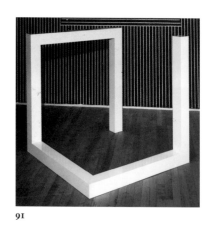

91

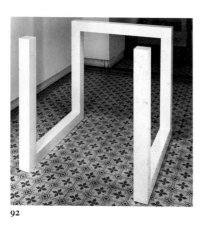

92

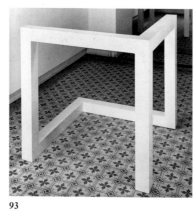

93

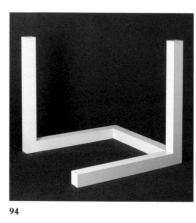

94

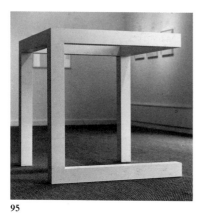

95

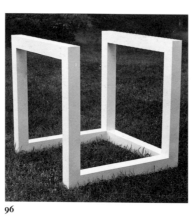

96

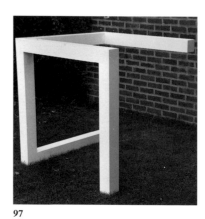

97

89. *INCOMPLETE OPEN CUBE*
6/16 1974
Baked enamel on aluminium
42 × 42 × 42 in
(106.6 × 106.6 × 106.6 cm)

90. *INCOMPLETE OPEN CUBE*
9/12 1974
Baked enamel on aluminium
42 × 42 × 42 in
(106.6 × 106.6 × 106.6 cm)

91. *INCOMPLETE OPEN CUBE*
6/12 1974
Baked enamel on aluminium
42 × 42 × 42 in
(106.6 × 106.6 × 106.6 cm)

92. *INCOMPLETE OPEN CUBE*
7/25 1974
Baked enamel on aluminium
42 × 42 × 42 in
(106.6 × 106.6 × 106.6 cm)

93. *INCOMPLETE OPEN CUBE*
7/28 1974
Baked enamel on aluminium
42 × 42 × 42 in
(106.6 × 106.6 × 106.6 cm)

94. *INCOMPLETE OPEN CUBE*
5/6 1974
Baked enamel on aluminium
42 × 42 × 42 in
(106.6 × 106.6 × 106.6 cm)

95. *INCOMPLETE OPEN CUBE*
8/24 1974
Baked enamel on aluminium
42 × 42 × 42 in
(106.6 × 106.6 × 106.6 cm)

96. *INCOMPLETE OPEN CUBE*
9/4 1974
Baked enamel on aluminium
42 × 42 × 42 in
(106.6 × 106.6 × 106.6 cm)

97. *INCOMPLETE OPEN CUBE*
6/14 1974
Baked enamel on aluminium
42 × 42 × 42 in
(106.6 × 106.6 × 106cm)

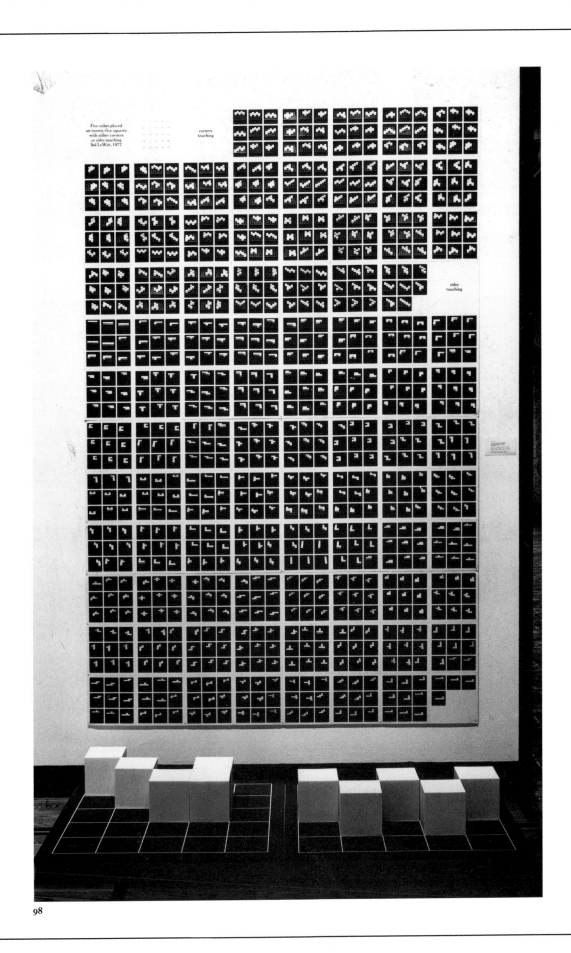

98. *FIVE CUBES ON 25 SQUARES* 1977 Plastic — Cubes: 6 × 6 × 6 in (15.2 × 15.2 × 15.2 cm)
Base: 1 × 33 × 33 in (2.5 × 83.8 × 83.8 cm)

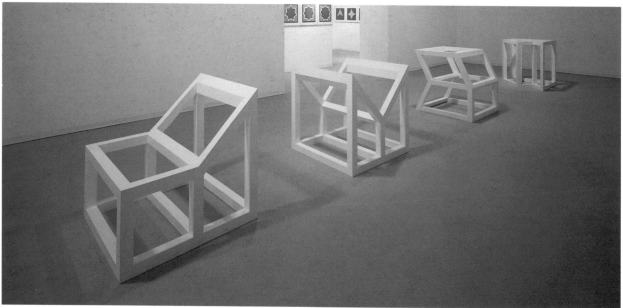

99

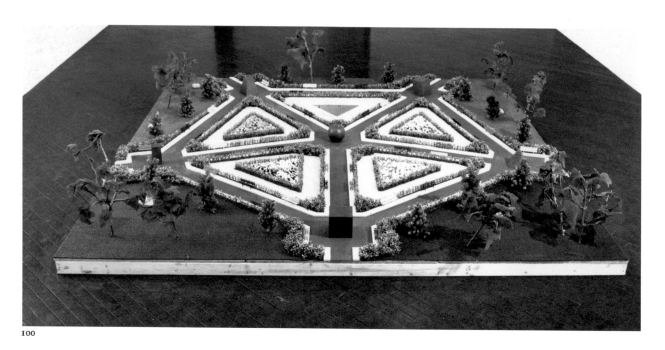

100

99. *FORMS DERIVED FROM A
 CUBE* 1983
 White painted wood
 Each: $31\frac{1}{2} \times 31\frac{1}{2} \times 31\frac{1}{2}$ in
 ($80 \times 80 \times 80$ cm)

100. *PLAN FOR A PARK* 1979
 Painted wood, plastic, stone, mirror
 $7 \times 144 \times 144$ in
 ($17.8 \times 365.7 \times 365.7$ cm)

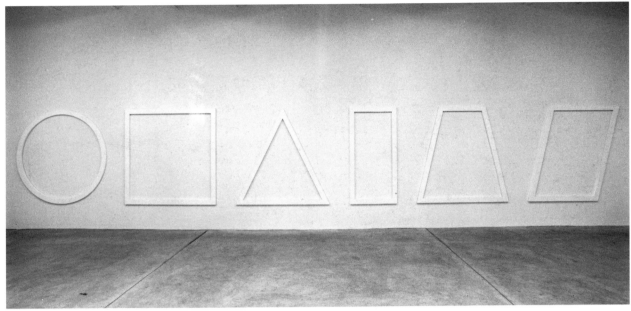

101

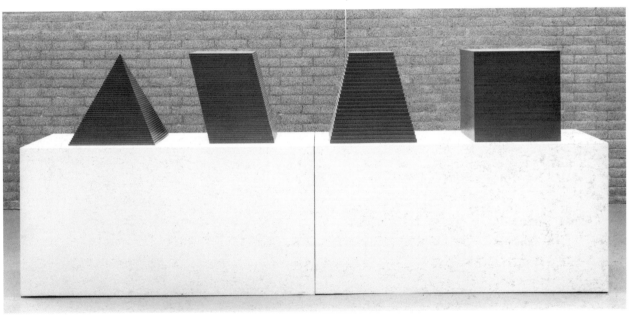

102

101. *GEOMETRIC FIGURES,*
OPEN 1977
White painted wood
Each: 60 × 60 in
(152.4 × 152.4 cm)

102. *GEOMETRIC FIGURES,*
SOLID 1983
Yellow painted wood
Each: 36 × 36 × 36 in
(91.4 × 91.4 × 91.4 cm)

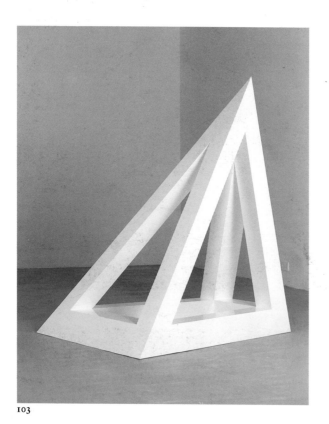

103

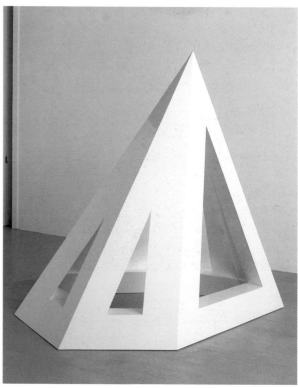

104

103. *FOUR- SIDED PYRAMID* 1991–2
white painted aluminium
72 × 60 × 51 in
(183 × 152.5 × 130cm)
(Cat.no.26)

104. *EIGHT- SIDED PYRAMID* 1992
white painted aluminium
76 × 74 × 74 in
(193 × 187 × 187cm)
(Cat.no.28)

105. *VARIATIONS ON A CUBE
(FORMS DERIVED FROM A
CUBE)* 1984
White painted wood
24 forms, each: 6 × 6 × 6 in
(15 × 15 × 15 cm)
Base: 1 × 54½ × 75½ in
(2.5 × 138.4 × 191.7 cm)

106. *ALL ONE-, TWO-, THREE-,
FOUR-, AND FIVE-PART
COMBINATIONS OF FIVE
GEOMETRIC FIGURES / FIVE
GEOMETRIC FIGURES AND
THEIR COMBINATIONS* 1991
White painted wood
Each: 6 × 6 × 6 in
(15.3 × 15.3 × 15.3 cm) Base:
12 × 74 × 124½ in
(30.5 × 187.9 × 316.2 cm)

105

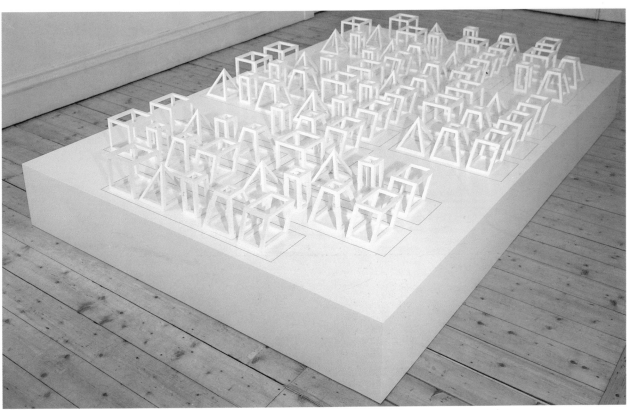

106

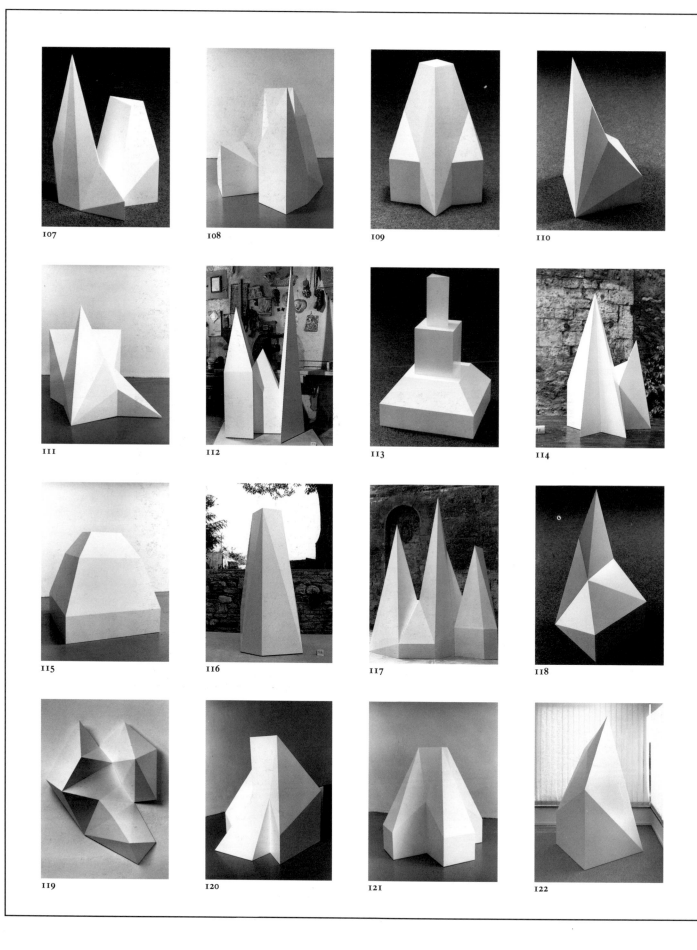

107

108

109

110

111

112

113

114

115

116

117

118

119

120

121

122

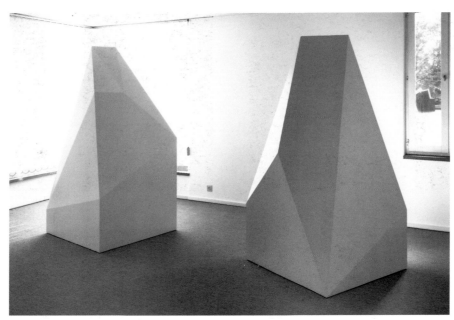

123

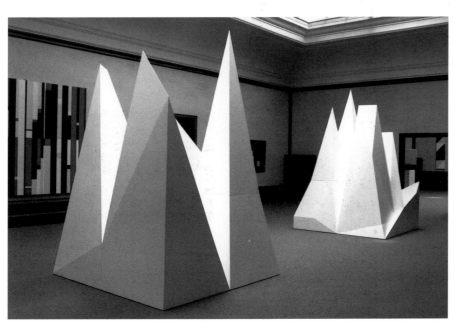

124

107. *COMPLEX FORM #25* 1988
White painted wood
24 × 24 × 36 in
(60.9 × 60.9 × 91.4 cm)

108. *COMPLEX FORM #9* 1988
White painted wood
16 × 16 × 40 in
(40.6 × 40.6 × 101.6 cm)

109. *COMPLEX FORM #27* 1988
White painted wood
24 × 24 × 36 in
(60.9 × 60.9 × 91.4 cm)

110. *COMPLEX FORM* 1988
White painted wood
24 × 24 × 36 in
(60.9 × 60.9 × 91.4 cm)

111. *COMPLEX FORM #12* 1988
White painted wood
39 × 39 × 39 in
(100 × 100 × 100 cm)

112. *COMPLEX FORM #89* 1988
White painted wood
$31\frac{1}{2} \times 35\frac{3}{4} \times 78\frac{3}{4}$ in
(80 × 90 × 200 cm)

113. *COMPLEX FORM* 1988
White painted wood
24 × 24 × 36 in
(60.9 × 60.9 × 91.4 cm)

114. *COMPLEX FORM #81* 1988
White painted wood
$12 \times 19\frac{1}{2} \times 29\frac{1}{2}$ in
(30 × 50 × 75 cm)

115. *COMPLEX FORM #16* 1988
White painted wood
39 × 39 × 39 in
(100 × 100 × 100 cm)

116. *COMPLEX FORM #55* 1990
White painted wood
39 × 78 × 78 in
(100 × 200 × 200 cm)

117. *COMPLEX FORM #71* 1990
White painted wood
120 × 104 × 42 in
(304.8 × 264.1 × 106.6cm)

118. *COMPLEX FORM #* 1988
White painted wood
24 × 24 × 36 in
(60.9 × 60.9 × 91.4 cm)

119. *COMPLEX FORM #36* 1990
White painted wood
50 × 16 × 20 in
(127 × 40.6 × 50.8 cm)

120. *COMPLEX FORM* 1988
White painted wood
39 × 39 × 39 in
(100 × 100 × 100 cm)

121. *COMPLEX FORM #10* 1988
White painted wood
16 × 16 × 40 in
(40.5 × 40.5 × 100 cm)

122. *COMPLEX FORM #44* 1990
White painted wood
80 × 40 × 40 in
(200 × 100 × 100 cm)

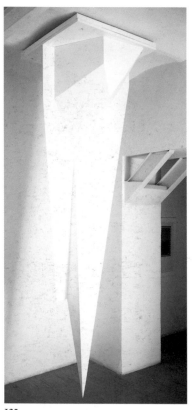

125

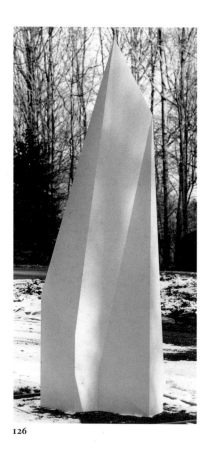

126

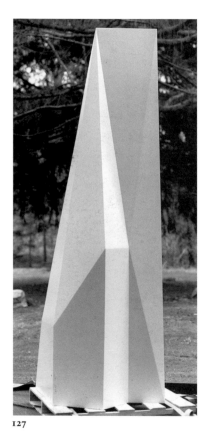

127

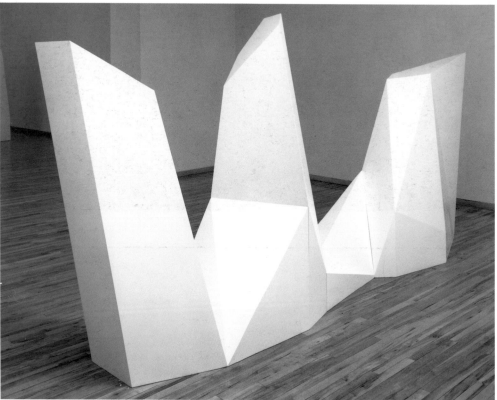

128

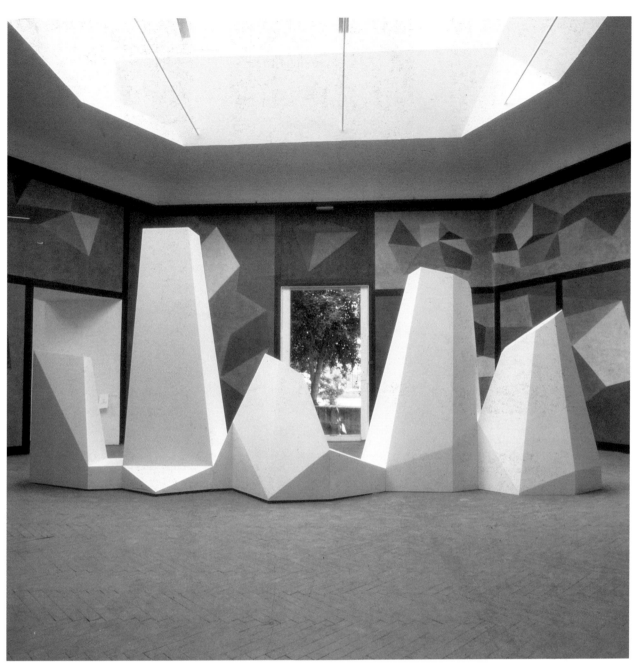

129

Previous page
overleaf:

123. *COMPLEX FORM #44, #45* 1990
White painted wood
Each: 80 × 40 × 40 in
(200 × 100 × 100 cm)
Installation: Galerie Vega, Brussels.

124. *COMPLEX FORM #49, 51* 1989
White painted wood
Each: 80 × 80 × 120 in
(200 × 200 × 304.8 cm)
Installation: Kunstmuseum
Winterthur, Switzerland

Opposite:

125. *HANGING COMPLEX
FORM* 1989
White painted wood
39 × 39 × 138 in
(100 × 100 × 350 cm)

126. *COMPLEX FORM MH 6* 1990
Baked enamel on aluminium
120 × 48 × 36 in
(304.8 × 121.9 × 91.4 cm)

127. *COMPLEX FORM #MH 13* 1990
Baked enamel on aluminium
112 × 60 in × 42 in
(284.4 × 152.4 × 106.6 cm)

128. *COMPLEX FORM #6* 1988
White painted wood
80 × 40 × 126 in
(203.2 × 101.6 × 320.4 cm)

This page:

129. *COMPLEX FORM #8* 1988
White painted wood
120 × 72 × 272 in
(304.8 × 182.8 × 690.8 cm) Installation:
Venice Biennale, 1988
(Cat.no.16)

Overleaf

130. *TOWER (WITH 12 GEOMETRIC
FIGURES AND LINES IN TWO
DIRECTIONS)* 1984
Cast concrete 252 × 84 × 84 in (640 × 213.3 × 213.3 cm)

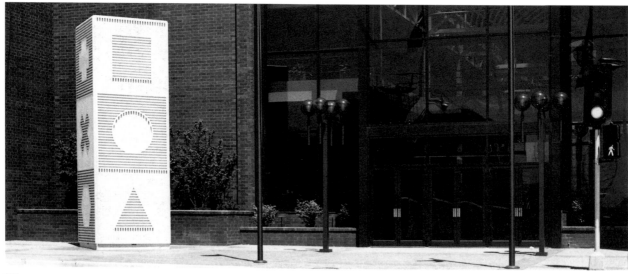

130

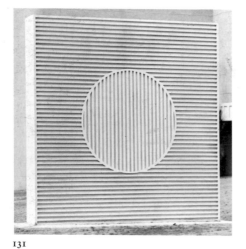

131

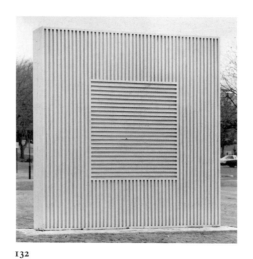

132

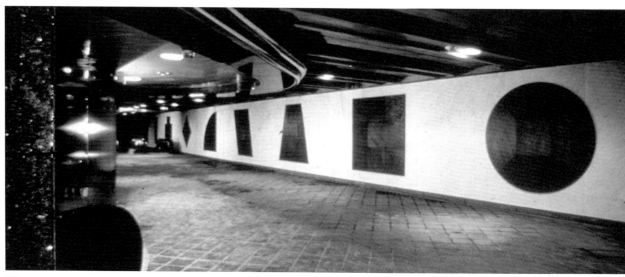

133

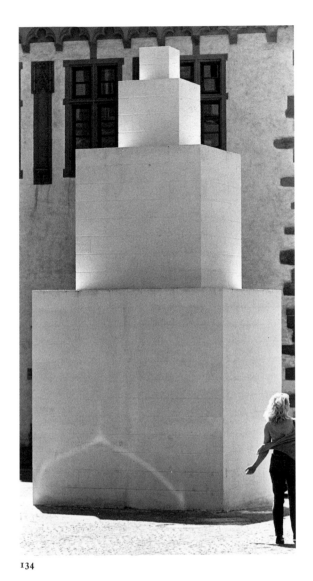

134

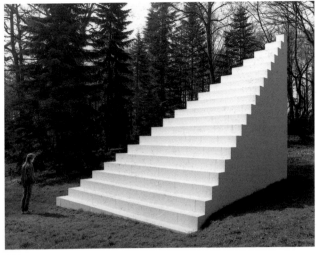

135

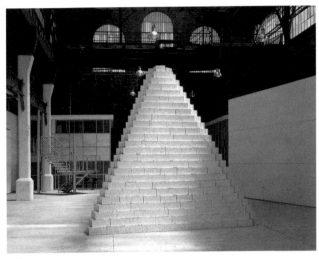

136

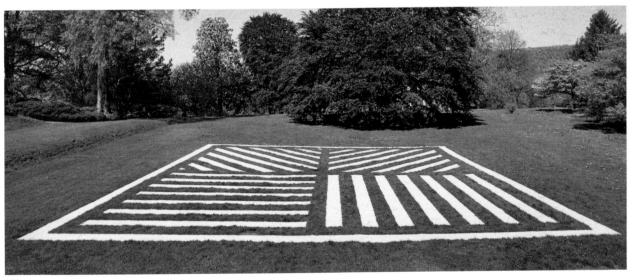

137

134. *FRANKFURT TOWER* 1990
White painted cinderblock
250 × 118 × 118 in
(635 × 300 × 300 cm)

135. *PYRAMIDE FÜR MÜNSTER* 1987
White painted cinderblock
200 × 200 × 200 in

136. *THREE-SIDED PYRAMID* 1988
White painted cinderblock
197 × 197 × 197 in (500 × 500 × 500 cm)
Installation: 'Meltem', Magasin, Centre
National D'Art Contemporain, Grenoble.

137. *LINES IN FOUR DIRECTIONS* 1982
Gravel 558 × 558 in
Installation: Wave Hill, Riverdale,
New York

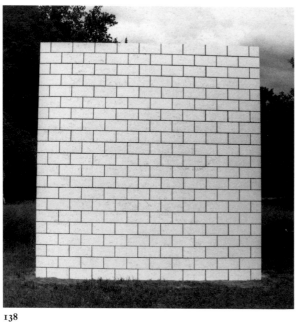

138

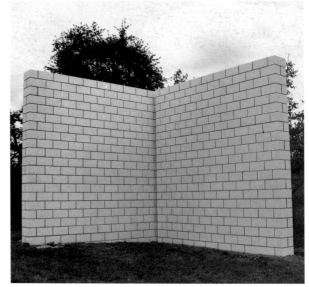

139

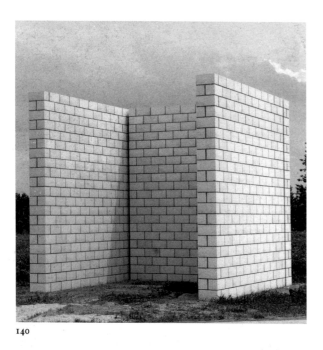

140

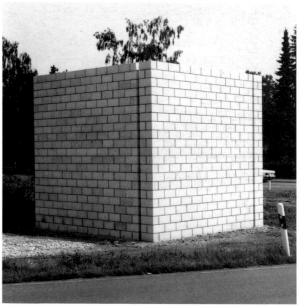

141

138. *FOUR-PART PIECE 1: 5 METRE SQUARE WALL*

139. *FOUR-PART PIECE 2: 2 WALLS 5 METRES SQUARE, PERPENDICULAR* AT THE CORNERS

140. *FOUR-PART PIECE 3: 2 WALLS PERPENDICULAR TO ONE AT TWO* CORNERS

141. *FOUR-PART PIECE 4: 4 WALLS FORMING A SQUARE*
(A space of 10 cm separates the walls from one another) 1992
Painted cinderblock

Each wall: 197 × 197 × 19½ in
(500 × 500 × 50 cm)
These four walls are in four separate towns near Stuttgart: 1 wall: Ruit; 2 walls: Kemnat; 3 walls: Scharnhausen; 4 walls: Nellingen.

142. *CUBE* 1986
Painted cinderblock
200 × 200 × 200 in
(500 × 500 × 500 cm)

143. *BLOCK* 1991
Cinderblock with Portland cement
165 × 130 × 130 in
(412 × 327 × 327 cm)
(Maquette included in the exhibition, cat.no.25)

144. *CUBE WITHOUT A CUBE* 1988
Painted cinderblock
197 × 197 × 197 in
(500 × 500 × 500 cm)

145. *MAQUETTE FOR VERTICAL #9* 1990
White painted wood
Proposed: cinderblock. Proposed height 640 in
(1625.6 cm),
base: 320 × 320 in
(812 × 812 cm)

146. *CUBE WITHOUT A CORNER* 1988
Painted cinderblock
200 × 200 × 200 in
(500 × 500 × 500cm)

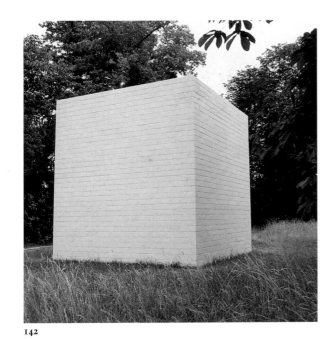

142

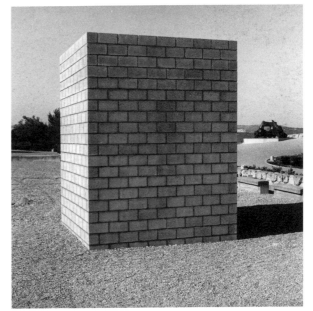

143

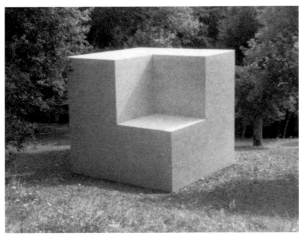

144

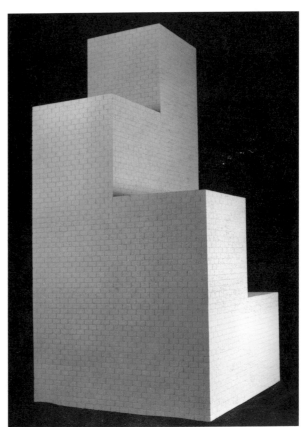

145

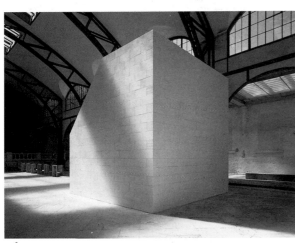

146

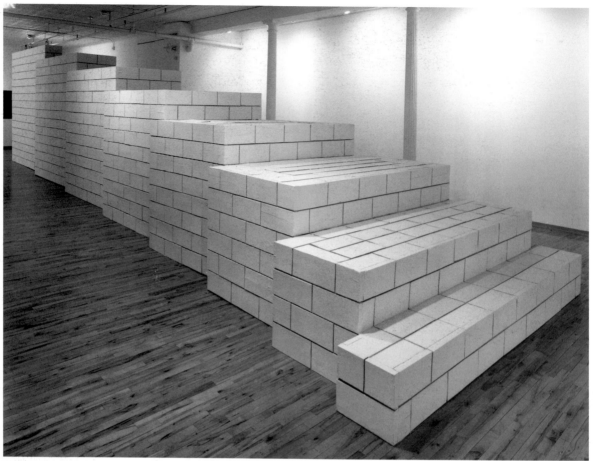

147

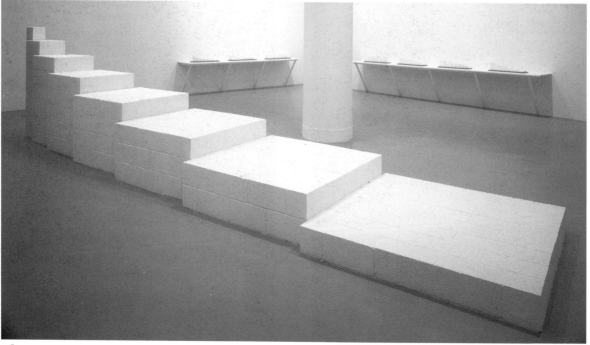

148

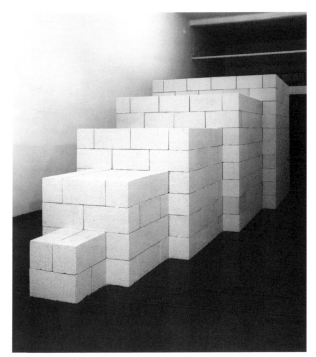

149

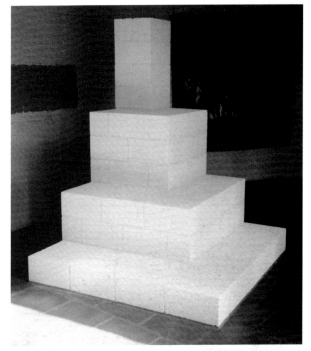

150

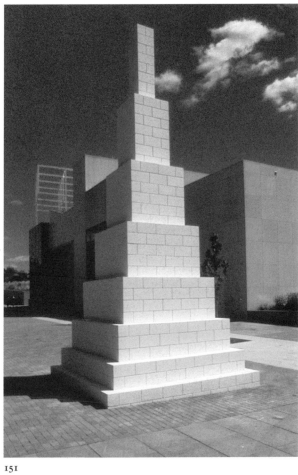

151

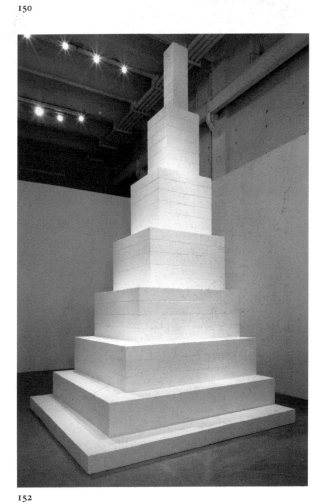

152

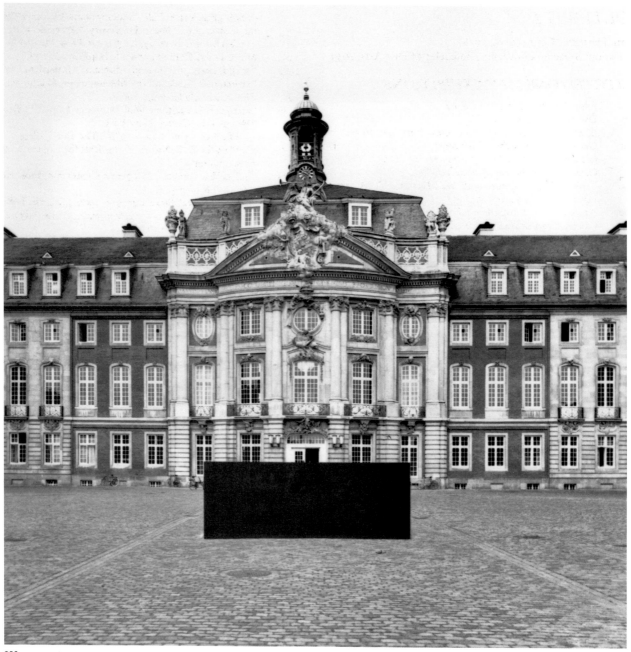

153

SOL LEWITT

Born: Hartford, Connecticut, 1928
Education: Syracuse University, Batchelor of Fine Arts, 1949

SELECTED ONE MAN EXHIBITIONS

1965 John Daniels Gallery, New York
1966 Dwan Gallery, New York
(also in Los Angeles, '67 and in New York '68, '70, '71)
1968 Galerie Konrad Fischer, Dusseldorf
(also in '69, '71, '72, '75, '77, '79, '81, '83, '87)
Galerie Bischofberger, Zurich (also in '69)
1969 "Sol LeWitt: Sculptures and Wall Drawings", Museum Haus Lange, Krefeld
1970 Art & Project, Amsterdam (also in '71, '71, '72, '73, '75)
Galerie Yvon Lambert, Paris (also in '73, '74, '79, '80, '84, '86, '87, '89, '91)
Galleria Sperone, Turin (also in '74, '75)
Lisson Gallery, London (also in '71, '73, '74, '77, '79, '83, '84, '88, '89, '91)
Gemeentemuseum, The Hague
Pasadena Art Museum, Pasadena
1971 "Structures and Wall Drawings", John Weber Gallery, New York
(also in '73, '73, '74, '77, '78, '80, '80, '82, '86, '88, '88, '90, '91, '92 (winter), '92 (fall))
1972 "Wall Drawings, Sculpture", Massachusetts Institute of Technology, Hayden Gallery, Cambridge, Massachusetts, Kunsthalle Bern, Nova Scotia College of Art & Design, Halifax, Nova Scotia, Canada
1973 Museum of Modern Art, Oxford
Portland Centre for the Visual Arts, Portland, Oregon
1974 Palais des Beaux Arts, Brussels
Rijksmuseum Kröller Muller, Otterlo
"Prints", Stedelijk Museum, Amsterdam
1974– "Fifty Drawings 1964–1974", New York Cultural Centre,
76 New York
(& subsequent tour to Canada and the United States)
1975 "Incomplete Open Cubes and Wall Drawings", Scottish National Gallery of Modern Art, Edinburgh and subsequent tour Museum of Modern Art, Oxford; Kunsthalle Basel.
Annemarie Verna, Zurich (also in '81, '84, '86, '88, 91)
1976 Dag Hammarskjöld Plaza Sculpture Garden, New York
"Wall Drawings, Structures, and Prints", Fine Arts Gallery, University of Colorado, Boulder
1977 The Art Gallery of New South Wales, Sydney, Australia
National Gallery of Victoria, Melbourne, Australia
"Incomplete Open Cubes, Prints, and Wall Drawings", University Gallery, University of Massachusetts, Amherst
1978– "Sol LeWitt" (Retrospective), Museum of Modern Art,
79 New York, travelled to the Museum of Contemporary Art, Montreal; Krannert Museum of Art, University of Illinois, Champaign; Museum of Contemporary Art, Chicago; La Jolla Museum of Contemporary Art, La Jolla, California
1979 Young/Hoffman Gallery, Chicago (also in '80, '82)
1981 Sol LeWitt Wall Drawings: 1968–1981", Wadsworth Atheneum, Hartford

"Photogrids, Brick Wall, Autobiography, On the Walls of the Lower East Side": University Art Gallery, New Mexico State University, Las Cruces, New Mexico
1983 Musée D'Art Contemporain de Bordeaux (CAPC)
1984 "Wall Drawings", Stedelijk Museum, Amsterdam
"Structures", Stedelijk Van Abbemuseum, Eindhoven
1985 The Saatchi Collection, London
1986 "Inaugural Exhibition: Wall Drawings by Sol LeWitt", The Drawing Center, New York
"Sol LeWitt: Prints 1970 – 1986", The Tate Gallery
"Sol LeWitt Wall Drawings", Institute for Contemporary Arts, London
1988 "Sol LeWitt Books", Minnesota Center for Book Arts, (MCBN) Minneapolis
1989 "Sol LeWitt Wall Drawings 1984–1989", Kunsthalle Bern
"Sol LeWitt: Wall Drawing, Structures, Prints and Drawings", Spoleto Festival U.S.A.
1990 "Sol LeWitt: New Structures", Rhona Hoffman Gallery, Chicago
"Sol LeWitt: Recent Works", Touko Museum of Contemporary Art, Tokyo
"Sol LeWitt: New Structures and Gouaches", Galerie Pierre Huber, Geneva
"Sol LeWitt: Books", Portikus, Frankfurt
"Sol LeWitt: Large Scale Concrete Block Sculpture", Max Protetch Gallery, New York
1991 "Sol LeWitt: New Structures", Donald Young Gallery, Seattle, WA
1992 "Complex Forms: Structures and Prints", Akus Gallery, Eastern Connecticut State University, Willimantic, Connecticut
"Sol LeWitt Wall Drawings", Butler Gallery, Kilkenny Castle, Kilkenny, Ireland
1992– "Sol LeWitt Drawings 1958–1992", Haags Gemeen-
94 temuseum, The Hague and subsequent tour: Museum of Modern Art, Oxford; Westfälisches Landesmuseum, Münster; Henry Moore Sculpture Trust, Leeds City Art Gallery Leeds; Kunstmuseum Winterthur, Switzerland; Centre Georges Pompidou, Paris; Fundació Tàpies, Barcelona; Museum of Fine Arts, Boston; The Baltimore Museum of Art, Baltimore

SELECTED GROUP EXHIBITIONS

1963 St. Mark's Church, New York
1964 Kaymar Gallery, New York
1965 "Young Masters", Graham Gallery, New York
1966 "Gallery Group", Dwan Gallery, New York
"Multiplicity", Institute of Contemporary Arts, Boston
"Primary Structures", Jewish Museum, New York
"Art in Process", Finch College Museum, New York
"3 – Man Show", Park Place Gallery, New York
1966 "10", Dwan Gallery, New York and Los Angeles
1967 "Sculpture Annual", Whitney Museum of American Art, New York
Los Angeles County Museum of Art, Los Angeles
"American Sculpture of the Sixties", Philadelphia Museum of Art, Philadelphia
"Serial Art", Finch College Museum, New York

"Scale Models and Drawings", Dwan Gallery, New York

"Language l", Dwan Gallery, New York

1968 "Cool Art", Aldrich Museum of Contemporary Art, Ridgefield, Connecticut

Whitney Museum of American Art, New York

"Language II", Dwan Gallery, New York

"Documenta IV", Kassel

"Prospect 68", Kunsthalle Dusseldorf, Dusseldorf

"Minimal Art", Galerie René Block, Berlin

"Earthworks", Dwan Gallery, New York

"Benefit for Student Mobilization Committee to End the War in Vietnam", Paula Cooper Gallery, New York (Curator: Lucy Lippard)

1968 "Minimal Art", Gemeentemuseum, The Hague.

"The Art of the Real", Museum of Modern Art, New York. Travelled to: Centre National d'Art Contemporain, Grand Palais, Paris; Kunsthaus, Zurich; Tate Gallery, London.

1969 "When Attitudes Become Form", Kunsthalle Bern; ICA, London; Stedelijk Museum, Amsterdam

"Andre, Flavin, Judd, LeWitt, & Morris", Hetzel Union Building Gallery, Penn State University, PA

"Seattle Art Museum Pavillion, "557.087", Seattle.

"Art by Telephone", Museum of Contemporary Art, Chicago

"Art From Plans", Kunsthalle Bern

1970 "69th American Exhibition", Art Institute of Chicago

"10th Biennale", Metropolitan Museum of Art, Tokyo

"Arte Povera", Museum Torino, Turin

"Walls", Jewish Museum, New York

"Information", Museum of Modern Art, New York

1971 "Sonsbeek '71", Arnhem

1971– "Etchings", Museum of Modern Art, New York

72 "White on White", Museum of Contemporary Art, Chicago

1972 "Grids", Institute of Contemporary Art, University of Pennsylvania, Philadelphia

1973 "3-D Into 2-D", New York Cultural Center, New York

"Contemporary Drawing", Whitney Museum of American Art, New York

1975 "Painting, Drawing and Sculpture of the '60s and the '70s from the Dorothy and Herbert Vogel Collection", University of Pennsylvania, Philadelphia

1976 "Drawing Now", Museum of Modern Art, New York

"200 Years of American Sculpture", Whitney Museum of American Art, New York

Venice Biennale

1977 Documenta VI, Kassel

"Works from the Collection of Dorothy & Herbert Vogel", University of Michigan Museum of Art

1979 "Grids : Format and Image in 20th Century Art", Pace Gallery, New York

1980 "Pier and Ocean" Hayward Gallery, London; travelled to: Rijksmuseum, Kroller-Muller Otterlo; Venice Biennale; "ROSC 80" Dublin

1981 "Westkunst", Cologne

1982 "'60–'80", Stedelijk Museum, Amsterdam

"Documenta VII", Kassel

1983 "1940–1980", The Museum of Contemporary Art, Los Angeles

1984 "Geometric Art of the Twentieth Century", Kunstmuseum Bern

"Flyktpunkter: Vanishing Points: Mel Bochner, Tom Doyle, Dan Graham, Eva Hesse, Sol LeWitt, Robert Smithson, Ruth Vollmer", Moderna Museet, Stockholm

1984– Hallen Für Neue Kunst, Schaffhausen, Switzerland

93

1984 "Skulptur im 20. Jahrhundert", Merian-Park of St. Jakob at Basel

1984– "From the Collection of Sol LeWitt", The University Art Museum, California State University, Long Beach; travelled to: Ackland Art Museum, University of North Carolina, Chapel Hill; Everhart Museum, Scranton, PA, The Grey Art Gallery and Study Center, New York; Museum of Art, Fort Lauderdale.

1984 "La Grande Parade: Highlights in Painting since 1940", Stedelijk Museum, Amsterdam

1985 "Ouverture", Rivoli Castle, Turin, Italy

"Art Minimal 1: Carl Andre, Donald Judd, Sol LeWitt, Robert Mangold, Robert Morris", Musée d'Art, Contemporain de Bordeaux, (CAPC)

1986 "Forty Years of Modern Art: 1945–1985", The Tate Gallery, London

"Chambre Des Amis", Ghent (Organised by Museum van Heddandaagse Kunst, Ghent, Belgium; curator: Jan Hoet)

1987 "From the Collection of Sol LeWitt", Wadsworth Atheneum, Hartford, Connecticut

"Skulptur Projekte Münster", Münster

"Meltem: Jannis Kounellis, Sol LeWitt, Hermann Nitsch, Giulio Paolini, Sarkis, Jean-Michel Alberola, Lothar Baumgarten, Clegg & Guttmann, Serge Spitzer, Pierre Weiss", Chateau D'Oiron, France.

"Drawing Now 1: Sol LeWitt and Robert Mangold", The Baltimore Museum of Art, Baltimore

1988 "Pyramids/Pyramiden", ICC, Berlin and Galerie Jule Kewenig, Freichen-Bachem, Germany

"Zeitlos", Hamburger Bahnhof, Berlin (curator: Harald Szeemann)

Venice Biennale

"Accademia", Bonnefantenmuseum, Maastricht

1989– "The Presence of Absence: New Installations", (exhibition organised by Independent Curators Incorporated, New York), University of Illinois at Chicago

93

1989 "Minimalism", Tate Gallery, Liverpool

"Bilderstreit", Rhineside Halls, Cologne

1990– "Contemporary Illustrated Books: Word and Image 1967–1988", Franklin Furnace Archive, Inc. New York. Travelled to: Nelson-Atkins Museum of Art, Kansas City, and The University of Iowa Museum of Art, Iowa City (curator: Donna Stein. Organised by ICI, New York).

91

"New Works for New Spaces: Into the Nineties", Wexner Center for the Visual Arts, Columbus Ohio

1991– "Motion and Document Sequence and Time: Eadweard Muybridge and Contemporary American Photography", National Museum of American Art, Smithsonian Institution, Washington, DC and subsequent tour.

93

"Open Mind: The LeWitt Collection", Wadsworth Atheneum, Hartford

1992 "Arte Americana 1930–1970", Lingoto, Turin

"Allegories of Modernism : Contemporary Drawing",

Museum of Modern Art, New York
"Sammlung Lafrenz", Neues Museum Weserburg, Bremen
"transForm : BildObjektSkulpture im 20. Jahrhundert" Kunsthalle Basel
"Platzverführung", Ostfildern, Stuttgart (curator: Rudi Fuchs, Veit Görner)
"Special Collections: The Photographic Order from Pop to Now", International Center of Photography, New York

SELECTED PUBLIC COLLECTIONS

*structures

Akron Art Museum, Akron, Ohio
Albertina, Vienna
Albright Knox Art Gallery, Buffalo, New York*
Allen Memorial Art Museum, Oberlin, Ohio*
Art Gallery of Ontario, Toronto*
Art in Public Places Inc., Chicago
Art Institute of Chicago, Chicago*
Australian National Gallery, Canberra
Baltimore Museum of Art, Baltimore
Bayly Museum, University of Virginia, Charlottesville*
Brooklyn Museum of Art, New York
CAPC, Musée d'Art Contemporain de Bordeaux
Columbus Gallery of Fine Art, Columbus, Ohio
Crex Collection, Schaffhausen, Switzerland*
Dallas Museum of Art, Dallas
Dayton Art Institute, Dayton, Ohio
Detroit Institute of Art, Detroit
General Services Administration, Syracuse, New York
Grenoble Museum, Grenoble
Solomon R. Guggenheim Museum, New York (Panza Collection)
Haags Gemeentemuseum, The Hague*
Hara Museum, Tokyo
High Museum of Art, Atlanta, Georgia*
Hirshhorn Museum and Sculpture Garden, Washington DC*
Indianapolis Museum of Art, Indianapolis
INK, Zurich*
Israel Museum, Jerusalem*
Kaiser Wilhelm Museum, Krefeld
Krannert Art Museum, Champaign, Illinois*
Kunstmuseum, Basel
Kunstnernes Hus, Oslo*
Kunstsammlung Nordhein-Westfalen, Dusseldorf*
Lock Haven Art Center, Orlando, Florida
Los Angeles County Museum of Art, Los Angeles*
Louisiana Museum, Humlebaek, Denmark*
Metropolitan Museum of Art, New York*
Milwaukee Art Museum, Milwaukee, Winsconsin*
Minneapolis Institute of Art, Minneapolis
Moderna Museet, Stockholm
Museum Boymans van Beuningen, Rotterdam*
Museum Moderner Kunst, Vienna
Museum of Art, Carnegie Institute, Pittsburgh
Museum of Contemporary Art, Chicago
Museum of Contemporary Art, San Diego

Museum of Fine Arts, Boston*
Museum of Fine Arts, Houston, Texas*
Museum of Modern Art, New York*
Musée d'Art et d'Histoire, Geneva*
Musée des Beaux Arts, Tourcoing, France
Musée National D'Art Moderne, Centre Georges Pompidou, Paris*
National Gallery of Art, Washington DC*
National Museum of American Art, Washington DC
New Britain Museum of American Art, New Britain, Connecticut*
New Mexico State University, Las Cruces, New Mexico
Giuseppe Panza di Buomo Collection, Varese, Italy
Philadelphia Museum of Art, Philadelphia
The Port Authority of Allegheny County, Public Art Program for the Light Rail Transit System (Pittsburgh) Wood Street Station.
Rijksmuseum Kröller-Müller, Otterlo*
Rochester Memorial Art Gallery, Rochester, New York
Saatchi Collection, London*
San Diego Museum of Contemporary Art, La Jolla*
San Francisco Museum of Contemporary Art, San Francisco*
Scottish National Gallery of Modern Art, Edinburgh*
Smith College Art Gallery, Northampton, Massachusetts*
Sprengel Museum, Hannover*
St. Louis Art Museum, St. Louis
Städtisches Hochbaument, Karlsruhe*
Städtisches Museum, Mönchengladbach*
Stedelijk Museum, Amsterdam
Stedelijk Van Abbemuseum, Eindhoven
Storm King Art Center, Mountainville, New York*
Tate Gallery, London*
Tokyo Metropolitan Museum*
University Art Gallery, University of Massachusetts, Amherst
University of California Art Museum, Berkeley, California
University of Kentucky Art Museum, Lexington
Visiting Artists Inc. Civic Activities Center, Davenport, Iowa
Wadsworth Atheneum, Hartford, Connecticut*
Walker Art Center, Minneapolis*
Weatherspoon Art Gallery, Greensboro*
Westfälischer Landesmuseum, Münster (LeWitt Collection)*
Wexner Center for the Visual Arts, Columbus, Ohio*
Whitney Museum of American Art, New York*
Wilhelm-Lehmbruck Museum, Duisburg, Germany*
Worcester Museum of Art, Worcester, Massachusetts*

SELECTED BIBLIOGRAPHY
(Publications in English)

Lippard, Lucy, R. *The Third Stream: Painted Structures and Structured Paintings*, Art Voices (New York), vol. 4, #4, Spring 1965, pp.44–49
Hoene, Anne., *Sol LeWitt*, Arts Magazine, September/October 1965, pp.63–64
Lippard, Lucy, R., *New York, Letter*, Art International (Lugano), vol.9, #6, September 20 1965, pp.57–61
Rose, Barbara, *ABC Art*, Art In America October/November 1965
Bochner, Mel, *Primary Structures*, Arts Magazine, May 1966, p.42
Smithson, Robert, *Entropy and the New Monuments*, Artforum, June 1966 p.26
Robins, Corinne, *Object, Structure or Sculpture: Where are We?*, Arts Magazine, September/October, 1966, p.61

Bochner, Mel, *Art in Process,* Arts Magazine, September/October 1966, p.33

Sol LeWitt, Arts Magazine, September/October 1966, p.33

Morris, Robert, *Notes on Sculpture: Part Two,* Artforum, October 1966, p.21

Lippard, Lucy R., *Rejective Art,* Art International October 1966

Graham, Dan, *Of Monuments and Dreams,* Art and Artists, March 1967, p.26

Perreault, John, *A Minimal Future?,* Arts Magazine March 1967, p.26

Graham, Dan, *Models and Monuments,* Arts Magazine, March 1967

Rose, Barbara, *Shall We Have a Renaissance,* Art In America, March/April 1967, p.31

Lippard, Lucy R., *Sol LeWitt: Non-Visual Structures,* Artforum, April 1967, p.42

Lippard, Lucy R. & Chandler, John, *Visual Art and the Invisible World* Art International, May 1967, p.28

Morris, Robert, *Notes on Sculpture: Part Three,* Artforum, June 1967

Bochner, Mel, *Serial Art Systems Solipism,* Arts Magazine, Summer 1967, p.3

Bochner, Mel, *The Serial Attitude,* Artforum, December 1967

Bochner, Mel, *Working Drawings,* New York, 1967

Baro, Gene, *American Sculpture: A New Scene,* Studio International, January 1968, p.9

Lippard, Lucy & Chandler, John, *The Dematerialization of Art,* Art International, February 1968, p.31

Siegel, Jeanne, *Sol LeWitt: 47 Variations Using Three Different Kinds of Cubes,* Arts Magazine February 1968, p.57

Tucker, Marcia, *Sol LeWitt,* Art News, vol. 66, #10, February, 1968

Kulterman, Udo, *The New Sculpture: Environments and Assemblages* Translated by Stanley Baron. Frederick A. Praeger, New York, 1968

Smithson, Robert, *A Museum of Language in the Vicinity of Art,* Art International, March 1968, p.21

Krauss, Rosalind, *Sol LeWitt, Dwan Gallery,* Artforum, April 1968

Mellow, James, *New York Letter,* Art International, April 1968, p.65

Chandler, John N., *Tony Smith and Sol LeWitt: Mutations and Permutations,* Art International, September 1968, p.17

Battcock, Gregory, *Minimal Art: A Critical Anthology,* E.P. Dutton & Co., New York, 1968

Siegelaub, Seth and Wendler, John W. eds, Carl Andre, Robert Barry, Douglas Heubler, Joseph Kosuth, Sol LeWitt, Robert Morris, Lawrence Weiner, (Xerox Book) Siegelaub/Wendler, New York 1968 (includes Sol LeWitt Set 1A, 1–24)

Burnham, Jack, *Beyond Modern Sculpture: The Effects of Science and Technology on the Sculpture of This Century,* George Braziller, New York, 1968

Reise, Barbara, *Untitled 1969: A Footnote on Art and Minimal Stylehood,* Studio International, April 1969, p.166

Sol LeWitt: Sculptures and Wall Drawings (catalogue to accompany exhibition at Museum Haus Lange, Krefeld

Atkinson, Terry, *From an Art and Language Point of View,* Art and Language, Volume 1. #2, February 1970, pp.25–60

Burnham, Jack, *Alice's Head: Reflections on Conceptual Art,* Artforum, February 1970

Battcock, Gregory, *Documentation in Conceptual Art,* Arts Magazine, April 1970, p.42

Alloway, Lawrence, *Artists and Photographs,* Studio International, April 1970, p.162

Bochner, Mel, *Excerpts from Speculation (1967–1970),* Artforum, May 1970, p.70

Correspondence, Studio International, March 1970, p.89

Sol LeWitt: Haags Gemeentemuseum: catalogue to accompany exhibition at Haags Gemeentemuseum. Texts by John N. Chandler, Enno Develing, Dan Graham, and others. Statement and layout by *Correspondence,* Studio International, March 1970, p.89

The Seventies: Post-Objects Art, Studio International, September 1970

Lippard, Lucy R., *Changing: Essays in Art criticism,* E. P. Dutton & Co., New York, 1971, pp.154–166 (Essay on Sol LeWitt published previously in Artforum, April, 1967, p.42)

Elderfield, John, *Grids,* Artforum, May 1972, p.52

Menno, Filiberto, *Sol LeWitt: Un Sistema della Pittura,* Data, Milan, #4, May 1972, pp.14–2l. Translated, *Sol LeWitt: A System of Painting* *Sol LeWitt: Kunsthalle Bern: 7 October–19 November, 1972* (catalogue to accompany exhibition)

Müller, Gregoire & Gorgoni, Gianfranco, *The New Avant Garde: Issues for the Art of the Seventies,* New York, Praeger Publishers Inc., 1972

Pincus-Witten, Robert, *Sol LeWitt: Word – Object,* Artforum, vol.11, #6, February 1973, pp.69–72

Flash Art, #39, February 1973, p.33

Millet, Catherine, *Donald Judd, Sol LeWitt,* Art Press, February 1973, p.6

Frank, Peter, *Judd, LeWitt, Rockburne,* Art News, vol.72, #3, March 1973, pp.71–72

Borden, Lizzie, *Sol LeWitt,* Artforum, vol.11, #8, April 1973, pp.73–77

Crimp, Douglas, *New York Letter,* Art International (Lugano), vol.17, #4, April 1973, pp.57–59, 102–103

Gula, Kasha Linville, *Sol LeWitt at John Weber,* Art In America, vol.61 #3 May/June 1973, p.10

Battcock, Gregory, *New York,* Art & Artists, June 1973, p.51 Flash Art # 42, October/November 1973, pp.4–6

Krauss, Rosalind, *Sense and Sensibility – Reflections on Post '60s Sculpture,* Artforum, Nov, 1973, p.43

Lippard, Lucy R.,(ed) *Six Years: The Dematerialization of the Art Object,* New York, Praeger Publishers Inc., 1973

Achille Bonito Oliva, *Contemporanea* (catalogue) Centro Di, Florence, 1973

Some Recent American Art; catalogue to accompany travelling exhibition organised by the Museum of Modern Art, New York. Introduction: Jennifer Licht. National Gallery of Victoria, Melbourne, Australia, 1973

Barthelme, Donald, *Letters to the Editor,* The New Yorker, February 25, 1974

Alloway, Lawrence, *Artists as Writers, Part Two: The Realm of Language* Artforum, April 1974, pp.30–35

Morris, Lynda, *Projekt #7,* Studio International, September 1974

Alloway, Lawrence, *Art Books 1974,* The Nation, December 14, 1974, p.632

de Vries, Gerd, (ed) *Über Kunst – On Art: Artists' Writings on the Changed Notion of Art After 1965,* Verlag M DuMont Schauberg, Cologne 1974

Lubell, Ellen, *Sol LeWitt,* (review) Arts Magazine, January 1975, p.9

Smith, Roberta, *Sol LeWitt,* Artforum, January 1975, p.60

Alloway, Lawrence, *Sol LeWitt : Modules, Walls, Books,* Artforum, vol.#8, April 1975, pp.38–45 (cover)

Kuspit, Donald, *Sol LeWitt: The Look of Thought,* Art In America, vol.63, #5, September/October 1975, pp.42–49

American Art Since 1945: From the Collection of the Museum of Modern Art New York – catalogue to accompany exhibition. (editor: Alicia

Legg), 1975

Sol LeWitt, (review) Data, November/December 1975, p.29

Seventy-second American Exhibition – catalogue to accompany exhibition. The Art Institute of Chicago, 1976 (introduction: Anne Rorimer)

200 Years of American Sculpture – catalogue to accompany exhibition; Whitney Museum of American Art, New York, 1976 (text : Barbara Haskell)

Sol LeWitt, Print Collector's Newsletter, September/October 1976, p.118

Masheck, Joseph, *Kuspit's LeWitt: Has He Got Style?*, Art in America, vol.64 #6, November/December 1976, pp.107–111

Art Actuel, *Skira Annuel #2*, Editions d'art Albert Skira, Geneva, 1976, p.49

Kuspit, Donald, B., Kuspit/Masheck (cont), Art in America, vol.65, #1, January/February 1977, pp.5–7

Perreault, John, *Patterns of Thought*, Soho Weekly News, March 10, 1977, pp.17–19

Donald Judd & Sol LeWitt: Structures, Art International, March/April 1977, p.32

Wooster, Ann – Sargent, Art News (review), May 1977, p.140

Lubell, Ellen, Arts Magazine (review), May 1977, p.37

Masheck, Joseph, *Cruciformality*, Artforum, Summer 1977, p.56

Glueck, Grace, *Sol LeWitt's 'Jungle Gym for the Mind'*, New York Times. January 29, 1978, p.D.25

Sol LeWitt : The Museum of Modern Art, New York – catalogue to accompany exhibition at Museum of Modern Art New York (editor: Alicia Legg; design: Sol LeWitt; introduction: Alicia Legg; texts: Lucy R. Lippard, Bernice Rose, Robert Rosenblum. Museum of Modern Art, New York 1978

Bell, Tiffany, *Sol LeWitt*, Arts Magazine, April 1978, p.28

Kuspit, Donald, *Sol LeWitt the Wit*, Arts Magazine, April 1978, p.118

Pincus-Witten, Robert, *Strategies Worth Pondering* : Bochner, Shapiro, 10

Wooster, Ann Sargent, *LeWitt Goes to School*, Art in America, May/June 1978, p.82

Perlberg, Deborah, *Dance*, Artforum, January 1980, pp.52–53

1980 Medals: Artist Sol LeWitt and Stonecutter John Benson, Architecture in America Journal, March 1980

Wooster, Ann-Sargent, *Sol LeWitt's Expanding Grid*, Art in America, May 1980 pp.143–147

On the Walls of the Lower East Side, Mela, pp.19–20

Smith, Roberta, *Gridlock*, Village Voice, July 15–21, 1981, p.73

Great Drawings of All Time : The Twentieth Century (editor: Victoria Thorson) Shorewood Fine Art Books, 1981

Sol LeWitt Wall Drawings – catalogue raisonée to accompany exhibition at Stedelijk Museum, Amsterdam. Editor: Susanna Singer; design: Sol LeWitt. Texts: Jan Debbaut, Alexander van Grevenstein. Interview with LeWitt: Andrea Miller–Keller; Stedelijk Museum, Amsterdam; Stedelijk Van Abbemuseum, Eindhoven; Wadsworth Atheneum, Hartford, Connecticut, 1984

Flyktpunkter: Vanishing Points – catalogue to accompany exhibition at the Moderna Museet, Stockholm. Editors: Olle Granath, Margareta Helleberg. Texts: Ted Castle, Lucy R. Lippard

American Art Since 1970 – catalogue to accompany exhibition organised by the Whitney Museum of American Art; Whitney Museum of American Art, New York, 1984

Liebmann, Lisa, *Stubborn Ideas and LeWitty Walls* Artforum, October 11, 1984, pp.64–68

From the Collection of Sol LeWitt – catalogue to accompany travelling exhibition, Independent Curators Inc., New York, in collaboration with the Wadsworth Atheneum, Hartford, Connecticut. Texts: Andrea Miller Keller, John Ravenal, 1984

Robins, Corrine, *The Pluralist Era: American Art 1968–1981*, Harper & Row, 1984

Art Minimal 1 – catalogue to accompany exhibition at CAPC, Musée d'Art Contemporain de Bordeaux. Introduction: Jean Louis Froment. 1985

New Works: Sol LeWitt – brochure to accompany exhibition at Arthur M. Sackler Museum. Texts: Caroline Jones and Peter Nisbet, 1985

Gimelson, Deborah, *The Tower of Art: The Equitable Life Assurance Society*, New York

Stephens, Suzanne, *An Equitable Relationship?*, Art in America, May 1986, pp.117–123

Sol LeWitt Prints: 1970–1986, catalogue raisonné to accompany exhibition at The Tate Gallery, London. Text: Jeremy Lewison. Tate Gallery Publications, London, 1986

Mater Dulcissima – catalogue to accompany exhibition at Chiesa dei Cavalieri di Malta, Siracusa, Italy. Texts on Sol LeWitt: Tomasso Trini, Germano Celant, 1986

Ooghoogte (Eye Level) – catalogue to accompany exhibition at Stedelijk Van Abbemuseum, Eindhoven. Texts: E.L.L. de Wilde, Rudi Fuchs, 1986

Individuals: A Selected History of Contemporary Art. Catalogue to accompany exhibition at The Museum of Contemporary Art, Los Angeles. Editor: Howard Singerman. Texts: Kate Linker, Donald Kuspit, Hal Foster, Ronald Onorato, Germano Celant, Achille Bonito Oliva, John C. Welchman, Thomas Lawson, 1987

Daniel Buren/Sol LeWitt – catalogue to accompany exhibitions at Centre National D'Art Contemporain de Grenoble – Magasin. Text: Sol LeWitt

Millet, Catherine, *Les Espaces paradoxaux de Sol LeWitt*, Art Press #111, February 1987, pp.28–32 (also includes an interview with LeWitt pp.28–29)

Dreher, Thomas, *Sol LeWitt: The Two series 'Forms Derived From A Cube' and Pyramids'* Arte Factum, November 1986 – January 1987, pp.2–9

Sol LeWitt – pamphlet to accompany exhibition at The Cleveland Museum of Art, Cleveland, Ohio. Text: Tom E. Hinson.

Howard, Jan, *Drawing Now: Sol LeWitt* – brochure to accompany exhibition at Baltimore Museum of Art, Baltimore, 1987

Rosenzweig, Phyllis, *Sol LeWitt Works – Interview with Sol LeWitt* – brochure to accompany exhibition at Hirshhorn Museum and Sculpture Garden, Washington DC, 1987

Stockebrand, Marianne, *Sol LeWitt, Tilted Forms, Wall Drawings*; Westfälischer Kunstverein, – catalogue to accompany exhibition at Westfälischer Kunstverein, Münster, 1987

Pick Up The Book, Turn the Page and Enter the System: Books by Sol LeWitt – catalogue to accompany exhibition at the Minnesota Center for Book Arts. Text: Betty Bright, 1987

Het Meubel Verbeeld. – Furniture As Art – catalogue to accompany exhibition at Museum Boymans van-Beuningen, Rotterdam. Text: Huub Mous, 1988

Sol LeWitt: Wall Drawings; Continuous Forms with Color and Gouache Superimposed – catalogue to accompany exhibition at Wiener Secession, Vienna Texts: Hildegund Amanshauser, Georg Schollhammer, 1988

Pyramiden – catalogue to accompany exhibition at Galerie Jule

Kewenig, Frechen-Bachem, Germany. Text: Hermann Wiesler, 1988

Sandler, Irving, *American Art of the 1960s*, Harper & Row, New York, 1988

Three Decades : The Oliver-Hoffmann Collection – catalogue to accompany exhibition at the Museum of Contemporary Art, Chicago. Texts: I. Michael Danoff, Bruce Guenther, Camille Oliver – Hoffmann, Phyllis Tuchman, Lynne Warren, 1988

Sol LeWitt Wall Drawings 1984–1988, catalogue raisonée to accompany exhibition at Kunsthalle Bern. Editor: Susanna Singer. Design: Sol LeWitt and Bill Brown. Text: Ulrich Loock, Kunsthalle Bern, 1989

Neff, Eileen, Sol LeWitt: Lawrence Oliver Gallery, Artforum, March 1989

Flash Art, #145 – March/April 1989 (cover)

Brüderlin, Markus, *Painting as Architecture*, Flash Art #145, March/April 1989

Sol LeWitt Wall Drawings, Kestner Gesellschaft, Hannover – catalogue to accompany exhibition. Text: Carl Haenlein, 1989

Sol LeWitt, Gibbes Museum of Art Spoleto Festival USA – catalogue to accompany exhibition. Text: Andrea Miller-Keller, 1989

L'Art Conceptuel, Une Perspective – catalogue to accompany exhibition at the Musée d'Art Moderne de la Ville de Paris. Texts: Suzanne Pagé, Claude Gintz, Benjamin Buchloh, Charles Harrison, Gabriele Guercio, Seth Siegelaub, 1989

Sol LeWitt Recent Works – catalogue to accompany exhibition at the Touko Museum of Contemporary Art. Editor: Haruo Fukuzumi, Susanna Singer. Essay: Robert Rosenblum, re-printed from Museum of Modern Art catalogue, 1978 and translated into Japanese.

Sol LeWitt: Opere recenti : Pyramids, Complex Forms e Folding Screens Texts: Achille Bonito Oliva, Marilena Bonomo, Luciano Elisei, Moreno Orazi. Electa Editori Umbri, Elemond Editori Associati, 1990

The Future of the Object! A Selection of American Art; Minimalism and After – catalogue to accompany exhibition at Galerie Ronny Van de Velde, Antwerp 1990. Essay: Kenneth Baker.

Collection: Christian Boltanski, Daniel Buren, Gilbert & George, Jannis Kounellis, Sol LeWitt, Richard Long, Mario Merz – catalogue to accompany exhibition at CAPC, Musée d'Art Contemporain, Bordeaux, France. Texts on LeWitt: Michel Bourel, Pascal Dusapin, Bernard Macardé, 1990

Sol LeWitt Books 1966–1990, – catalogue to accompany exhibition at Portikus, Frankfurt, 1990. Designed by Sol LeWitt

Sol LeWitt Complex Forms 1990 : Wall Drawings Gerichtsgebäude E, Frankfurt Am Main. Text: Ingrid Mossinger, 1991

American Abstraction at the Addison, The Addison Gallery of American Art, Andover, Massachusetts. Catalogue to accompany exhibition. Text: Jock Reynolds

Yvon Lambert Collectionne, Musée D'Art Moderne de la Communauté Urbaine de Lille, Villeneuve D'Ascq, Musée des Beaux Arts de Tourcoing. Catalogue to accompany exhibition. Interview with Lambert by Joëlle Pijaudier; Introduction: Dominique Bozo

Sammlung Lafrenz, Neues Museum Weserburg, Bremen, Germany. Catalogue to accompany exhibition. Text: Martin Hentschel.

Sol LeWitt Wall Drawings 1984–1992, Updated and expanded version of 1989 catalogue raisonné. Editor: Susanna Singer. Design: Sol LeWitt. Text: Ulrich Loock. Kunsthalle Bern, 1992

Sol LeWitt Drawings 1958–1992 Catalogue to accompany exhibition and tour organised by Haags Gemeentemuseum, The Hague. Editor: Susanna Singer. Design: Sol LeWitt. Text: Franz W. Kaiser, Rudi Fuchs. Haags Gemeentemuseum, The Hague, 1992

SELECTED ARTICLES AND CATALOGUES BY THE ARTIST

Ziggurats, Arts Magazine, vol.41, #1 November 1966, pp.24–25, 8 × 8 in.

Serial Project No. 1, Aspen Magazine, section 17, #5–6, 1966

Paragraphs on Conceptual Art, Artforum, vol.5, #10 June 1967, pp.79–83

Drawing Series 1968 (Fours), Studio International, vol.177, #910 April 1969, p.18

49 Three-Part Variations Using Three Different Kinds of Cubes, 1967–1968, Bruno Bischofberger, Zurich, 1969 $6\frac{1}{2}$ × 14 in

Four Basic Kinds of Straight Lines, Studio International, 1969, 32pp 8 × 8 in

Sentences on Conceptual Art, Art-Language, vol.1, #1 May 1969, pp.11–13

Battcock, Gregory, Editor, *Documentation in Conceptual Art*, Arts Magazine vol.44 #6, April 1970, pp.42–45, includes Sol LeWitt on Wall Drawings

I Am Still Alive, On Kawara, Studio International, vol.180, #924 July/August 1970, p.37

Four Basic Colours and Their Combinations, Lisson Publications, London, 1971, 37pp.

Doing Wall Drawings, Art Now: New York, vol.3, #2, June 1971

Arcs, Circles, & Grids, Kunsthalle Bern and Paul Bianchini, Paris, 1972, 208pp, 8 × 8 in

All Wall Drawings, Arts Magazine vol.46, #4, February 1972, pp.39–44 and cover

Cercles & Lignes, Galerie Yvon Lambert, Paris, France, 1973, 8pp.

Sol LeWitt, Marilena Bonomo, Bari, Italy, 1973

Wall Drawings: Seventeen Squares of Eight Feet with Sixteen Lines and One Arc, Portland Center for the Visual Arts, Portland, Oregon, 1973, 18pp. $8\frac{1}{2}$ × $5\frac{1}{2}$ in

Vier Muurtekeningen/Quatre Dessins Muraux, Art & Project, Amsterdam/MTL, Brussels, 1973, 4pp.

Sol LeWitt, Flash Art, #41, June 1973, p.2

The Location of Eight Points, Max Protetch Gallery, Washington DC., 24pp., $5\frac{1}{2}$ × $5\frac{1}{2}$ in

La Posizione di Tre Figure Geometriche/The Location of Three Geometric Figures, Galleria Sperone, Torino, Italy, 1974, 16pp.

Location of Three Geometric Figures, Société des Expositions, Brussels, Palais des Beaux Arts, 1974

Incomplete Open Cubes, John Weber Gallery, New York, 1974, 264pp., 8 × 8 in

Drawing Series I, II, III, IIII A & B, Galleria Sperone, Torino, Italy and Galerie Konrad Fischer, Dusseldorf, 1974, 224pp., 9 × 9 in

The Location of Lines, Lisson Publications, London, 1974, 48pp., 8 × 8 in

Arcs and Lines, Editions des Massons S.A. Lausanne, and Galerie Yvon Lambert, Paris, 1974, 56pp., 8 × 8 in

Lines and Color, Galerie Annemarie Verna, Zurich; Rolf Preisig, Basel, and Marilena Bonomo, Bari, 1975, 72pp., 8 × 8 in

Incomplete Open Cubes, Art & Project, Amsterdam, bulletin 88, 1975, 4pp.

Grids, Pour Ecrire La Liberté, Brussels, 1975, 8pp., 10 × 10 in

Graphik, Kunsthalle Basel and Verlag Kornfeld und Cie, Bern, 1975

Red, Blue & Yellow Lines from Sides, Corners and the Center of the Page to Points on a Grid, Israel Museum, Jerusalem, 1975, 16pp., 7 × 7 in

The Location of Six Geometric Figures, double page, #1, Annemarie Verna, Zurich, January 1976

The Location of Straight, Not-Straight & Broken Lines And All Their Combinations, John Weber Gallery, New York, 1976, 16pp., 8 × 8 in

Five Structures, Hammarskjold Plaza Sculpture Garden, New York, John Weber Gallery, New York, 1976, 8pp., 5 × 5 in

Geometric Figures Within Geometric Figures, Department of Fine Arts of the University of Colorado, Boulder, Colorado, 1976, 52pp., 8 × 8 in

Modular Drawings, Adelina von Furstenberg, Geneva, 1976, 104pp., 6 × 6 in

Lippard, Lucy R., *Eva Hesse*, New York University Press, New York, 1976: Designed by Sol LeWitt.

Books, Art Rite, New York, #14, Winter 1976–1977, p.10

Wall Drawings in Australia, John Kaldor, Sydney, Australia, 1977, 16pp., 7 × 7 in

Brick Wall, Tanglewood Press, New York, 1977, 32pp., 10 × 8 in

Photogrids, Paul David Press, New York, 1977, 48pp., 10½ × 10½ in

Five Cubes on Twenty Five Squares, Galleria Marilena Bonomo, Bari, Italy

197 Color Grids, Multiples, New York, 1977, 92pp., 8 × 8 in

Four Basic Kinds of Lines & Colour, Lisson Gallery, London, Studio International, London, Paul David Press, New York, 1977, 36pp., 8 × 8 in

Open Geometric Structures: Five Geometric Structures and Their Combinations, Lisson Gallery, London, 1979, 36pp., 4 × 8 in

Geometric Figures & Color, Harry N. Abrams, New York, 1979, 48pp., 8 × 8 in

On The Walls of the Lower East Side, (photographs), Artforum, December 1979

All Four Part Combinations of Six Geometric Figures, Galerie Watari, Tokyo 1980, 16pp., 5 × 12 in

Sunrise & Sunset at Praiano, Rizzoli, New York and Multiples, New York, 1980, 32pp., 8 × 8 in

Cock Fight Dance, Rizzoli, New York, and Multiples, New York, 1980, 48pp., 4 × 4 in

Six Geometric Figures and All Their Double Combinations, Galerie Yvon Lambert, Paris, 1980, 15pp., 6 × 8 in

Autobiography, Multiples, New York and Lois & Michael Torf, Boston, 1980, 128pp., 10½ × 10½ in

A Project by Sol LeWitt, Artforum, October 1981, pp.59–63 and cover

Three Structures: 1978–1980, Annemarie Verna, Zurich, 1981, 6pp., 6 × 8 in

Isometric Drawings, Paula Cooper Gallery, New York, and John Weber Gallery, New York, 1982, 44pp., 9 × 9 in

Geometric Forms in Black and White and Color, A E I U O, December 1982

Venti Forme Derivate Da Un Cubo, Ugo Ferranti, Rome, 1982, 40pp., 6 × 6 in (15.24 × 15.24 cm)

Lignes en Quatre Directions et Toutes Leurs Combinaisons, Musée d'Art Contemporain, CAPC, Bordeaux, 1983, 36pp., 9 × 9 in (unfolds to one sheet, 9 × 158½ in)

Lines in Four Colors and Four Directions, Tema Celeste, Siracusa, Italy, October, 1984, 4 pp., 8½ × 11 in

From Monteluco to Spoleto, December 1976, Stedelijk Van Abbemuseum, Eindhoven

Openbaar Kunstbezit, Weesp, 1984, 40pp., 10 × 10 in

Sol LeWitt, Au Fond de la Cour à Droite, Chagny, France, 1984, 18pp., 7 × 7 in

Alighiero E. Boetti, Sol LeWitt, Giulio Paolini, Edizioni Pieroni, Rome, 1984, 28pp., 9 × 6 in

Borges, Jorge Luis, Ficciones, with silkscreen illustrations by Sol LeWitt, printed by Jo Watanabe, New York. Limited Editions, New York, 1984. Edition: 1500, 312pp., 8 × 8 in

Mario Merz-Sol LeWitt, Edizioni Pieroni, Rome, Italy, 1985, 24pp., 8 × 9¾ in

Piramidi, Marco Noire Editore, Turin, 1986, 10 fold-out pages, each 8½ × 26½ in (21 × 66 cm), Edition: 400, signed and numbered, 9 × 9 in (22.5 × 22.5 cm)

Piramidi, Marco Noire Editore, Turin, 1986, 2 fold-out pages, each 6½ × 19 in, (16 × 47.5 cm). Edition: 150, 7 × 5 in (17.5 × 12.5 cm)

Pyramiden, Galerie Peter Pakesch, Vienna, 1986, 25pp., 7⅔ × 7¾ in (19½ × 19½ cm)

Four Colors And All Their Combinations, Musée d'Art Moderne de la Ville de Paris, 1987, 44pp., 9¼ × 7 in (24 × 17.5 cm)

Sol LeWitt, Arc/Musée d'Art Moderne de la Ville de Paris, 20 Fevrier – 20 Avril, 1987, 24pp (including cover and back), 6 × 9½ in (15.6 × 23.75 cm)

Gekippte Formen (Tilted Forms – black and white scribbles), Westfälischer Kunstverein, Münster, 1987, 27pp.(including cover and back), 10½ × 10½ in (26 × 26 cm)

Lithographies (Flat-Top Pyramids), Noise, Numero 7, Maeght Editeur, Paris, pp.26–31, edition: 2000, plus 120 signed and numbered, 14½ × 10⅝ in (36 × 26 cm)

Lines in Two Directions and in Five Colors with All Their Combinations Walker Art Center, Minneapolis, 1988, 80pp., 9 × 9 in (22.5 × 22.5 cm)

Sol LeWitt: Forms Derived from a Cube, 1986, Galerie Pakesch, Vienna, 1988 12pp (text: Ferdinand Schmatz; photographs: Wolfgang Woessner), 8¼ × 6 in (21 × 15 cm)

Lines et Formes, Galerie Yvon Lambert, Paris, 1989, 12pp. (including cover and back), 11¼ × 12¾ in (28 × 32cm)

Cube: A Cube Photographed by Carol Huebner Using Nine Light Sources and All Their Combinations, John Weber Gallery, New York; Edizioni Mario Pieroni, Rome; Verlag der Buchhandlung Walther Konig, Cologne, 1990, 516pp (including cover & back), 7¼ × 7¼ in (18 × 18 cm)

A Drawing Page: Cubes: A Project for Artforum by Sol LeWitt, Artforum XXIX, No.9, May 1991 pp.101–102

ILLUSTRATIONS OF STRUCTURES IN PRIVATE AND PUBLIC COLLECTIONS 1962–1993; LIST OF OWNERS

1. LeWitt Collection; Wadsworth Atheneum, Hartford, Connecticut, extended loan
2. Collection of the artist
3. Whereabouts unknown
4. LeWitt Collection; Wadsworth Atheneum, Hartford, Connecticut, on extended loan
5. LeWitt Collection; Wadsworth Atheneum, Hartford, Connecticut, on extended loan

6. Collection of the artist
7. LeWitt Collection; Wadsworth Atheneum, Hartford, Connecticut, on extended loan
8. LeWitt Collection; Wadsworth Atheneum, Hartford, Connecticut, on extended loan
9. LeWitt Collection; Wadsworth Atheneum, Hartford, Connecticut, on extended loan
10. LeWitt Collection; Wadsworth Atheneum, Hartford, Connecticut, on extended loan
11. Destroyed
12. Collection of the artist
13. Collection Sondra and Charles Gilman Jr.
14. Collection Pierre Huber, Geneva, Switzerland
15. Destroyed
16. Whereabouts unknown
17. Collection Norman Goldman, New York
18. LeWitt Collection; Wadsworth Atheneum, Hartford, Connecticut, on extended loan
19. Collection Paula Cooper, New York
20. Collection Lucy R. Lippard, New York
21. Destroyed, re-made in 1976
22. Destroyed
23. Destroyed
24. LeWitt Collection; Wadsworth Atheneum, Hartford, Connecticut, on extended loan
25. Destroyed
26. Whereabouts unknown
27. Destroyed
28. LeWitt Collection; Wadsworth Atheneum, Hartford, Connecticut, on extended loan
29. Collection Will Insley, New York, NY
30. Collection Leo Valledor, San Francisco
31. Courtesy Margo Leavin, Los Angeles
32. Estate of Robert Smithson
33. Collection Virginia Dwan, New York
34. National Gallery of Art, Washington, Vogel Collection
35. LeWitt Collection; Wadsworth Atheneum, Hartford, Connecticut, on extended loan
36. Collection Robert and Sylvia Mangold
37. Collection Daniella Dangoor, London
38. Courtesy Sperone Westwater, New York.
39. Wood version destroyed
40. Destroyed. Remade in steel, 1975 Museum Mönchengladbach (on permanent loan) Collection MJS, Paris; also Collection Paul Maenz, Cologne
41. Whereabouts unknown
42. Collection Virginia Dwan, New York
43. Destroyed, remade in steel 1970
44. Collection Virginia Dwan, New York
45. Destroyed, remade in steel 1968
46. The Museum of Modern Art, New York, Gift of Alicia Legg
47. Whereabouts unknown
48. Collection Bernard Venet, France
49. Courtesy Galerie Daniel Templon, Paris
50. Private Collection, Denver; Art Gallery of Ontario, Toronto
51. Detroit Institute of Arts, Detroit; Whitney Museum of American Art, New York
52. Whereabouts unknown
53. Whereabouts unknown
54. Rijksmuseum Kröller-Müller, formerly Visser Collection
55. Rijksmuseum Kröller-Müller, formerly Visser Collection
56. Private Collection Paris, courtesy Daniel Varenne Gallery, Geneva
57. Collection Gerald Elliott, Chicago
58. The Museum of Modern Art, New York; Tokyo Metropolitan Museum, Tokyo
59. Hallen für Neue Kunst, Schaffhausen, Switzerland
60. Whereabouts unknown
61. Whereabouts unknown
62. Museum of Fine Arts, Houston, Texas
63. Destroyed. Remade in steel: $45 \times 300 \times 195$ in ($14.3 \times 762 \times 495.3$ cm). Collection Allen Memorial Art Museum, Oberlin College, Roush Fund for Contemporary Art, 1972 White painted wood, 1984 Each: $23 \times 8 \times 8$ in ($58.4 \times 20 \times 20$ cm) Base: $63 \times 47\frac{1}{4}$ in (160×120 cm). Collection Klaus Lafrenz. Baked enamel on aluminium Collection Sofia LeWitt, on long-term loan to the Des Moines Art Center, Des Moines, Iowa
64. Private Collection
65. LeWitt Collection; New Britain Museum of American Art, New Britain, Connecticut, on extended loan.
66. Commissioned by the General Services Administration, Syracuse
67. Crex Collection, Schaffhausen, Switzerland
68. Museum of Contemporary Art, San Diego
69. Museum Haus Lange, Krefeld
70. Private collection, courtesy Barbara Kornblatt Fine Art
71. Courtesy John Weber Gallery, New York
72. Collection Smalley Sculpture Garden, University of Judaism, Los Angeles
73. Collection Karsten Grève, Paris
74. Whereabouts unknown
75. Courtesy Annemarie Verna, Zurich
76. Courtesy Rhona Hoffman Gallery, Chicago
77. Collection Claes Oldenburg and Coosje van Broogen
78. Collection Robert M. Cocran
79. Private collection, courtesy Irena Hochman Fine Art Ltd.
80. Courtesy Lisson Gallery, London
81. Courtesy Lisson Gallery, London
82. Courtesy Lisson Gallery, London
83. Courtesy Lisson Gallery, London
84. Courtesy Donald Young Gallery, Seattle
85. Courtesy Donald Young Gallery, Seattle
86. Scottish National Gallery of Modern Art, Edinburgh
87. Collection Jeffrey Deitch, New York
88. LeWitt Collection; New Britain Museum of American Art, New Britain Connecticut, on extended loan
89. Collection Beyertz
90. Milwaukee Art Museum, Milwaukee
91. Collection Gerald Pook, Chicago
92. Whereabouts unknown
93. Whereabouts unknown
94. Whereabouts unknown
95. Weatherspoon Art Gallery, University of North Carolina at Greensboro, North Carolina. Purchased by the Weatherspoon Art Gallery Association Purchase, 1988
96. Whereabouts unknown
97. Whereabouts unknown
98. The Arthur and Carol Goldberg Collection steel version:

Lorenzo & Marilena Bonomo Collection, Bari
99. Installation: Galleria Marilena Bonomo, Bari, 1986
100. Courtesy John Weber Gallery, New York
101. Collection Migros, Zurich
102. Collection of the artist
103. Courtesy Lisson Gallery, London
104. Courtesy Lisson Gallery, London
105. Collection Paul and Camille Oliver-Hoffmann, Chicago. Also individually, 1982, 19 × 19 × 19 in (48 × 48 × 48 cm) and baked enamel on aluminium, 1988, 32 × 32 × 32 in (81.2 × 81.2 × 81.2 cm)
106. Courtesy Graeme Murray Gallery, Edinburgh. This is a half-size version of similar works from 1979, although the complete set had never previously been fabricated. However, in 1979 each figure was 12 × 12 × 12 in (30.5 × 30.5 × 30.5 cm). There are: 2 sets of singles; 1 two-part, 1 set of 3-parts; 1 set of 4-parts and 2 sets of 5-parts exist (1 within a square, and 1 in a row).
107. Courtesy Studio G7, Bologna
108. Courtesy Massimo Minini, Brescia
109. Courtesy Studio G7, Bologna
110. Courtesy Studio G7, Bologna
111. Courtesy Massimo Minini, Brescia
112. Courtesy Galleria Marilena Bonomo, Bari
113. Courtesy Studio G7, Bologna
114. Collection Andrea Marescalchi, Florence
115. Courtesy Massimo Minini, Brescia
116. Courtesy Pierre Huber, Geneva
117. Courtesy Pierre Huber, Geneva
118. Courtesy Studio G7, Bologna
119. Courtesy Galerie Peter Pakesch, Vienna
120. Courtesy Massimo Minini, Brescia
121. Courtesy Massimo Minini, Brescia
122. Collection Mr. and Mrs. Goldberg, Brussels
123. #45 Collection Michael Villers, Brussels
124. Courtesy Galleria Mario Pieroni, Rome
125. Installation: Spazio d'Arte, Alfonso Artiaco, Pozzuoli, Italy, 1989

126. Collection Mr. & Mrs. Brewster Atwater, Minneapolis
127. Courtesy Galerie Vega, Brussels
128. National Museum of Japan, Tokyo
129. Collection of the artist; on long-term loan to Westfälisches Landesmuseum für Kunst und Kulturgeschichte, Münster
130. Commissioned by Visiting Artists Inc. for the Civic Activities Center, Davenport
131.,132. New Mexico State University, Las Cruces, New Mexico
133. The Port Authority of Allegheny County, Public Art Programme for the Light Rail Transit System (Pittsburgh), Wood Street Station
134. Destroyed
135. Private Collection, United States
136. Collection Nicholas and Caroline Logsdail, London
137. Destroyed
138.–
141 1 wall: Ruit; 2 walls: Kemnat; 3 walls: Scharnhausen; 4 walls: Nellingen. Installation: 'Platzverführung', Ostfildern, Stuttgart (Curator: Rudi Fuchs, Veit Görner)
142. Installation: 'Skulptur im 20 Jahrhundert', Merlan Park of St. Jacob, Basel. Collection Bechtler Foundation, Zurich
143. Israel Museum, Jerusalem
144. Collection Giuliano Gori, Villa Celle, Pistoia, Italy
145. Collection of the artist
146. Installation: 'Zeitlos' exhibition, Hamburger Bahnhof, Berlin. Destroyed.
147. Installation: John Weber Gallery, New York. Destroyed.
148. Installation: Donald Young Gallery, Seattle. Destroyed
149. Installation: Massimo Minini, Brescia
150. Collection Martin Visser, Bergeyk, Holland
151. Installation: 'New Works for New Spaces: Into the Nineties', Wexner Center for the Visual Arts, Columbus, Ohio
152. Installation: Max Protetch Gallery, New York
153. First installation: Skulptur Projekt, Münster. Collection City of Hamburg. Installed at Platz der Republik, Hamburg, Altona.

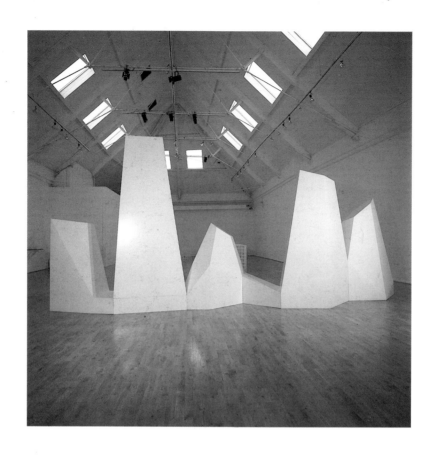

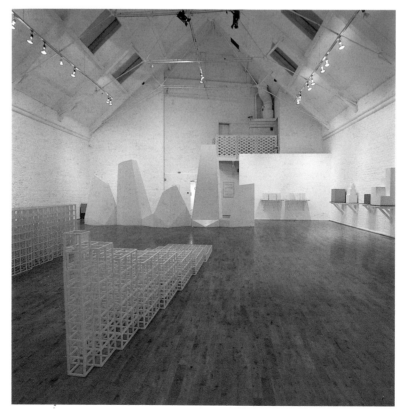